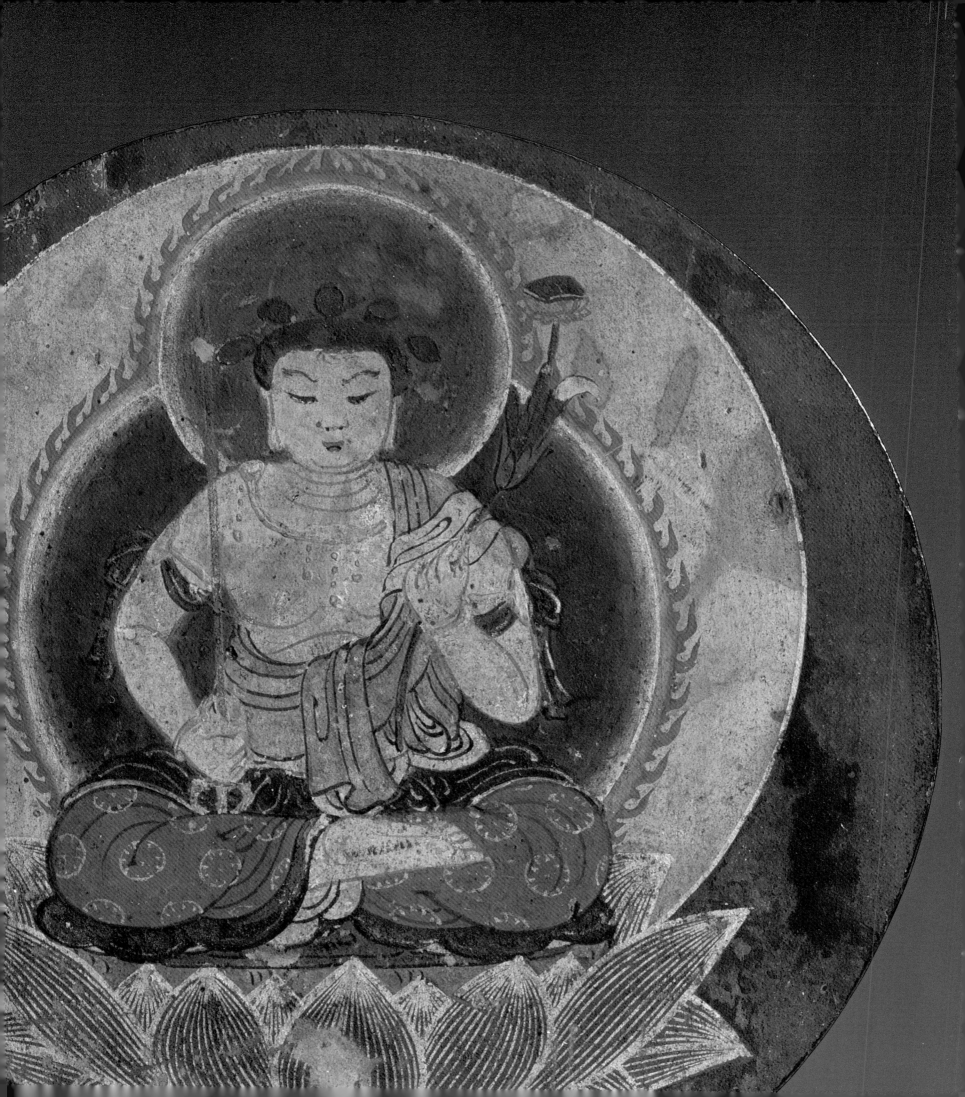

Crosscurrents

Masterpieces of East Asian Art
from New York Private Collections

Amy G. Poster

with contributions by
Richard M. Barnhart and Christine M. E. Guth

Photography by John Bigelow Taylor

Japan Society, New York in association with the Brooklyn Museum of Art

DISTRIBUTED BY HARRY N. ABRAMS, INC., PUBLISHERS

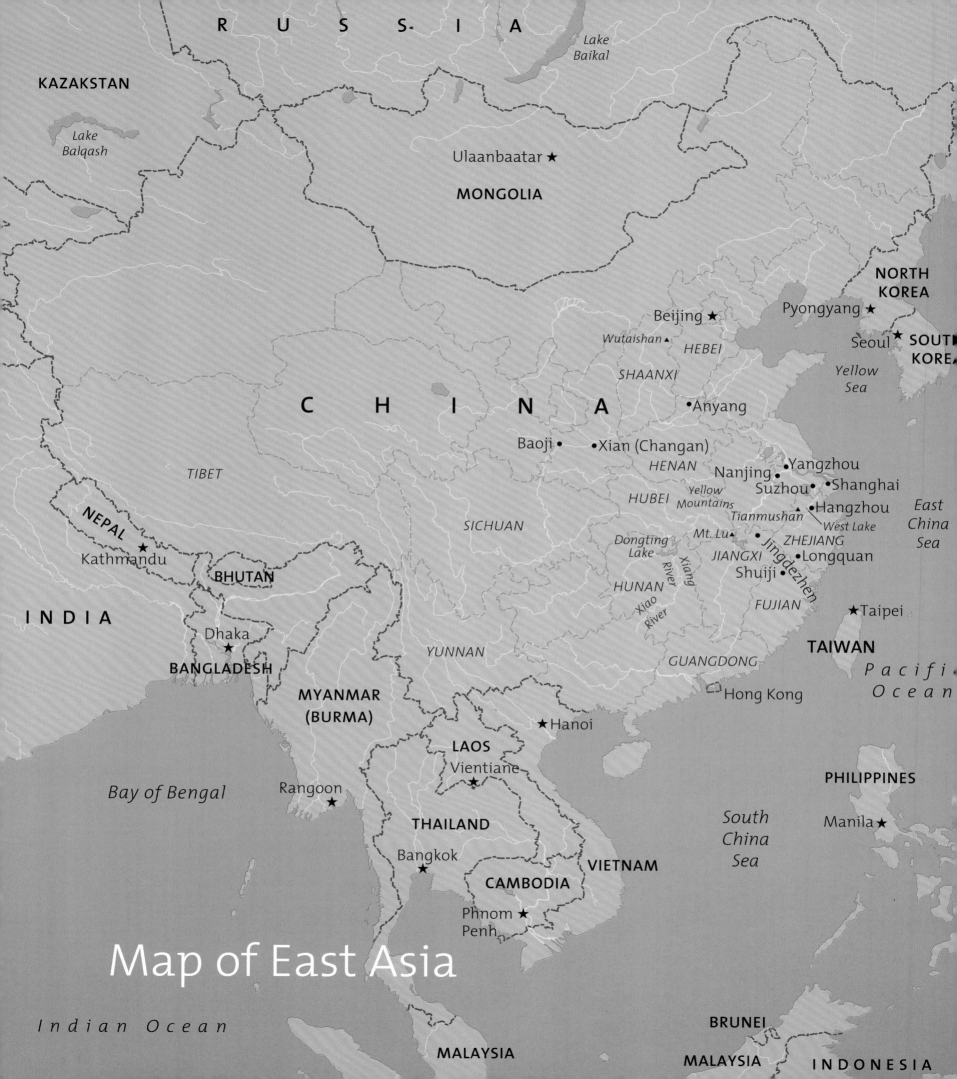

RUSSIA

Lake
Baikal

KAZAKSTAN

Lake
Balqash

Ulaanbaatar ★

MONGOLIA

NORTH
KOREA

Pyongyang ★

Beijing ★

Seoul ★ SOUTH
KOREA

Wutaishan ▲ *HEBEI*

SHAANXI

C H I N A

*Yellow
Sea*

•Anyang

Baoji • •Xian (Changan)

Nanjing • •Yangzhou

HENAN

Suzhou • •Shanghai

*Yellow
Mountains*

TIBET

HUBEI

Hangzhou

SICHUAN

Tianmushan ▲

West Lake

*East
China
Sea*

NEPAL

Kathmandu ★

*Dongting
Lake*

Mt. Lu ▲

ZHEJIANG

•Jingdezhen •Longquan

BHUTAN

JIANGXI

Shuiji

INDIA

Dhaka ★

HUNAN

*Xiang
River*

FUJIAN

★ Taipei

BANGLADESH

*Xiao
River*

TAIWAN

MYANMAR
(BURMA)

YUNNAN

GUANGDONG

★ Hanoi

*Pacific
Ocean*

Hong Kong

Bay of Bengal

Rangoon
★

LAOS

Vientiane
★

PHILIPPINES

*South
China
Sea*

Manila ★

THAILAND

Bangkok
★

CAMBODIA

VIETNAM

Map of East Asia

Phnom
Penh ★

Indian Ocean

BRUNEI

MALAYSIA

MALAYSIA

INDONESIA

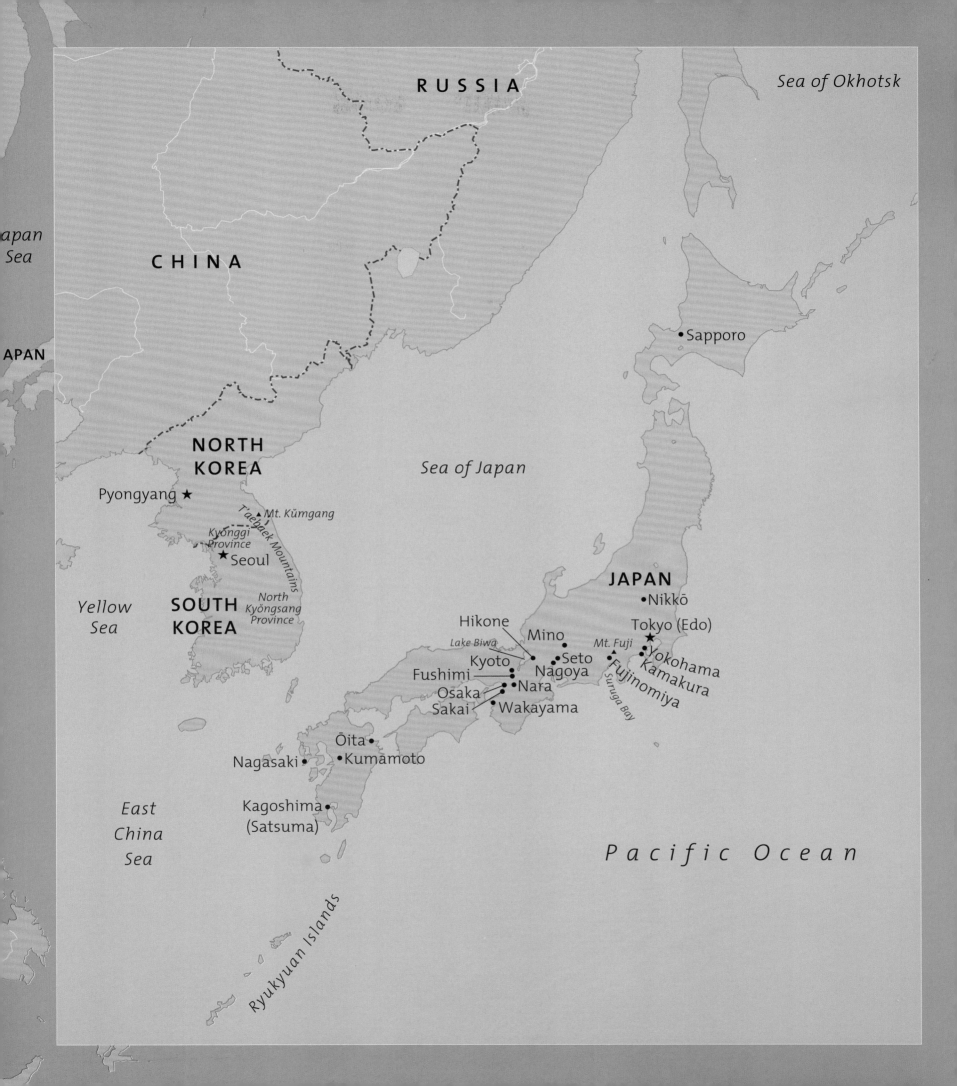

RUSSIA

Sea of Okhotsk

*Japan
Sea*

CHINA

APAN

Sapporo

NORTH
KOREA

Sea of Japan

Pyongyang ★

▲ Mt. Kŭmgang

Taebaek Mountains

*Kyŏnggi
Province*

*Yellow
Sea*

SOUTH
KOREA

★ Seoul

*North
Kyŏngsang
Province*

JAPAN

• Nikkō

Tokyo (Edo)

Hikone

Mino

Mt. Fuji ★

Lake Biwa

Seto

Yokohama

Kyoto

Nagoya

Kamakura

Fushimi

Nara

Fujinomiya

Osaka

Suruga Bay

Sakai

Wakayama

Ōita •

*East
China
Sea*

Nagasaki •

• Kumamoto

Kagoshima •
(Satsuma)

Ryukyuan Islands

Pacific Ocean

China

Neolithic Period 10,000–2100 BCE

Xia Period ca. 2100–ca. 1600 BCE

Shang Period ca. 1600–ca. 1045 BCE

Zhou Period

 Western Zhou ca. 1045–ca. 771 BCE

 Eastern Zhou ca. 771–256 BCE

Qin Period 221–206 BCE

Han Period

 Western Han 206 BCE–23 CE

 Eastern Han 25 BCE–220 CE

Six Dynasties Period 220–589

Sui Period 581–618

Tang Period 618–907

Five Dynasties Period 907–960

Liao Period 916–1125

Song Period

 Northern Song Period 960–1127

 Southern Song Period 1127–1279

Jin Period 1115–1234

Yuan Period 1272–1368

Ming Period 1368–1644

Qing Period 1644–1911

Chronology

Japan

Jōmon Period 10,500–400 BCE

Yayoi Period 400 BCE–ca. 300 CE

Kofun Period ca. 300–ca. 600

Asuka Period 538–645

Nara Period 710–794

Heian Period 794–1185

Kamakura Period 1185–1333

Nanbokuchō Period 1333–1392

Muromachi Period 1392–1573

Momoyama Period 1573–1615

Edo Period 1615–1868

Meiji Period 1868–1912

Korea

Neolithic Period ca. 7000–ca. 1000 BCE

Bronze Age ca. 1000–ca. 300 BCE

Iron Age ca. 300 BCE
Three Kingdoms Period
 Silla Kingdom 57 BCE–668 CE
 Koguryŏ Kingdom 37 BCE–668 CE
 Paekche Kingdom 18 BCE–660 CE
 Kaya Federation 42–562

Unified Silla Dynasty 668–935

Koryŏ Dynasty 918–1392

Chosŏn Dynasty 1392–1910

This volume accompanies the exhibition *Crosscurrents: Masterpieces of East Asian Art from New York Private Collections*, shown at Japan Society Gallery, New York, from March 24 through July 11, 1999.

The exhibition is organized by Japan Society in association with the Brooklyn Museum of Art.

The exhibition is sponsored by Ætna

This publication is made possible through the generosity of The W. L. S. Spencer Foundation.

Programs of Japan Society Gallery are supported by the Lila Wallace–Reader's Digest Endowment Fund and the Friends of Japan Society Gallery.

General Editor: Amy G. Poster
Managing Editor: Richard A. Pegg
Editors: Kathleen M. Friello and Reiko Tomii

Design: Anthony McCall Associates, New York
Photography: John Bigelow Taylor and Dianne Dubler

Additional photography: Roger Asselberghs, Brussels (cat. no. 18); Patricia Bazelon (cat. no. 32); Dean Brown (cat. nos. 6, 17); Shin Hada (cat. no. 62); Schecter Lee (cat. nos. 34, 41, 42); Carl Nardiello (cat. no. 4); Hiroshi Sugimoto (cat. no. 7)

Distributed by Harry N. Abrams, Inc., New York

Set in FF Thesis, The Mix Light
Printed by Hull Printing, Meriden, Connecticut
Bound by Riverside Bindery, Rochester, New York

ISBN: 0-8109-6386-8

Japan Society Gallery
333 East 47th Street, New York, NY 10017
www.japansociety.org

Front cover: Detail of NAKABAYASHI CHIKUTŌ, *Garden Party at the Orchid Pavilion*, cat. no. 30
Back cover: *Female Dancer*, cat. no. 21
Frontispiece: Detail of *Monju*, cat. no. 5

Contents

Aetna is proud to sponsor this important exhibition of masterpieces of Japanese, Chinese, and Korean art from New York's preeminent private collections.

This exhibition, organized by Japan Society in association with the Brooklyn Museum of Art, has opened the door to new scholarship on Japan's relationships with other cultures in East Asia. Through the exploration of Japanese art in the context of the dynamic interaction with the arts of China and Korea, we are reminded of the economic impetus that allowed this important cultural exchange. Trade and commerce among Asian countries has greatly enriched Japan's cultural heritage, demonstrated in the stunning objects selected for this exhibition.

Throughout its history of 145 years, Aetna has been among the group of American companies committed to international business and cultural exchange. This tradition carries on today in our rapidly growing businesses in the Pacific Rim, including China, Hong Kong, Taiwan, Malaysia, the Philippines, and Indonesia. In addition, Aetna has been a strong and involved corporate citizen in the communities we serve, supporting a wide range of arts, education, community development, child advocacy, and health and social organizations. Our sponsorship of Japan Society's exhibition, *Crosscurrents: Masterpieces of East Asian Art from New York Private Collections*, reflects our interest and commitment as an international company.

Richard L. Huber
Chairman, Aetna

Sponsor's Foreword

Japan Society

Since its founding in 1907 as a private American organization, Japan Society has been active in fostering deeper, more enlightened relations between Japan and the U.S. Our cultural, educational, business, and policy programs have long been committed to the belief that better awareness of the great riches of Japanese culture and thought will enhance American life.

Japan Society, in its focus on U.S.-Japan relations, has both influenced and been influenced by current events. Today, U.S.-Japan relations are far more complex than they were even a decade ago. One of the more significant developments we now face is Japan's closer identity with East Asia as a geopolitical, economic, and cultural sphere. Diplomatic rapprochement between Japan and her neighbors has helped bring about remarkable exchanges that have served as reminders to the Japanese of their shared patrimony with the continental civilization of China and Korea. Scholars in Nara and Seoul have jointly undertaken an official revision of early Buddhist art, and major loan exhibitions of Chinese art in Japanese museums have proliferated.

In this shifting context, the U.S.-Japan relationship must also be redefined and updated to fit into a regional framework. The present exhibition is an attempt to expand our interpretation of Japanese art by demonstrating its dynamic interactions with the arts of China and Korea. Trade, diplomatic envoys, and cultural exchange have helped to define Japanese culture since at least the fifth century, and early international influence has greatly enriched the indigenous culture. *Crosscurrents: Masterpieces of East Asian Art from New York Private Collections*, organized by Japan Society Gallery in association with the Brooklyn Museum of Art, under the direction of Alexandra Munroe, celebrates an exciting vision of Japan in the crosscurrents of East Asian history—a vision beautifully exemplified by these marvelous objects selected by the show's curator, Amy G. Poster, from New York's preeminent private collections of Chinese, Japanese, and Korean art.

Our sincere thanks are extended to Aetna, Inc. for their major sponsorship of this exhibition. Thanks are due as well to The W. L. S. Spencer Foundation for its generous funding of this publication. We also appreciate the Lila Wallace–Reader's Digest Endowment Fund, which supports much of the Gallery's programming, and the continuing support of the Friends of Japan Society Gallery.

Michael I. Sovern
Chairman

William Clark, Jr.
President

Prefaces

Brooklyn Museum of Art

For nearly a century, the Brooklyn Museum of Art's collections of Asian art have been presented in our galleries, reflecting a long-term commitment to the unique qualities of these cultures as well as the important relationships among them. Brooklyn's Asian collections are widely representative of the diverse tastes, functions, and contexts of this art. Our longstanding goal has been to depict the richness of Asia's history and culture through ongoing acquisitions, special exhibitions, and educational programming.

While we are particularly proud of exhibitions focused on the specific strengths of Brooklyn's collections, such as the recent *Royal Persian Paintings: The Qajar Epoch, 1785–1925*, we are also very committed to presentations that address Asian art in a broader, pan-Asian perspective. The 1984 exhibition co-organized in conjunction with the Los Angeles County Museum of Art, *Light of Asia: Buddha Sakyamuni in Asian Art*, successfully offered a view of a specific theme—the image of the historical Buddha—within a broad cultural and geographical context. With the exhibition *Crosscurrents: Masterpieces of East Asian Art from New York Private Collections*, organized by Japan Society in association with the Brooklyn Museum of Art, we once again have focused upon Asian art within the expansive framework of East Asia.

The Brooklyn Museum of Art is also fortunate to continue its longstanding relationship with the community of Asian Art collectors, and we have benefited from the generous support of our flourishing Asian Art Council. As a consequence of such friendship, Brooklyn has been particularly fortunate to hold long-term loans of great importance, such as the twelfth-century *Chōjū giga* fragment, which is included in this exhibition (cat. no. 6).

Crosscurrents has engaged our curatorial staff in an important collaborative effort with Japan Society. Through the vision of Alexandra Munroe, Director of Japan Society Gallery, and the leadership of Brooklyn's Amy G. Poster, Curator and Chair of the Asian Art Department, this exhibition has opened the door to new scholarship on Japan's relationships with other cultures in East Asia.

We are delighted to be partners once again with Japan Society in this important endeavor which will bring new ways of looking at Asian art to a wider audience.

Dr. Arnold L. Lehman
Director

Crosscurrents: Masterpieces of East Asian Art from New York Private Collections offers a view of Japanese art within the context of East Asia as an enduring cultural sphere. The objects have been selected from New York's finest private collections to reflect the highest achievements of East Asian art and thought, and should contribute to an expanded understanding of Japanese and East Asian culture as a vital, interconnected historical process. New cultural theories that are oriented toward a dynamic transnational view of cultural development, rather than a focus on national identity, have informed in part our conceptual approach.

The legacy of Nara, one of the great cities of the ancient world, has shaped the interpretation of Japanese art that *Crosscurrents* celebrates. This imperial capital was the eastern terminus of the Silk Road, an ancient trade route that traversed the Eurasian continent. A diverse community of artists, regularly enlarged by immigrants from China and Korea, contributed a high level of experimentation in medium and style to the creation of one of the most sophisticated visual cultures in the Buddhist world. The city streets, laid out in a grid after the Tang capital of Changan (presently Xian), were thronged with pilgrims, merchants, artisans, laborers, and monks. Visitors from overseas, from as far away as India and Central Asia or even the Mediterranean, introduced exotic articles and foreign tastes. Most dazzling of all

was the city skyline, towering with pagoda spires and the roofs of several hundred monasteries, including Tōdai-ji which housed the colossal gilt-bronze statue of Birushana, the Cosmic Buddha, that Emperor Shōmu had sponsored in 752. The visual culture that developed out of this matrix, in effect the classical foundation of Japanese art, was one of such creative energy that it defined Japanese art for centuries.

Diplomatic, trade, and cultural envoys continued to crisscross the seas and continent long after Nara's glory faded, bringing back a treasure trove of foreign objects, artistic media and technologies, and philosophical ideas into the realm of Japanese material culture. The incorporation of these into highly syncretic art forms blending classical and native, continental and local sensibilities produced what Louise Allison Cort calls in her essay here on tea "the powerful eclecticism of mature" Japanese taste. Hardly passive, this energetic interchange reflects rather a high degree of aesthetic and intellectual selectivity, an openness to other cultural forms and practices, and an awareness of the fundamental power of the new that are, with a contemporary reading, remarkably modern concepts.

Recent diplomatic developments and initiatives of cultural exchange among China, Japan, and Korea have in part prompted our enterprise. For reasons that we have just begun to address and

reassess, exhibitions that juxtapose the arts of East Asia have been rare in the United States. In the prewar period, from the Orientalism of Ernest Fenellosa to Frank Lloyd Wright to Mark Tobey, Japan was admired as unique for its eclecticism but never separate from the Asian sphere. Its modernity, while astonishing, may have distinguished the island nation from China or Korea, but its shared Eastern heritage was never wholly eclipsed. By contrast, the postwar discourse on Japan has tended to emphasize those aspects of Japanese culture and character that are most unique and distinct from East Asia, while emphasis on Japan and the Western world has dominated cultural discourse and popular perception. The disastrous decades of Japanese aggression followed by the victory of Communism in mainland China and in North Korea produced a painful political and psychological break in Japan's relations with East Asia that was to last for the duration of the postwar Shōwa period. Further, the immediate postwar move by U.S. policy makers to rehabilitate Japan as a friendly partner in the Cold War made Japan's isolation within East Asia strategically imperative. Recent developments that promote East Asia as a geopolitical and cultural sphere have produced welcome shifts in our perception of Japan, and Japan's perception of itself, within the wider Asian world.

Above all, *Crosscurrents* is about the transmission and transformation of ideas,

Introduction and Acknowledgments

Japanese Art in the Crosscurrents of Asian Culture

Richard M. Barnhart

Ernest Fenollosa was fond of observing how appropriate it was for Japan to serve as the world's interpreter both of Asia to the West and of the West to Asia. Japan after all had been the first Asian nation to adopt fundamental elements of European civilization, beginning in the Meiji period (1868–1912). And, in fact, from the Meiji period until World War II, Japan did indeed serve as the major point of connection in Asia linking the practice and understanding of traditional Asian cultures with the scientific technology and democratic ideas of the rapidly modernizing West. If we were to list here just the names of twentieth-century Chinese artists whose sojourns in Japan provided them with their essential knowledge of non-Chinese traditions and practices, it would be a roster of the most important and influential artists of this era. Not only did they there first encounter Sesshū and Kōrin, Tessai and the masters of *Nihonga* (Japanese-style painting), they also encountered Leonardo, Picasso, Titian, and van Gogh.

The story of Japan's role in this century as intermediary among Asian nations and between Asia and Europe would be a chapter in several very different types of history, including those of imperialism and colonialism, economic development, modern education, litera-ture, and art. Among all these there are clearly inseparable connections, and in all of these arenas Japan has been a major force in the modern world. More than any other nation in Asia, and often despite its deeply conservative traditions, Japan has been a powerful force for international exchange in all spheres of human endeavor. The reasons for this are no doubt so complex that even to reflect upon them in a brief essay of this kind may well be pretentious. Yet, it seems a worthwhile enterprise.

Japan was the latecomer among major Asian civilizations, reaching its first great eras as a nation long after India and China had passed through several of their defining national ages. Before the coming of Chinese civilization to Japan, it was a settled agricultural society, without a written language, without a social philosophy that found any echo in later memory, with religious beliefs based upon naturism or animism, with a primitive social structure, and undeveloped industry and economy. From the continent slowly came the bits and pieces of civilization, came language and thought, religion and philosophy, came clothing and furniture and architecture and art. How all of this actually happened remains one of the great mysteries of the world, only barely illuminated today even by archaeology. But it is certain that Korea, that fertile peninsula linking continental China to Japan, played a major role in the early transmission of culture and people, setting

in motion patterns of exchange and the movement of influences that would continue to define Japan's relations with the continent, right down to Japan's colonial ambitions in China, Korea, and Southeast Asia in later centuries.

For it is likely that those early events, mostly still little understood, created in Japan both a profound indebtedness to the continent and a lingering ambiguity over the sources and transmitters of those alien cultures. It appears to be a human trait that gift-giving endows the giver with power and the receiver with both gratitude and vulnerability. From another perspective, furthermore, the actual flesh-and-blood Chinese and Korean monks, priests, traders, artists, and craftsmen who flooded into Japan in the sixth and seventh centuries represented a physical intrusion into an already well-established if relatively simple Japanese society: a suddenly visible "other."

The Japanese people, however they had come to exist, had already mostly obliterated or marginalized the native peoples who had earlier inhabited the Japanese islands, and in popular perception remained throughout their history one of the most ethnically closed societies in Asia. At the same time, strikingly, the Japanese have been among the most curious and receptive of Asian civilizations, sending pilgrims, traders, emissaries, and travelers to the continent, and welcoming the peoples of continental Asia and their cultures onto its shores. Japan has repeatedly accepted refugees from across Asia in times of chaos and displacement, most dramatically during the eras of the Mongol and Manchu conquests. Each of these major waves of immigration set in further motion waves of response and reaction that profoundly affected the course of Japanese culture, as is clearly evident in the realm of art. Inkwash landscape painting, for example, appeared in Japan in the aftermath of mass exodus from the continent just ahead of the Mongols. *Zenga* (Zen painting) and *nanga* (literati painting) both grew from renewed immigrations at the time of the Manchu invasion of China.

Unlike China and Korea, Japan has never fallen victim to colonial or imperial aggression— the Second World War was Japan's only defeat in international conflict. Hence, on another level of reflection, Japan has long been curious about the peoples and cultures of the world in a way that could not have been true of China. Even today it is the only nation in Asia that has deliberately sought to collect, understand, and preserve not only its own arts but the arts of India, China, and Europe. In contrast, there is no Indian or European art to speak of in China (and very little Japanese art), and scarcely any Chinese, Japanese, or European art in India. It may be true that this telling point of common association of Japan with the cultures of Europe and America is tied closely to national practices of

imperialism and colonialism. Money and power buy art, to be sure, but even when China was the wealthiest nation on earth it rarely found the art of any other culture to be sufficiently interesting to become valuable as anything more than mere curiosity or entertainment.

If, however difficult to see clearly, the roots of Japan's distinctive character lie in the early transmission of continental culture to the Japanese islands, it is equally striking how quickly the elements of continental culture that we can isolate were transformed into distinctively Japanese phenomena, a process that has continued down to the present. The Japanese written language may be the most dramatic example of this process in both its derivation from classical Chinese and its departure from that base. It is undeniably true that Japanese society is in every respect far more different from China than the United States is from Great Britain and Europe. Perhaps during the next thousand years—the approximate difference in duration of these two processes of separation—the United States will become as different from its continental roots as Japan has become from China, but the process was inexorable. It was also always two-directional, because as rapidly as Japan changed from the seventh to the ninth centuries, so too did the culture of China. What began as shared elements of a common culture during the Tang and Heian eras became soon after so different that Japanese landscape paintings done during the Fujiwara period (894–1185) in the so-called *Yamato-e* manner, based on the Tang "blue-and-green style," were collected in Song China as examples of archaic Tang painting. So we are able to reflect upon the fact that China sometimes reconstructed and imagined its own past by looking at objects made in contemporary Japan, objects that had long ago been based upon Chinese models that no longer existed in China. Sitting on mats instead of chairs is such an example drawn from daily life.

Strikingly, already by the seventh century, as shown by the contents of Shōsō-in, the celebrated Japanese imperial treasury, objects and treasures from the Mediterranean Sea to the China coast were being collected and esteemed in Japan. Buddhism, by this time, having spread from India through Central Asia across China and Korea to Japan between the third and sixth centuries, linked Japan to the far reaches of South Asia, Central Asia, and China with a network of fundamental shared beliefs and ideals as Buddhism joined Islam and Christianity in becoming the most widespread and popular religions in the world. At the same time, Japan built its great capital at Nara on the model of the Tang capital Changan and constructed its own aristocratic society on the basis of Tang imperial culture.

Japanese travelers to China during the Tang and Song periods, including such distinguished Buddhist pilgrims as Ennin and Chōnen, continued an unbroken pattern of bringing back to Japan paintings and statues, drawings and books, silks and jades, many of which remain among the National Treasures of the country. They also carried with them to the continent objects of Japanese manufacture that entered the daily lives of the Chinese people. This was always a two-way exchange, although that fact is not well recorded on the Chinese side. Korea was often along the path of this two-way movement, and it was not unusual for the objects of such transactions to subsequently lose their original identities. They exist today in China, Korea, and Japan still misidentified. Especially ignored and often lost in the exchange process is Korea, many of whose paintings lie anonymously among Chinese and Japanese paintings and are only gradually being identified by modern scholars and collectors.

Influence is a concept that we have all been made to regard with caution in recent years because of the limited and culturally based biases of our understanding of it. Japan, like Great Britain and the United States among others, offers a rich focus for studies of influence in this postcolonial era because it was largely shaped by other, powerful cultures, but was not ruled by them, and therefore could choose freely from among the sources that offered their influence without the mitigating circumstances of colonialism or of cultural diffusion from a civilization perceived as superior. To begin with, Japan adopted Chinese culture at all levels—but, of course, the society of Japan was never like the society of China. Probably from the beginning, Korean culture was a part of the social-cultural mix connecting China, Korea, and Japan in such a way that it became difficult to distinguish which nation was supplying which element, and the Korean became intermixed with the Chinese, the Japanese with the Korean. Somehow, despite these complexities, it is clear that China, Korea, and Japan each possessed a distinctive society that could never be confused at any time with the other. The traveler from China to Korea would know instantly that he had entered a new country, and after crossing from Korea or China to Japan no traveler would be in any doubt that she had crossed profound social, cultural, physical, and linguistic boundaries.

With the spread of Buddhism across all of Asia came other powerful foreign ideas and beliefs, and these too became a part of Japanese society in such a way that something once Indian could scarcely be distinguished from something Japanese. When the Mongols overran China, many Chinese and Korean monks, scholars, and craftsmen fled to Japan; when the Manchus overran China, the same process took place again. Not only did

cultural elements intermix, people intermixed. In the twentieth century, again, as the Manchu Qing dynasty slowly crumbled in the face of an emerging modern world, Japan beckoned as haven and as university to the Asian world. Modernization and imitation of European models of education, economy, and culture were the issues being explored and discussed in Japan at a level of sophistication well beyond that of the continent. Preservation of tradition while responding to the need for modernization was the curriculum, and no Asian nation was as well prepared to offer it as Japan. Having consciously absorbed elements of distant cultures for centuries, Japan responded to the need for modernization as if from practiced habit.

The direct encounter of Europe and Japan had begun in the sixteenth century (briefly, profoundly, tragically), and resumed in the nineteenth (irreversibly). And Japan, with enormous difficulty and after long and painful debate and reflection, followed a path that might be held up as a model for the world of maintaining tradition while embracing modernization.

Influence, now, takes on a distinctive character in this historical narrative, because it is clear in retrospect that it was Japan that made nearly all the choices: choosing the Chinese model of Confucianism, imperial social structure, and the Chinese language as the basis of Japanese society; choosing Buddhism (while retaining Shinto) as the basis of religious practices; permitting repeated and regular influxes of continental people and ideas, and continuously adapting culture to the new and promising, while rejecting what did not suit; observing the character of the world beyond Asia when it finally appeared, exploring and rejecting it as untimely, inappropriate, and a violation of Japanese ideals; and, finally, recognizing that essential national traits could accommodate even European ideals and grow in the directions Japanese society favored, achieving the unique combination of Chinese, Korean, Indian, European, and Japanese cultural, social, linguistic, political, and artistic elements that constitute the nation of Japan today.

It is a striking fact that, if Americans were to look for the country in the world that most resembles theirs in the peculiar combinations of historical experiences, traditional values, national ideals, cultural and artistic traits, and the other nuances of national identity that define states and people, Japan would certainly be among the few that came into consideration. It has taken the United States a long time to realize this (if, indeed, it has).

And if Japan was created through influences, Japan has in turn influenced the entire world in so many ways that we are neither able to count them nor even to separate them from the things that influence us from elsewhere. Japanese modernism in the realms

of fashion and design, architecture, sculpture and painting, film, music, taste and aesthetics, can hardly be separated from high European modernism, but is not identical to it. It is simply a major part of international modernism. There are books on the influence of Japan on Dutch society from the seventeenth century to the present, books on the influence of Japan on France in the nineteenth century, books on the influence of Japan on America, and there are—or should or could be—similar books on the influence of Japan on virtually every society in the world. Throughout its history, Japan has been a powerful, dynamic, independent cultural force, sharing important elements of identity with the great nearby continental power of China and with the Korean peninsula, selectively choosing from among more distant sources of influence, and continuously radiating out into the world a unique and distinctive culture, art, and national ideals that influence every civilization in the world today.

Once Japan is seen as acting within this constant international process of dynamic exchange—an image very different from that of a closed, restricted society remaining isolated within its inaccessible islands in the Japan Sea—it becomes clear that throughout history the art and culture of Japan have been in a permanent state of interaction and engagement with the world beyond the islands. And it becomes clear that it was nearly always Japan that acted as agent in the process of influence. The popular view of influence, as Michael Baxandall describes it, of a billiard ball hitting another billiard ball, imagines the influencer to be the sole agent, often acting against the interests of the influenced. But it was Japan that made the choices as to which influences would be accepted. It chose China for social structure and philosophy, often gaining access to the Chinese model through Korea; it chose India for religion (initially; others followed), Germany for educational models, the United States for economic patterns, France (and others) for artistic culture—and so on and so forth.

In the present exhibition it is Japan's relationship to the other countries of East Asia that offers a focus, and the richness of these interactions alone provides a rare opportunity to reflect on the nature of interregional influences and the criteria of choice lying behind the artistic process of selection—selective borrowing followed by rapid adaptation—that marks this arena of world exchange. It will be observed, for example, that the single most common body of artistic similarities among China, Japan, and Korea lies within the sphere of Buddhist culture. That is to say, we have come to believe that we can almost always distinguish between a Chinese, Japanese, and Korean ink painting of bamboo or landscape. We can usually distinguish between Japanese and Chinese calligraphy (except, notably, in the writing of Buddhist sutras). The differences between Korean and Chinese

celadons are generally clear. Beyond the confines of this exhibition, the architecture of each country is distinctive, as are costumes and fashion—although, they too, like nearly everything in human life, were subject to selective borrowing and imitation. And both the ancient and the modern arts of China, Korea, and Japan all have their distinctive national characteristics. Observing those identifying national characteristics, isolating and defining them, can be challenging, of course, but generally speaking it can be done. Difficulties arise mainly in the area of Buddhist art. Twelfth-century Korean, Chinese, and Japanese Buddhist icons of the identical subject might well be so similar as to defy the possibility of distinguishing among them.

There are interesting and important reasons for this difficulty. Sometimes, after all, the same craftsmen were involved; Chinese and Koreans lived in Japan, and Japanese lived in both China and Korea; Sesshū painted for the Ming imperial court at one time in his life. In such cases it would in all probability be nearly impossible to distinguish the Japanese from the Chinese painting. What would such a painting be in terms of national origin anyhow, Chinese or Japanese? Identifying signs of specific national origin in the manufacture of religious icons and ritual objects was inevitably even less likely to be a significant factor in making, using, or appreciating such objects. On the contrary, adherence to accepted standards dictated by the traditions and ideals of the Buddhist religion held far higher power. The Greek Orthodox Church, similarly, attends relatively little to national preferences in the accouterments of its services while maintaining traditions that are those of the founding Church. So too with Islam and Buddhism.

Given the closeness of cultural exchanges among Japan, Korea, and China in all spheres together with their common veneration for Buddhism, it would in fact be totally surprising if there were not profound similarities in given circumstances. Even when there are, however, we must suppose that the meanings of art, of objects, and of styles differed profoundly from country to country and across time. The distinctive form of landscape painting known as the "blue-and-green style" may have originated beyond China in Central Asia from still farther sources. In any case, it seems to appear first in Central Asian cave-temple sites, then become popular in China as the setting for Buddhist icons. It may also have taken on Daoist connotations. Before the end of the Tang dynasty, in any case, it was taken over by the imperial court and made into a symbol of the great Tang state and empire. As such, and as a favorite setting for Buddhist divinities, it went to Japan, where it later came to function as a kind of romantic reference to the great Tang culture, slowly taking on other associations with Japanese poetry and literature that made it distinctively Japanese. In Korea it had quite different meanings and associations, since Korea

seems not to have been nostalgic for either the Tang or the poets of Japan, but cherished the classic Song styles of Li Cheng and Guo Xi and sometimes lent a "blue-and-green" aura to their legacy in Korea. Many similar observations could be made of the changing meanings of inkwash landscape painting as it moved from China to Korea and Japan. Defining moments in the evolution of national styles always came when hallowed images of the national landscape appeared in paintings: Mount Lu, West Lake, and the Xiao and Xiang Rivers in China, Mount Fuji in Japan, the Diamond Mountains in Korea.

When we reflect on the interactions among the nations of Asia it should be remembered that virtually all paintings, statues, sutras, and ritual objects made for the Buddhist religion were used continuously in temple services. And most such objects were used until they could be used no more and then thrown away. The elevation of ritual objects to the status of art is a very recent development in Japan, and, interestingly, owes a great deal to a small number of American, European, and Japanese scholars, artists, and aesthetes —like the circle around Fenollosa—who came to the study of Japanese art from a modern European perspective. Ironically, moreover, because of repeated state persecutions of Buddhism in China and a slow decline in scholarly interest in Buddhism, Japan had by the beginning of this century also come to preserve much of China's heritage of religious art, as well as much of Korea's. Thus, Japanese Buddhist temples have proven to be the safest repository of portable Buddhist images in the world.

The presence in Japanese Buddhist temples since the sixth and seventh centuries of works of religious veneration and ritual use from across the Asian world suggests another way of understanding Japan's unique engagement with the world beyond. Great temples functioned, without intention—and only for the Buddhist community—as an early form of museum, preserving and displaying a broad range of international artistic styles and monuments, long before there was in fact any other form of such museums. By now of course most such works are preserved in museums for their better protection, not in temples. They have mostly been removed from ritual use and have become art.

The present exhibition ranges across the secular and religious arts of Japan, Korea, and China, across media and time, presenting a modest panopticon illustrating the historical interchanges that have characterized the history of Japanese art as it evolved within the crosscurrents of Asian civilizations. When this can be done in a field that includes India, the ancient Near East, Persia, Greece and Rome, Europe, and the United States, we will have an even more complete sense of the true dynamics of Japan's long engagement with the world beyond its islands.

The Exotic, the Aesthetic, the Spiritual
Japanese Art in the Eyes of Early American Collectors

Christine M. E. Guth

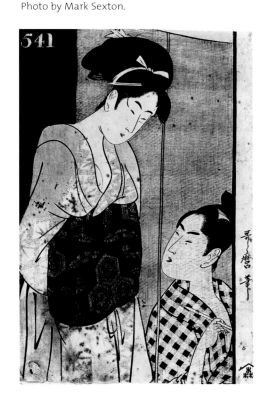

Exactly two hundred years ago, in 1799, Captain James Devereux, the first recorded American collector of Japanese art, sailed into the port of Nagasaki to pick up the annual shipment of trade goods usually carried by Dutch ships. There he purchased for himself five woodblock prints that were later donated to the East India Maritime Society, the forerunner of Salem's Peabody Essex Museum. When these prints were officially accessioned by the museum in 1832, they were not classified by artist, medium, or subject matter, but rather as specimens of the marvelous and exotic, together with an antelope foot, a compass, a cap worn by chiefs at Owhyhee, and a Chinese painting.[1] Furthermore, each was defaced by being stamped on the front with a number from 538 to 542 (fig. 1). Such apparent insensitivity to the aesthetic value of woodblock prints may shock us today, but it also serves as a reminder that artistic taste is relative, and deeply colored by the historical and cultural conditioning of the beholder.

Works of art never entirely transcend the culture in which they are created and first received, so at some level their appreciation by those from another time or place is always an exercise in the art of translation. Since the meaning and pleasure of the viewing experience is based on a consensus of meaning—of form, function, and content—that is often lost or altered when an object passes from one generation to the next, and even more so, from one culture to another, to see the products of a distant world involves reshaping them in terms of what the viewer already knows and feels. Thus, works of art, themselves inventions, are ever open to reinvention.

Collectors are instrumental in mediating the range of meanings an object or image assumes once freed from the contingencies of its original time and place. Aesthetic merit alone being no guarantee of a lasting reputation, by their choices they help determine which works of art are remembered for generations and which are altogether forgotten. Their personal responses and outlook may also stimulate others to rethink their own. The history of Chinese and Japanese art is rich in collectors who helped others to see both familiar and unfamiliar objects in a new way. In the sixteenth century, Sen Rikyū (1522–1591) contributed to a reevaluation of the rough stoneware jars Japanese farmers used for storing rice when he adopted them as water containers (*mizusashi*) for use in the tea ceremony. The collector Charles Lang Freer (1854–1919) played a similar role in this century: by installing Whistler's lavishly decorated "Peacock Room," presided over by a painting of the kimono-clad *Princess of the Land of Porcelain* in the Freer Gallery of Art,

The souvenirs acquired by American collectors in Japan both shaped and reflected these expectations. Among the materials the Boston collector William Sturgis Bigelow (1850–1926) brought back from his seven-year stay there in the 1880s are a large number of photographs by the Austrian photographer Baron Raimund Stillfried von Rathenitz (1839–1911). Since these photographs were not recognized as art, after Bigelow's death they were donated to Harvard's Peabody Museum of Ethnology and Archeology rather than the Boston Museum of Fine Arts, the recipient of most of his collection. Figuring prominently among them are carefully staged scenes of semi-nude women at their toilette or asleep, and half-length portraits of bare-breasted women (fig. 4). This genre of photograph is a variation of the European pictorial tradition of courtesans and nudes to which Titian's *Venus* and Manet's *Olympia* belong, that tells more about its intended audience than the culture it purports to represent.[13]

Bigelow also acquired in Japan a large number of woodblock prints that, then as now, crossed the bounds of the visually acceptable in Boston; most have never been put on display in the Museum of Fine Arts. Concerned that they would not be permitted into the country, given the political power of the notorious Anthony Comstock, then Secretary for the Society for the Supression of Vice in New York, Bigelow sought his friend President Roosevelt's help:

> The old Japanese like the Greeks and Romans put some of their best work into such subjects.— Every Museum, like every Library, has things of value that are not for the general public. I should like to see these safely stowed in the Art Museum here.… There are Comstocks in Japan too, and there is friction in getting them out.—It would need special arrangements at both ends to get them out and in.[14]

Bigelow's letter is only one of many signs of the conflicts and ironies that resulted from the encounter between American and Japanese culture. During the Edo period (1615– 1868), sexually explicit woodblock prints had been produced in great numbers, and while not actually condoned, they were not the target of government censorship. Over the course of the Meiji era (1868–1912), however, the European and American assumption that nakedness was a sign of primitive immorality led Japanese officials desirous of dispelling the image of Japan as a backward country to censor many forms of artistic expression on the grounds that they were "injurious to public morals."[15] Yet, even as they were eager and proud to be playing a role in Japan's modernization, Americans yearned to preserve Japan's character as an exotic refuge from the modern world.

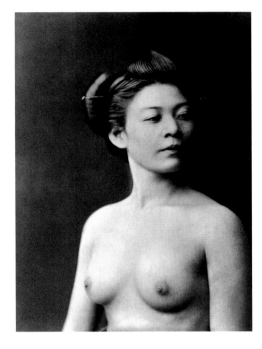

FIGURE 4

A prostitute, ca. 1860s–70s. Albumen print, Stillfried & Andersen Co. Photo courtesy Peabody Museum, Harvard University.

33

The Aesthetic

Attended by 9,789,392 people—almost a quarter of the nation's population—the Philadelphia Centennial Exposition marked a watershed in the history of the reception of Japanese art in the United States.[16] The "Empire of Japan" display in the Main Exhibition Hall, festooned with banners featuring the imperial chrysanthemum and dominated by a towering pyramid of eye-catching porcelains, was the hit of the event. Visitors extolled the array of ceramics, bronzes, lacquers, and ivories for their originality, ingenuity, and intricate craftsmanship. The press was equally enthusiastic. Declared one reviewer: "After the Japanese collection everything looks in a measure commonplace, even vulgar."[17]

The "Japan craze" that swept the country in the late 1870s and 1880s marked the first blurring of the lines between "high" and "popular" culture in America. This mutually reinforcing, and most emphatically commercial, phenomenon underlay the extraordinary breadth and depth of American *Japonisme*. Objects, like those formerly displayed solely in the homes of affluent residents of cities and ports on the Eastern Seaboard, were purveyed throughout the country by Japanese and Chinese, as well as American, merchants. Vantine's had shops in New York, Boston and Philadelphia; the Morimura Brothers in New York, Boston, and Chicago; and Yamanaka and Company in New York and Boston. In Texas, there was the Japanese Art Store in Houston, Wah Long in Galveston, and two shops, Quong Yuen and Company and Kay Doc Sing and Company, in El Paso. Yamanashi and Nippon Dry Goods Company were among the merchants in San Francisco.[18] All promoted a tantalizing array of goods ranging from painted, modestly priced fans, parasols, and teapots to costly bronzes, lacquered tables, and ceramics. To eager consumers, it mattered little whether these were actually made in Japan—which, in fact, many were not.

The Japan craze coincided with and was reinforced by the spread of the British aesthetics movement led by John Ruskin (1819–1900) and William Morris (1834–1896), which had as its aim the elevation of standards of workmanship and public taste in arts and crafts.[19] As Japanese art came to figure increasingly prominently among those commodities whose acquisition conferred elite cultural status on middle-class consumers, American exponents of the British aesthetics movement increasingly sought to imbue it with qualities that would lift it beyond the commercial realm. This they did by imputing to it aesthetic and moral values that already resonated deeply in the minds and hearts of American audiences. Like his medieval counterparts, the Japanese artisan was idealistically envisioned as "born to pride and skill in his work."[20] As James Jackson Jarves, an early American follower of Ruskin, also asserted in *A Glimpse at the Art of Japan* (1876): "There was a marked contrast, involving a fathomless aesthetic gulf between him and the average European artisan, doomed to monotonous uninspiring toil, herded with his fellows in unwholesome factories

or the filthy purlieus of crowded cities."[21] It was further held that since the Japanese craftsman strove after beauty, not money, his creations were honest, well-designed, and free of pretensions. As an article in the popular magazine *Illustrated American* told its readers in 1890, "whatever the moon-eyed people of the 'Land of the Rising Sun' touch they make pleasing and sincere."[22]

Proponents of aesthetic reform focused much of their attention on the domestic interior, advocating the creation of harmonious decorative ensembles through careful attention to wall treatments, textiles, furnishings, and an eclectic assortment of beautiful objects, as well as paintings and sculptures. The incorporation of Japanese objets d'art in the Longfellow family residence following Charles's return from Japan illustrates the popular Victorian response to this movement as well as its ties to American cultural nationalism.

With the approaching centenary, the Longfellow residence, which had served briefly as George Washington's headquarters, assumed a double pedigree as a national and literary monument, and its interior decor was promoted as a model for all cultivated Americans. Many descriptions of the house highlighted the tastefulness of the Japanese art on display. The author of *The Book of American Interiors*, published in the centennial year, recommended such decor because "brilliant Japanese screens and ornaments give life and piquancy to the quiet which sometimes reigns too supreme in the library of the good American."[23] A room decorated in Japanesque style by Charles and his cousin, Alexander Wadsworth Longfellow (1854–1934), who later became a successful architect and founding member of the Boston Arts and Crafts Society, was also noted in publications at that time (fig. 5).[24]

With the notable exceptions of Isabella Stewart Gardner (1840–1924) and Louisine Havemeyer (1855–1929), collecting Japanese art on a grand scale was the preserve of male aesthetes, who had both the means and opportunities to purchase from dealers in the United States and abroad. Most American women moved in a cultural world circumscribed by the home. Yet the nineteenth-century cult of domesticity, which encouraged women to become responsible for creating an environment where their families could be educated and refined, also invested them with considerable cultural power. As the vogue for Japanese art grew, every woman with any pretension to taste had to display in her parlor a bamboo basket, a hanging scroll, a cloisonné vase, or at the very least a painted fan or two.

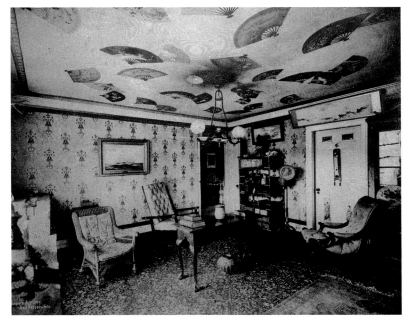

FIGURE 5
Charles Longfellow's "Japan Room," ca. 1899. Photo courtesy National Park Service, Longfellow National Historic Site.

The appropriation and disposition of Japanese art in the domestic sphere reinforced the already strong feminine overtones that Japan and its culture had in the eyes of most Americans. Since the time of the Philadelphia Exposition, Americans had extolled the restraint, harmony, and delicacy of Japanese art, likening these aesthetic qualities to the character of the Japanese people.[25] This view encoded a larger set of assumptions about the unequal power relationship that Ernest Fenollosa summed up his poem "East and West." "Eastern culture," he wrote, "slowly elaborated, has held to ideals whose refinement seems markedly feminine. ... Western culture, on the contrary, has held to ideals whose strength seems markedly masculine."[26]

The qualities that made Japanese art particularly suitable for feminine consumption also made it ideal for emulation. Japanese motifs, design principles, and color schemes were held up as models for housewives who sought to cultivate themselves and enhance their surroundings by taking up drawing, needlework, porcelain painting, and other domestic arts. A few of them, such as the designer Candace Wheeler (1827–1923), who joined Louis Comfort Tiffany's interior decorating firm in 1879, made the transition from the amateur to professional world.[27] Two years earlier, Wheeler had founded the Society of Decorative Art of New York City, which became the model for similar societies in other cities. Inspired by Wheeler's crusade to gain them a more public role in the art world, women also began to push for the establishment of museums of decorative arts that would provide models for women to study. The Rhode Island School of Design in Providence, the Cincinnati Art Museum, and the Wadsworth Atheneum in Hartford, all developed under predominantly female sponsorship, formed collections of Japanese decorative arts.[28]

The diminutive wares associated with the tea ceremony were deemed particularly suitable for developing feminine aesthetic sensibilities. Henry Havemeyer, for instance, believed that tea caddies — perhaps because, like dolls, they could be dressed and undressed from their brocade bags — would be a particularly good way to introduce his young wife to the beauties of Japanese art. Havemeyer already had amassed a large collection of Asian art by 1884, when he presented Louisine with over five hundred jars designed to hold powdered tea.[29] Of the sixty-five ceramic objects from the Havemeyer collection now in the Metropolitan Museum of Art, twenty-three are tea caddies (fig. 6).

Despite early enthusiasm for the types of lacquers and ceramic wares made to serve in the tea ceremony, this cultural practice does not seem to have made much of an impact on the American public until the publication of Okakura Kakuzō's *The Book of Tea* in 1906. The book grew out of a series of lectures that Okakura, who was at the time serving as

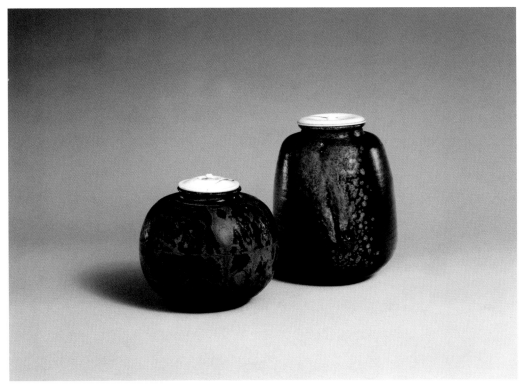

FIGURE 6

Tea jars. Left: Takatori ware, 18th century,
h: 6.4 cm. Right: Bizen ware, ca. 1850, h: 8.3 cm.
H.O. Havemeyer Collection, bequest of
Mrs. H.O. Havemeyer, 1929 (29.100.648, .664)
The Metropolitan Museum of Art, New York.

advisor to the Department of Asiatic Art at the Boston Museum of Fine Arts, was invited
to give at the residence of Isabella Stewart Gardner. Gardner's curiosity about the tea cere-
mony was a manifestation of her deep interest in aesthetics and ritual.[30] Okakura may
have further encouraged her enthusiasm for the tea ceremony because of his recognition
of its affinity to the "delicate clatter of trays and saucers" and the "soft rustle of feminine
hospitality" of the afternoon teas that she and her lady friends frequently hosted.[31]

Okakura's education, travels, and close contacts with American artists and scholars had
taught him much about Western philosophy and aesthetics, giving him a different perspec-
tive on his own culture from that held by his less cosmopolitan peers. When he discussed
the Japanese culture of tea, it was with the full knowledge that he was addressing an
American audience. Well-attuned to what they wanted to hear, he described the tea cere-
mony in the language of the aesthetics movement:

> The Philosophy of Tea is not mere aestheticism in the ordinary acceptance of the term, for it
> expresses conjointly with ethics and religion our whole point of view about man and nature.
> It is hygiene, for it enforces cleanliness; it is economics, for it shows comfort in simplicity rather
> than in the complex and costly; it is moral geometry, inasmuch as it defines our sense of
> proportion to the universe. It represents the true spirit of Eastern democracy by making all its
> votaries aristocrats in taste.[32]

Okakura also recognized the sacrosanct status of the home, and drawing an implicit analogy between it and the tearoom, declared that "The simplicity of the tea-room and its freedom from vulgarity make it truly a sanctuary from the vexation of the outer world.... Nowadays industrialism is making true refinement more and more difficult all the world over. Do we not need the tea-room more than ever?"[33]

By holding up the ritualization of daily life central to the tea ceremony as a microcosm of Japanese culture, Okakura embraced and confirmed the idealized vision of Japan as an aestheticized feminine alternative to the modern industrial world. Through the publication of *The Book of Tea*, he articulated for Americans, and later for Japanese, what have become canonical principles of Japanese aesthetics.[34]

The Spiritual

The spiritual was a third key component of the attraction Japanese art held for American collectors. Like the romantic exoticism and the aesthetic primitivism to which it was closely allied, the discovery of the transcendent in Japanese art had as much to do with its beholder's state of mind as with the characteristics of Japanese religion. The impact of urbanization, industrialization, and Darwinism, as well as widespread disillusionment with orthodox religion in the last quarter of the nineteenth century combined to make many Americans receptive to alternative religious beliefs and practices. This was especially true in New England, where Transcendentalism, by sowing the seeds of revolt against rationalism and materialism, prepared the ground for the unusually warm reception of Buddhism.

Anglo-Catholicism, which attracted many Japanophiles disillusioned with their sober churches, was also conducive to appreciation of the sensuous aesthetico-religious experiences of Buddhist art and ritual.[35] Even collectors such as Fenollosa and Bigelow, who were unusually knowledgeable of Buddhism, understood its principles and its arts through the prism of American religious and aesthetic developments. While it is hard to uncover today the full range of meanings Buddhism held for them, Bigelow's declaration that "Buddhist philosophy is a sort of Spiritual Pantheism—Emerson, almost exactly," is suggestive of the syncretic outlook he shared with others of his generation.[36]

For many collectors, the spirituality intrinsic to Japanese art was not specifically linked to Buddhism or Shinto, but stemmed from the aura of sacrality that enveloped the country and people who had created it. This outlook had much to do with belief in the immanence of the divine in man and nature popularized by Transcendentalists such as Emerson and

Thoreau. Japan, like much of the Orient, was envisioned as possessing a spiritual-ized geography not unlike that earlier located in the Holy Land. When La Farge's quest for a numinous landscape to serve as backdrop for a mural he was commissioned to paint for New York's Church of the Ascension led him to the mountains of Nikkō, he discovered there the quality he sought to capture in his painting—something akin "to what we call the miraculous."[37]

Japan was also idealized because, like medieval Europe, it was a society where artists were thought to be filled with the spirit of true religion. In Fenollosa's esti-mation, the painter Kano Hōgai (1828–1888) was a "seer," a "prophetic priest," and a "painter sage."[38] Furthermore, the seamlessness between Japanese artists' apprehension and representation of the natural world—because they did not use techniques such as chiaroscuro or scientific perspective to create the illusion of reality—revealed a closeness to nature lost to their counterparts in the indus-trialized West. The conviction that Chinese and Japanese painters were primarily concerned with giving expression to the inner spiritual world rather than the external material world was closely related to this reaction against the spirit of scientific inquiry. This outlook underlies Fenollosa's passionate characterization of the fifteenth-century ink painter Sesshū: "One other greatest quality Sesshū possesses in large measure, and that is 'spirit.' By this first of the Chinese categories is meant the degree in which a pictured thing impresses you as really present and permeated with a living aura or essence." As a result, Sesshū's paintings could arouse in the viewer a quasi-religious response: "You are held before them as if that etchers's needle were holding live wires to your heart; you rise from their presence breathless and purified as if you had learned to breathe some new ether."[39]

The Buddhist icons that first elicited special note from American viewers were those whose form and content could be reconciled with paintings and statues of the Virgin and various saints that they were discovering through their European grand tours. It is no accident that James Jackson Jarves, a disciple of Ruskin and a pioneer collector of Italian "primitives," was also among the first Americans to consider Japanese Buddhist art in similar aesthetic terms. Of the Great Buddha of Kamakura he wrote ecstatically:

Retaining the general characteristics of the human model, largely and majestically conceived, he has constructed this giant statue, which, while suggesting man, inspires less awe from its inscrutable calm and distance from mundane interests and cares. ... Long wave-like ripples of drapery flow over its shore-like limbs; a head-dress of shells forms an effective ornament,

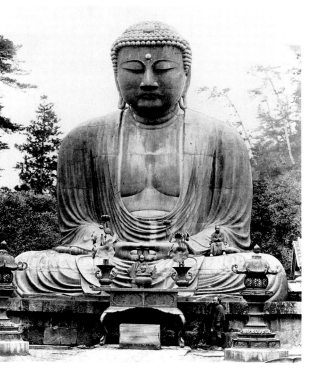

whilst broad contours and masses, and the unspeakable repose and benediction which illumines its every feature, each and all harmoniously unite into a stupendous image of intensified enigma.[40]

Jarves had begun collecting Japanese paintings, prints, books, ceramics, lacquer, metal-work, and ivories while in Florence in the 1860s and 1870s, but he never traveled to Japan.[41] He must have learned of this giant bronze statue from admiring travelers' accounts and popular commercial photographs by Felice Beato (1825–1904), an Italian photographer active in Japan during this period (fig. 7).[42] While the esteem the Great Buddha of Kamakura enjoyed may seem strange today, it should be kept in mind that access to temples and shrines in Nara and Kyoto was still limited, making Kamakura one of the few repositories of pre-Edo culture accessible to foreign tourists. Even in photographic form, this mysterious, imposing bronze statue appealed to the sense of the sublime and picturesque, visual and aesthetic qualities central to nineteenth-century artistic appreciation.

The responses to portrayals of the deity Kannon on the part of Ernest Fenollosa, the historian Henry Adams (1838–1918), and the artist John La Farge, reveal further examples of this process of acculturation.[43] In the Japanese Buddhist tradition, Kannon Bosatsu is the embodiment of compassion, a deity who may assume any form to respond to the needs of devotees. Although Kannon is theoretically sexless, artists in both China and Japan often invested their portrayals with feminine attributes. It was precisely these feminine qualities, and their compatibility with those associated with the Virgin, that attracted these Americans.

Fenollosa's personal engagement with Kannon is vividly illustrated by the title *The Creation of Man*, which he gave an unusual painting of the deity he commissioned from Kano Hōgai in 1883 and later sold to Charles Freer (fig. 8). The deity stands on a cloud, holding in one hand a spray of willow and in the other a vase from which she pours water on a naked child enveloped in a bubblelike halo. By his title Fenollosa suggests that this work gives tangible form to the "unique dramatic epoch in human affairs" that will culminate "in the two halves of the world com[ing] together for the final creation of man."[44] In this utopian synthesis of East and West, Kannon represents the regenerative power of the feminine East.

Adams and La Farge traveled to Japan together in 1886, and in the company of Fenollosa and Bigelow visited art dealers, temples, and private collections. In *An Artist's Letters from Japan*, La Farge recalled, "Of all the images that I see so often, the one that touches me most—partly, perhaps, because of the Eternal Feminine—is that of the incarnation that

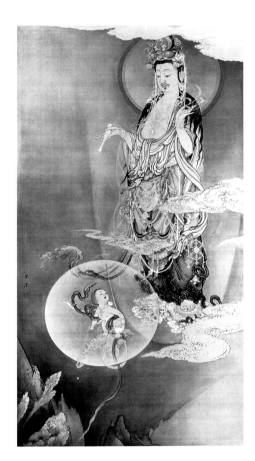

FIGURE 8
Kano Hōgai (1828–1888). *Kannon Bosatsu (The Creation of Man)*, 1883. Hanging scroll: ink, gold, and color on silk, 165.7 x 84.8 cm. Freer Gallery of Art, 02.225.

In contrast to the orthodox hierarchical view, there was also the concept of the *yipin* or "untrammeled" artist in China. These nonconformist individuals embody the unconventional, existing outside the system. Yet they were revered and their achievements celebrated, as indicated in the Tang treatise *Lidai minghuaji* (Record of the history of famous paintings) by Zhang Yanyuan (ca. 815–875). Many brief anecdotes described the fantastic or outrageous abilities of these artists, emphasizing the dichotomy between the system or convention and nonconformity. In this sense, the Chinese had a notion of the artist as a nonconformist, which in the Western tradition was a product of the Romantic movement—and very much at odds with the "craftsman" connotation of the earliest sense of the term "masterpiece" in the West. At any rate, the Chinese have historically recognized certain artists as "masters," and in that sense, the work of a master being a master-piece, the concept was not unknown in China.

Certainly, within a finite tradition such as the Imperial Academy of the Northern Song it would have been possible to distinguish between the three generally recognized levels of ability: *shen* (inspired), *miao* (excellent or marvelous or subtle), and *neng* (competent).[3] However these categories neither have the implications of the Western term "masterpiece," nor are self-evident in the context of the art historical questions that have largely been the preoccupation of Chinese writers on the subject. For example, the early twelfth-century *Xuanhe huapu* (Catalogue of Paintings in the Xuanhe collection) provides biographical information on artists and categorizes different subjects of painting in the imperial collection during the Song period. They are symptomatic of ranking systems which applied equally to works of art and artists.[4]

In China, the concept of the masterpiece did not embrace the artist's status, experience, and training, but was simply related to the artist's skill. The scholar-artists, who served as arbiters of Chinese culture, traditionally derived their standards of excellence from Confucian thought, especially the notion of attempting to attain the ideal through self-cultivation. They created a hierarchy among artists, giving highest preference to those of the educated elite. Outside this group, artisans were not given the same recognition as their counterparts in the West.

In the modern era, the wealth of archaeological finds has played a part in changing the way the Chinese consider the importance or masterpiece status of these and related works. New discoveries, such as the terra-cotta soldiers of the First Emperor (r. 221–210 BCE) of Qin's tomb or the bronzes recently excavated in Sichuan province, enter the canon

of objects of timeless cultural importance, whether for aesthetic, technical, or historical reasons. "Gems of Chinese Cultural Relics" exhibitions produced in China, highlighting important recent excavated material, give evidence of this new attitude, though one must hasten to add that a reverence for the past has always played a role in the Chinese appreciation of objects. It is important to note that the status afforded archaeological material has expanded the notion of masterpiece to include different standards (including rarity, technical advances, and evidential historical value).

Throughout its history, Korea's culture has been influenced by external forces as well as by internal developments. Historical writings on art objects in Korea are limited in number and have not been reviewed comprehensively.[5] However, Korea adopted the Japanese system of designating important cultural properties in the early twentieth century. This system was revised with the Korean Act on Cultural Properties (1962), under the direction of the Agency of Cultural Affairs. The concept of masterpiece in Korea, however, in part came to be associated with a separate cultural identity, and elevated to independent cult status icons such as Mount Kŭmgang. In fact, the subject as symbol found relevance with dignitaries from China and Japan, where celebrated sites and scenic places were also idealized in art and literature.

In Japan, objects of merit have long been identified as *meibutsu* (famous objects), a term that emerged in the Momoyama era (1568–1615) and became the focus of tea practice and central to the collection of objects for the tea ceremony.[6] These are objects of such importance that they are preserved and handed down from one owner to another. The modern term *meihin*, literally, "name-article," is not so much a concept as it is a descriptive term applied to works known through their outstanding artistic merit or the names of their producers, past owners, or people who were otherwise associated with them.

Meihin are given formal recognition when they are designated as National Treasures (*kokuhō*), Important Cultural Properties (*jūyō bunkazai*), or Important Art Objects (*jūyō bijutsuhin*) as defined by a series of government acts beginning in 1897. Difficult as it may be to define the intellectual framework for these designations, in practical terms, they do denote for us much of what constitutes the Japanese equivalent of a masterpiece.

In Japan, prized objects were collected and preserved throughout history; the most notable example of this practice is the eighth-century Shōsō-in in Nara that houses objects collected from the Silk Road, China, and Korea, as well as those of Japanese origin. It originally

served as the repository of the Buddhist temple Tōdai-ji and was under temple administration. It stored the personal possessions of Emperor Shōmu (r. 724–49) and temple treasures and Buddhist regalia (*shōsō* meant "storehouse" in archaic Japanese). Among these are a large number of foreign-made articles, and their presence may suggest a connection between the appeal of the unknown and exotic and the idea of a masterpiece. Most of these articles were probably gifts brought back to Japan from China by the Japanese emissaries dispatched to the Tang court. The Shōsō-in treasures, unlike excavated pieces, are preserved in near-perfect condition—even colors remain bright—and help us to reconstruct the history of Tang arts and crafts. The importance of heirloom objects (*densei*) can thus be associated with the concept of masterpiece.

This presentation reflects notions of the masterpiece in both East Asia and the West. Clearly, the idea of the masterpiece of East Asian art is a complex one and there are many different standards of excellence. In this exhibition, we have incorporated notions of the masterpiece, early and contemporary, East Asian and Western. A defining limit of this assembly of objects is their location in New York, that in itself reflects distinct patterns of collecting.

In contemplating such a group of objects one observes the fast bonds that constitute the cultural connections among China, Korea, and Japan. These objects are for the most part central to Japanese artistic activity, fulfilling two important conditions: they are of a type or subject known in Japan during the premodern period; or they are of a type collected there in the nineteenth and early twentieth century. But collecting patterns in the United States are different from those in Asia, and this exhibition begins to explore the qualities unique to collectors in New York.

Arranged in thematic groupings, these objects may be seen to represent overarching cultural themes, specific to each culture as well as revealing an interaction of the cultures from which they arose. Technically superb and aesthetically impressive, with overlapping and multiple resonances, these objects defy categorization. They have much to teach us about Asian art and the world beyond.

NOTES

1. The standard work in this area is Walter Cahn's *Masterpieces: Chapters in the History of an Ideal* (Princeton: Princeton University Press, 1979). As Cahn has wryly noted, functionally, the degree of Ph.D. has traditionally been the equivalent of the masterpiece in university life, but the use of the term in the context of the guilds (arenas of manual labor or dexterity) has resulted in its avoidance in academic circles.

2. Chinese writings on connoisseurship are discussed in several specific studies, including Craig Clunas, *Superfluous Things: Material Culture and Social Status in Early Modern China* (Cambridge, England: Polity Press, 1991); Sir Percival David, trans. and ed., *Chinese Connoisseurship: The Ko Ku Yao Lun* (New York: Praeger, 1971); and Chu-tsing Li and James Watt, eds., *The Chinese Scholar's Studio: Artistic Life in the Late Ming Period*, exh. cat. (New York: The Asia Society Galleries, 1987).

3. Cahn, 8.

4. I am grateful to Richard Vinograd for his suggestions on aspects concerning the concept of masterpiece in China.

5. In Korea, this is very complicated and not yet fully considered by scholars. Future research might provide more information.

6. The subject of the masterpiece in Japanese art was the focus of papers given at the 1997 Conference at the University of East Anglia, Norwich. Christine Guth (paper untitled) and Andrew Watsky ("Exhausting the Possibilities of Goodness and Beauty: Recognizing the Momoyama Masterpiece") have graciously shared their research and insights with the author.

Art and modes of thought are intercon-
nected in Asian culture. Art made manifest
the conceptions of life and death, the
mundane and the cosmic realms, and the
world of spirits and ancestors that animat-
ed ancient East Asian civilization. In early
China, animal imagery permeated the
forms of funerary objects made to accom-
pany the deceased into the afterlife.
Creatures of cosmological significance
were common decorative motifs, often ren-
dered in composite form. These ritual
objects are not merely powerful aesthetic
expressions but fusions of structure and
ornament as auspicious emblems of politi-
cal power and social status.

From the Han through Tang periods in
China, grave goods consisted of not only
vessels but also figural images and architec-
tural models essential for imagining and
constructing a posthumous world. These
"spirit objects" (*mingqi*) might, for example,
replicate in ceramic an emperor's favorite
horse or court dancer, carrying into the
afterlife reminders of the imperial court.

Quite different were the arts of Buddhism,
a religion first imported from India into
Han China, and thereafter communicated
to Korea and Japan. The elaborate icono-
graphies and stylized modes of religious
representation that accompanied it further
enriched the visual culture of the sacred
and ritual arts in East Asia. The impact
of Buddhism is undeniable. Its teachings
were transmitted and transformed in ways
that integrated indigenous religious and
visual cultures, encompassing ancestor
worship and animism, Daoism and
Confucianism in China, Shamanism in
Korea, and Shinto in Japan.

The universal Buddhist ideals of tranquility,
contemplation, and benevolence were
reflected in the sacred arts, often enhanc-
ing their efficacy for religious practice.
The portrayal of many popular figures of
worship, including the historical Śākyamu-
ni Buddha (Ch: Shajia; J: Shaka; K: Sokka)
showed a strong consistency from culture
to culture. Others assumed regional identi-
ties, such as the Ajaya Avalokiteśvara of
the Dali Kingdom. In further adaptations of
local or popular culture, humor and carica-
ture surfaced in artworks as commentary
on religious themes.

Enlightenment, of course, was the goal of
Buddhists, and the path to enlightenment
was a central subject of most religious
works. Enlightenment was aided by the
contemplation of sacred images or the
copying of sutras, and the commission
of them was a worthy deed, itself an aid to
proceeding along that path. Sumptuous
materials could suggest the attainment of
paradise. In the non-iconic, meditative
school of Zen, focusing the mind through
the arts of poetry, painting, and calligraphy
was encouraged. Further, Zen themes in
art illuminated the metaphysical paths to
enlightenment by dream visions, sudden
awareness, or the instructional riddles
known as *kōan*. —AGP

Section One
Sacred and Ritual Arts

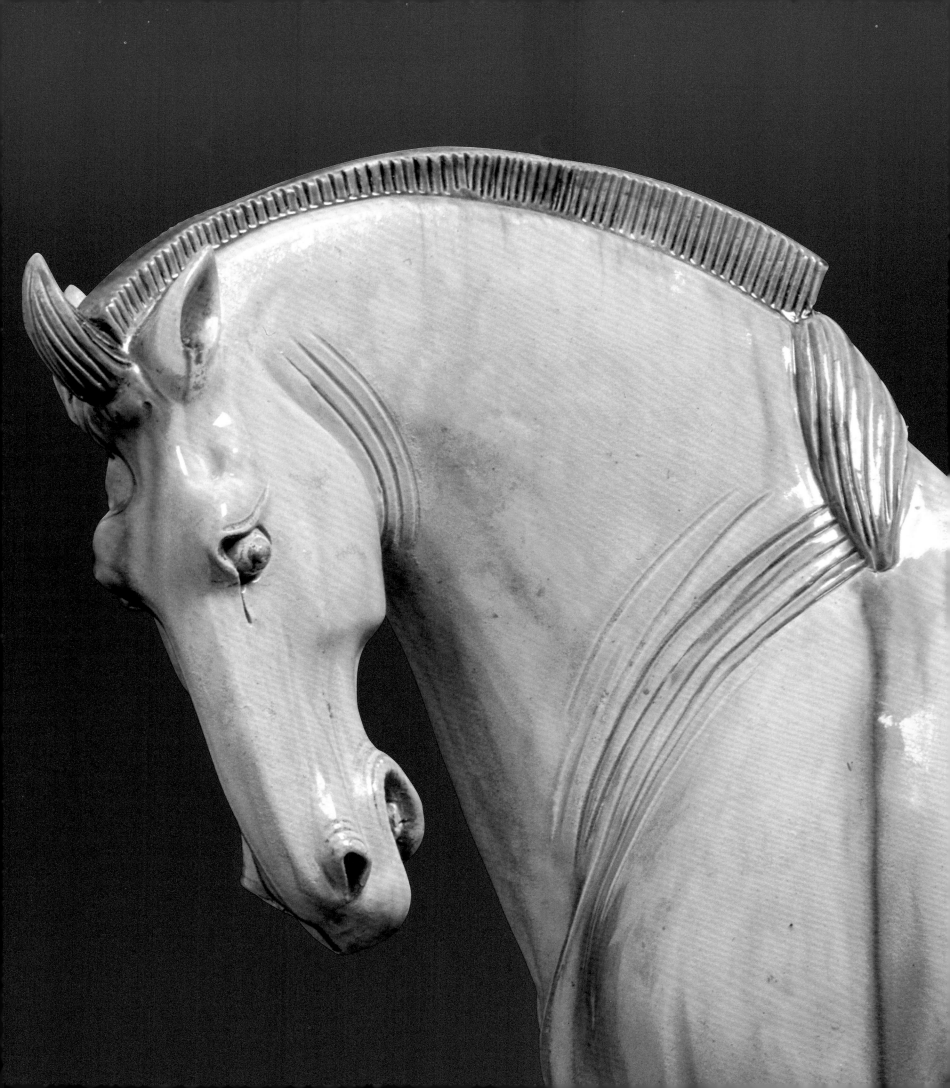

Standing Jizō

Japan, Kamakura period, 13th century
Wood, with remnants of lacquer, polychrome,
and *kirikane*
h: 71 cm

Dr. and Mrs. Robert Dickes Collection

The bodhisattva Jizō is, like all bodhisattvas, a being of great spiritual advancement who has given up his own enlightenment in order to help sentient beings reach a state of deliverance from the sufferings of illusory existence. His name, which in the original Sanskrit—Ksitigarbha—means "Womb of the Earth," signifies how he encompasses the whole of the world in his compassion and his powers. According to the many sutras that expound Jizō, most importantly the *Jizō jūrin-kyō* (Sutra of the Ten Wheels) and the *Jizō Bosatsu hongan-kyō* (Sutra of the True Vow of Bodhisattva Jizō), his special role is the compassionate management of the Six Realms (*Rokudō*) of existence in the time before the coming of the Future Buddha Miroku (Sk: Maitreya), when all will be saved. These Six Realms, from human to animal and including Hell, comprise the various levels of existence through which humans and other sentient beings are driven by the forces of karmic retribution until they are able to achieve deliverance through enlightenment.

The cult of Jizō emerged in Central Asia and China in the fifth century and by the ninth century had been introduced to Japan where it flourished as nowhere else. Representation of Jizō (Ch: Dizang) in China conformed to the standard bodhisattva iconography—crown and jewelry, royal costume, sash and scarf; however, in Central Asia and Japan Jizō was depicted in the guise of a simple monk with shaved head. This more widespread iconic

type derived from cultic focus on his role as a benevolent savior throughout the Six Realms and especially in Hell. Like a good monk, Jizō was believed to seek out sufferers and ease their pain.

Here a statue of the kindly Jizō offers a comforting vision of the bodhisattva as savior in this world and the next. The frail but straight body is enveloped in a robe that hangs in loose folds over the arms and abdomen, with the under-robe descending below to the ankles. A delicate face, gentle and introspective, yields a hint of youthful innocence beneath the shaved head. But the vast powers of the mature Buddha-being that is Jizō are symbolized by the spherical object held in the left hand and by the sistrum grasped in the right. The spherical object represents a marvelous pearl-like jewel called *nyoishu* (wisdom gem) by which Jizō is able to grant wishes, especially those of the tormented and the bereaved. The sistrum with its multiple rings, traditionally carried by monks as one of the insignia of monkhood, signifies as well the magical staff that Jizō wields as he beats away the demons of hell.

Jizō statuary such as this was produced in large quantity in Japan during the twelfth and thirteenth centuries in tandem with extended worship of Jizō as a savior figure. The Jizō cult flourished in a cultural climate of social change as the ancient civilian order gave way to that of the warrior. It also appealed to the many aristocrats and commoners who believed that the world was ending in what was known as *mappō*, the latter days of the Buddhist Law.

As here, statues of Jizō frequently bore ornate designs on the robed sections of the image. The wood was first finished with several layers

of lacquer mixed with sawdust and sometimes incense; remnants of such lacquering are visible over the chest of the statue. Colors were then applied, usually as floral motifs, over areas representing fabric. This was usually accompanied by application of fine strips of gold leaf in patterned cutouts known as *kirikane*, an expensive and time-consuming technique. Vestiges of *kirikane* can be seen along the hem of the robe and on a vertical axis from abdomen to hem.

In style of execution the statue recalls the classical forms of sculpture produced for the high aristocracy in the eleventh and twelfth centuries. New formal vocabularies, emphasizing naturalism and dynamism, had been introduced from the continent to be taken up by the new military rulers of Japan. But this statue, perhaps commissioned with classical tastes in mind, reminds us that even as Chinese modalities gained strength in the thirteenth century, a native stylistic tradition in statuary remained viable as an alternative.

—MHY

BIBLIOGRAPHY

Masterpieces of Asian Art in American Collections II. New York: The Asia Society, 1970, 120–21, entry no. 48.

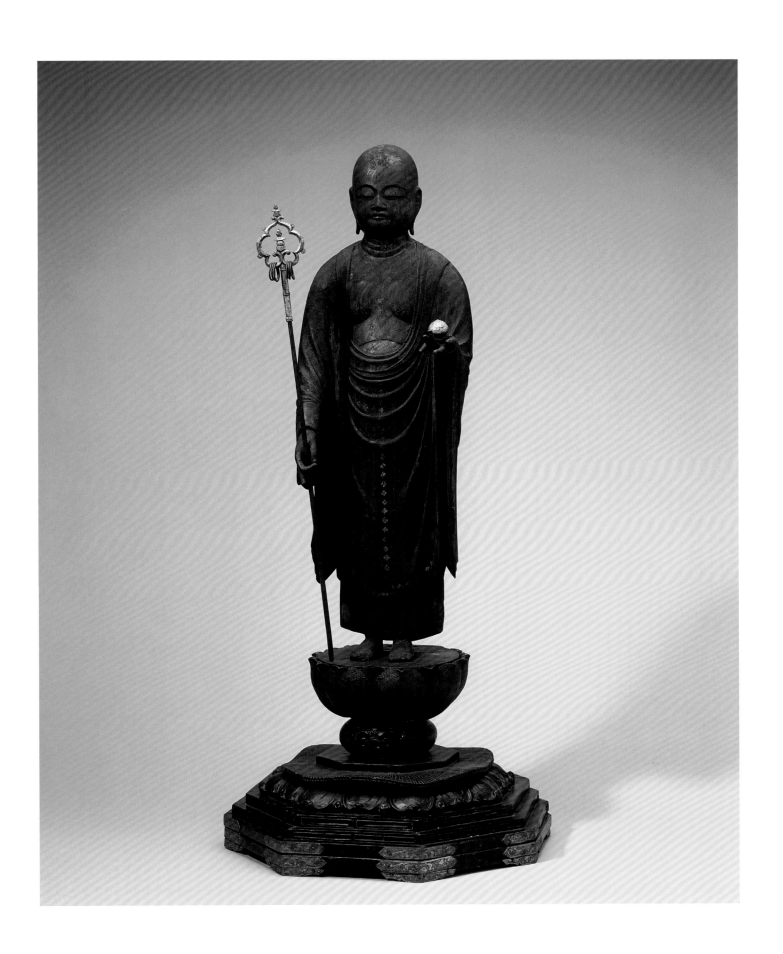

Seated Shaka

Japan, 12th century
Wood, with traces of gesso lacquer and gold leaf; joined-wood method of construction
h: 33.5 cm

George Gund III Collection

In the pantheon of Mahayana Buddhism, the tradition which came to Japan in the sixth century and which evolved over the next several centuries, there were numerous Buddhist deities—*bosatsu* (Sk: *bodhisattva*), *shitennō* (Sk: *lokapāla*; guardian kings), *rakan* (Sk: *arhat*), and other Buddha-beings—and myriad Buddhas, including Dainichi (Sk: Mahāvairocana), the Great Sun Buddha, and Amida (Sk: Amitābha), the Buddha of the Western Paradise. Also prominent is Shaka (Sk: Śākyamuni), the historical Buddha who walked the earth as Prince Siddhārtha, renounced his royal status, became a monk, and attained enlightenment and Buddhahood.

In the early years of Buddhism in Japan, the sutras that were particularly influential in Japan were the *Sutra of Cause and Effect, Past and Present* (Kako genzai inga-kyō), the *Sutra of the Golden Light* (Kōnkōmyō saishōō-kyō), the *Flower Garland Sutra* (Kegon-kyō), and the most popular of all, the *Lotus Sutra* (Hoke-kyō). All touched upon the life of Shaka. However, scenes from his life are depicted relatively rarely in Japanese art. Of these the most frequently seen are the infant Shaka with one hand pointing to the sky and the other to the earth indicating that he is the one; Shaka emaciated from the austerities prior to his enlightenment; and Shaka in *nehan* (Sk: *parinirvāna*), lying on a bier surrounded by mourners.[1] The most common form, however, is Shaka as a Nyorai (Sk: *Tathāgata*) or an enlightened being;

he is usually shown simply dressed in monk's robes, with his right hand raised, as we see here. Shaka Nyorai does not represent a specific event in the legend of the Buddha's life but is an image intended for worship.

In the *Sutra of the Great Nirvana* (Daihatsu nehan-kyō), a Mahayana Buddhist text revealing the record of the Buddha's last sermon, Shaka is described as having bared his body to reveal the thirty-two major characteristics and eighty minor marks that identified the body of a Buddha, a description that accords with the traditional manner of portraying the Buddha and which is echoed in the Gund sculpture.[2]

Seated in the yogic position of meditation, the image is identified as Shaka by a number of these symbolic marks (Sk: *laksana*): the cranial protuberance, snail-curl coiffure, the curl of hair (shown as a small circular hole between the eyebrows for the inset of a precious stone or crystal), downcast eyes, elongated earlobes, and three lines at the neck. The elongated narrow eyes, aquiline nose with slightly flared nostrils, and bowed upper lip are stylistic features, while Shaka's plain robes are ubiquitous, presented as a formalized arrangement of drapery covering both shoulders, exposing the bare chest, and falling in slightly asymmetrical folds.

The right hand is raised in the gesture of mercy and reassurance (*semui-in*) and the left, resting on the figure's left leg, with the palm outward, in the wish-fulfilling gesture (*yogan-in*). These gestures are symbolic traits identifying him as an enlightened being. Such gestures could also indicate the image of Yakushi (Sk: Bhaisajyaguru), the Buddha of Healing, who would have held a medicine jar in the palm of his left hand. From early on, there was a

close resemblance in pose and hand gestures between Yakushi and Shaka, and so it is often difficult to securely distinguish between images when they are taken out of their original context. Their physiognomy and dress are often similar as well.[3]

The craftsmanship of chiseled wood and subtly modeled surfaces follows the longstanding tradition of joined-wood construction. The surface was once covered with gesso lacquer and gold leaf (gold also symbolizing the Buddha's enlightened being), which now remains only on the ridges of the garment folds, along the snail curls in the coiffure, and on other raised details of the sculpture. —AGP

NOTES

1. Amy Poster, "The Buddha Image in Japan" in *Light of Asia: Buddha Sakyamuni in Asian Art*, ed. Pratapaditya Pal, exh. cat. (Los Angeles: Los Angeles County Museum of Art, 1984), 183–90.

2. Mimi Hall Yiengpruksawan, "The Legacy of Buddhist Art in Japan" in *Buddhist Treasures from Nara*, exh. cat. (Cleveland: The Cleveland Museum of Art, 1998), 12–13.

3. Poster, 190.

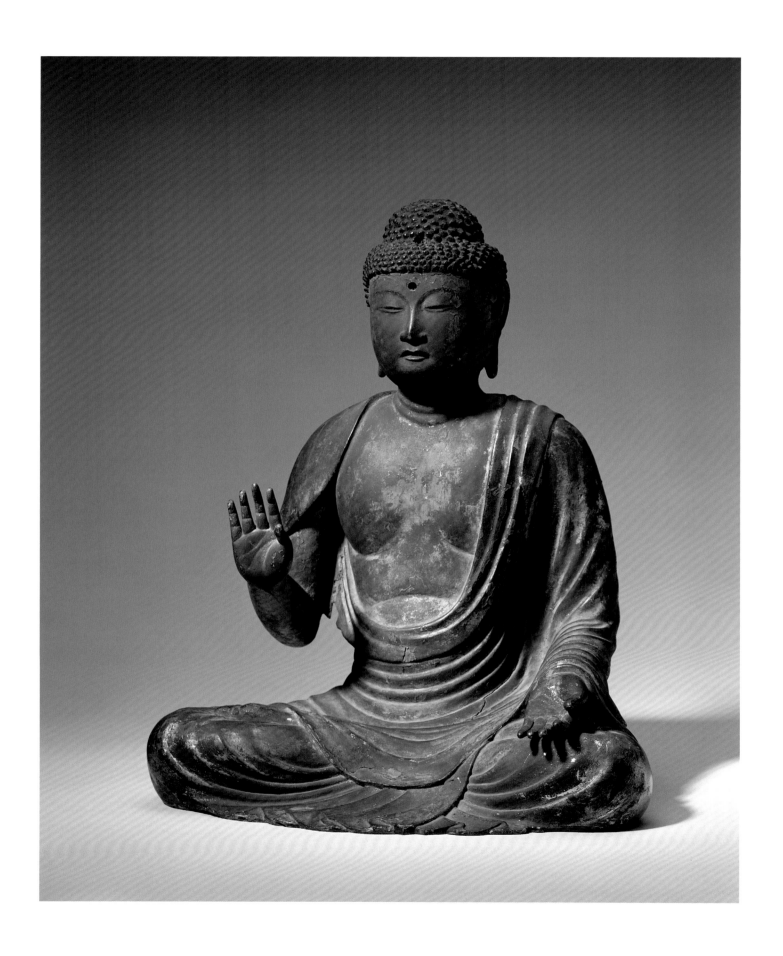

Welcoming Arrival of Amida

Japan, Nanbokuchō period, late 14th century
Hanging scroll; color and gold on silk
102 x 40.1 cm

Property of Mary Griggs Burke

Represented here is a vision of a compassionate Buddha, called Amida (Sk: Amitābha)—"Infinite Light"—in reference to the radiance of wisdom that surrounds him, coming to earth to welcome a dying soul to paradise. Accompanying him are the bodhisattvas Kannon (Sk: Avalokiteśvara), with the lotus, and Seishi (Sk: Mahāsthāmaprāpta), who are his faithful attendants and representatives in the world of the sentient. That this is a *raigō*, or "welcoming arrival" of Amida is symbolized by the hand gestures (Sk: *mudrā*) made by the Buddha figure. The iconography is based on a sutra beloved in medieval Japan, *Kanmuryōju-kyō* (Sutra of Contemplation on the Buddha of Immeasurable Life), which contains the teachings of Buddha regarding rebirth in the gloriously beautiful Pure Land of Amida in the Western sector of the cosmos.

The cult of Amida began to flourish in Japan at the end of the tenth century and in time stimulated an enormously rich visual culture based in part on descriptions of the Western Paradise in the *Kanmuryōju-kyō* and other Pure Land sutras. A stunningly gorgeous place, where Amida lives in a fabulous palace on a lake surrounded by a forest of bejeweled trees, the Western Paradise can be reached in the afterlife by those who profess faith in Amida. Indeed, the sutras explain that, by chanting Amida's name while envisioning him in his paradise, even the most sinful person will be reborn inside a lotus on the lake in front of the palace.

Works like this painting, showing Amida at the moment he comes to welcome the dying, were routinely displayed at deathbed rituals as a focus for chanting and contemplation; they were also commissioned as memorials to the dead. Accounts in diaries and other primary records suggest that these *raigō* scenes provided comfort and solace for both the dying and the bereaved and were regarded as beautiful markers of the passage of loved ones into the afterlife.

Each element of the composition, from subject matter to technique, embodies the fundamental concerns of Pure Land visual culture. The Buddha at the center glows as if alight with warm compassion. His body emits beams of golden light that, enfolding him, also spread outward beyond the picture frame as if into the space of the beholder. The diagonal placement of the figures generates a sense of acceleration; Amida and his attendants appear to rush through space—clouds billowing behind them—as if hastening toward the believer who awaits them. Even the lush surface, of gold pigment laced with cut-gold-leaf patterns called *kirikane*, suggests the precious substances of which paradise is formed. This shining materiality calls to mind a basic premise of Buddhist belief, especially in the Pure Land context, that the perfect comes about through the imperfect. The high craft evidenced by this painting, from the *kirikane* to the costly malachite green, shows how the artist, too, becomes part of the process of illumination that leads to salvation.

As a work of the fourteenth century, this *raigō* painting offers an important glimpse of traditional Japanese culture in a time of shifting aesthetics and art technologies. During this period the Chinese practices of Zen Buddhism and monochromatic ink painting had been widely adopted in intellectual circles and posed an alternative cultural model—with strong continental overtones—for the patronage and reception of art. What is seen in the *raigō* painting is a continuation of the classical tastes and needs developed in the court culture of the eleventh and twelfth centuries. Such tastes are apparent in the matte applications of gold, blue, and green in rich layers of pigment; in the delicate cut-gold-leaf designs; and in the vivid flatness of the forms. They are seen as well in the subject matter itself with its focus on salvation and the intimacy of a loving Buddha. Here we encounter the emotive strength of classical themes and classical techniques that give such paintings as this their special significance in the wider context of cultural exchange and national identity.

—MHY

BIBLIOGRAPHY
Miyeko Murase. *Japanese Art: Selections from the Mary and Jackson Burke Collection.* Exh. cat. New York: The Metropolitan Museum of Art, 1975, 56–58, cat. no. 15.

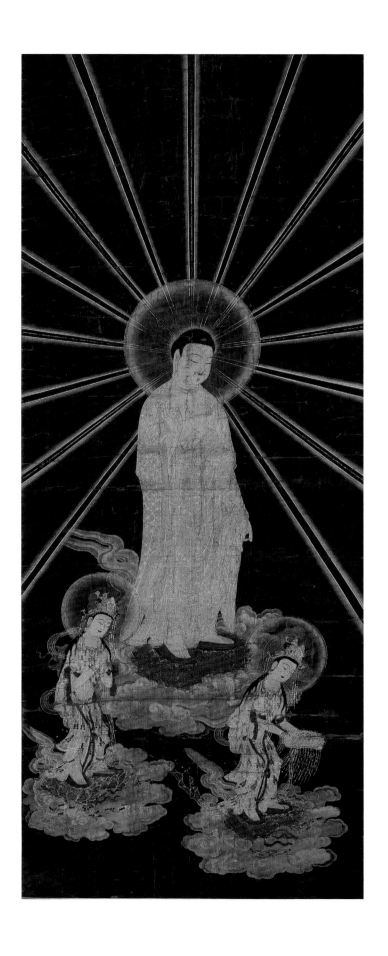

Sokka and Attendants

Korea, Chosŏn dynasty, dated 1565
Hanging scroll; color and gold on silk
69.5 x 33 cm

Mary and Jackson Burke Foundation

This hanging scroll is considered the finest example of Korean Buddhist painting in a private American collection. It represents an important historical document, as a symbol of the brief flourishing of Buddhism in the Chosŏn dynasty and a demonstration of the merging of Koryŏ-dynasty painting styles with those of the Chosŏn.

In this Buddhist triad, Sokka or Śākyamuni, the historical Buddha and founder of the faith, is seated in the lotus position on his Cosmic Mountain throne. His right hand is in the *bhūmisparśa-mudrā*, or earth-touching gesture that calls the earth to witness his enlightenment. The two ornately dressed and bejeweled figures flanking him are probably the bodhisattvas Munsu (Sk: Manjuśrī), who holds a long-stemmed lotus, and Pohyŏn (Sk: Samatabhadra), holding an unidentifiable stemmed object.

Although the painting was executed in the Chosŏn dynasty, the triangular composition that places the Buddha at the pinnacle, seated on a high throne, and the two bodhisattvas standing in the foreground, derives from earlier Koryŏ prototypes. The decorative motifs of the costumes are a stylistic continuation of Koryŏ-dynasty conventions, while the smaller face of the Buddha is a Chosŏn innovation. This painting displays a technical mastery and refined sophistication in the careful balance of shades of red and green that are combined with gold to highlight the garment patterns

and ornamental details. The use of sumptuous gold and rich mineral pigments harks back to the finest of Koryŏ painting traditions. Chosŏn characteristics are apparent in the manner in which the double halos intersect, as opposed to the clearly separated halos seen during the Koryŏ period, and in the less gossamer, more tangible quality of the drapery.

This painting's inscription provides primary evidence of imperial patronage of Korean Buddhist monasteries during the sixteenth century of the Chosŏn dynasty. Written in gold ink using Chinese standard characters, the inscription begins along the right margin and continues below the bodhisattvas. It is dated, using the Chinese Ming-period reign-dating system, to the forty-fourth year of the Jiajing reign (1565) and is signed by Powu (died 1565), chief religious advisor to Queen Dowager Munjŏng (died 1565).

From the inscription we learn that this painting is part of a commission of four hundred paintings, one hundred images each (fifty in gold and fifty in color) of the four Buddhas: Sokka; Amit'a (Sk: Amitābha), the Buddha of Infinite Light; Yaksa (Sk: Bhaisajyaguru), the Healing Buddha; and Miruk (Sk: Maitreya), the Buddha of the Future. Of the original four hundred, only four are known today, this one being the only example in the United States.[1]

This massive undertaking was sponsored by the Queen Dowager as part of the dedication of the Imperially sponsored restoration of Hoeam-sa, one of Korea's great *sŏn* (Zen) temples, located in Kyŏnggi province. The paintings were also intended to ensure blessings and longevity for her son, King Myŏngjong (r. 1545–67).

During the first century and a half of the Chosŏn dynasty, Buddhism was suppressed and replaced by Confucianism as the official state religion. During Queen Munjŏng's official and unofficial reign from 1546 to 1565, however, she promoted and revitalized Buddhism. Beginning in 1551 she revived the administrative systems and reinstated thousands of priests. This brief flourishing of Buddhism was unfortunately terminated at her death, shortly after this set of four hundred paintings were dedicated at the newly renovated Hoeam-sa.

—RAP/HW

BIBLIOGRAPHY

Arts of Korea. Exh. cat. New York: The Metropolitan Museum of Art, 1998, 176–77, cat. no. 80.

Kim Hongnam. *The Story of Painting: A Korean Buddhist Treasure from the Mary and Jackson Burke Foundation.* Exh. cat. New York: The Asia Society Galleries, 1991.

NOTES

1. The other three paintings are in the National Museum of Korea, The Tokugawa Museum of Art, and Ryujo-in in Japan. See Kim, figs. 15, 20, 21. Notably, these three paintings are all from the set of one hundred depicting Yaksa and two attending bodhisattvas. The Burke image is the only known painting of the set of one hundred to show Sokka.

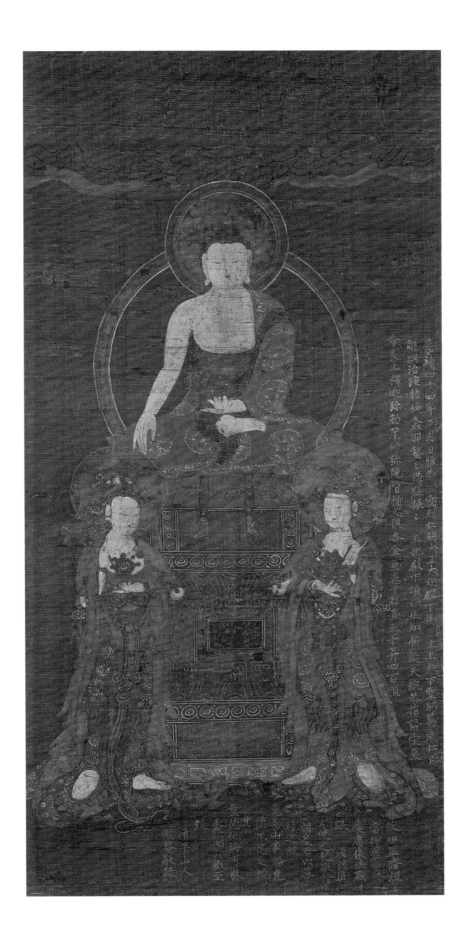

Monju

Japan, Kamakura period, 13th century
Buddhist votive plaque; gold and color on
wood with *kirikane*
diam: 8.8 cm

Hiroshi Sugimoto Collection

The painting is a study in circles, strong colors, and gold accents. Its subject, a seated male figure, wears the royal costume of a bodhisattva. The face is lively and full of expression, the buff-colored body appears muscular and strong. The hair is blue with five chignons. In his left hand the figure holds a lotus on a long stem atop which rests a blue book. In the left hand is a sword with a golden hilt in the shape of a double-pronged ritual implement called a *kongō* (Sk: *vajra*) or diamond bolt. The figure sits with legs crossed atop a green lotus blossom. He is framed by a set of circles including the circular form of the plaque itself.

The five chignons, the lotus and book in the left hand, and the sword in the right hand identify this figure as a representation of Monju (Sk: Mañjuśrī), the bodhisattva of wisdom and one of the most popular figures in East Asian Buddhism. A devoted disciple of the Buddha, Monju facilitates the spread of Buddhist teachings through his intelligence and foresight. A Monju (Ch: Manjushili) cult emerged in China during the fifth century and flourished at Wutaishan, a mountain complex of five peaks that had come to be identified with Qingliangshan (Cool Clear Mountain), where he was believed to reside.

In the painting the five chignons symbolize Wutaishan and establish the iconography as that of Monju at Qingliangshan as he awaits those who seek the Buddha path. The book

that he holds in his left hand symbolizes the vast Buddhist wisdom that he embodies. The sword with its diamond-bolt hilt signifies the adamantine strength of wisdom as it cuts down illusion. The lotus reminds the beholder that all wisdom grows like the lotus from the muddy ground of existence to blossom in the sunlike radiance of the Buddhist teachings.

Wisdom is power, as well, and the five chignons, combined with the book and the sword, point to another important facet of the Monju cult in the context of the Esoteric Buddhist practices known as Tantrism. These practices emphasize chanting, ritualized gestures and poses, and intense concentration through which practitioners achieve mystical union with Buddhist deities, gain access to their secret teachings, and muster their magical powers for deployment in the world. Monju with his store of wisdom was a primary object of such rituals both in China, where the practice developed, and in Japan after his cult was introduced in its Esoteric form in the ninth to tenth century.

The circular plaque on which the painting has been executed further links the image to Esoteric practices. Known as a *kakebotoke* (pendant Buddha), this format emerged in the twelfth to thirteenth century in connection with religious syncretism that integrated Buddha and *kami* (spirit) worship. Mirrors had long been used to represent *kami* and were regarded as powerful embodiments, or reflections, of the gods. Circles and mirrors were also important in Esoteric Buddhist rituals; practitioners were instructed to visualize a Buddha or bodhisattva on a disk-shaped surface that was likened to the full moon. After the format was introduced from China in the late

tenth century, it soon became a popular Japanese modality for iconic representation. Its small size and portability made it well suited to private worship in the home; *kakebotoke* were also given as gifts to temples and shrines by parishioners.

Both the subject of this painting and its format exemplify the Monju cult as it emerged in the thirteenth century under the patronage of military rulers and Buddhist reformists. Worship of Monju was taken up by the same communities that welcomed Zen teachings and other continental practices; possibly the connection to Wutaishan gave the cult an international flavor in a time when Chinese artisans and intellectuals had begun to make their mark in Nara, Kyoto, and Kamakura. The brilliant colors and confident brushwork bring to mind the professional Buddhist painters of China under the Song emperors. But a strong domestic component is seen in the *kakebotoke* format, with its links to *kami* worship and native ritual. It is also glimpsed in the precise applications of gold leaf, or *kirikane*, and in the sumptuous two-dimensionality of the image. In these ways the painting underscores that blend of continental and local cultures that came to exemplify Japan in the medieval period. —MHY

to wonder who is human and who is not, and whether it matters.

Of course, much of the fun in these scrolls derives from the mischief of representing a courtier as a monkey or a Buddha as a frog. Here we encounter the lively touch of an irreverent counterculture that provides the flip side to the serious task of standard Buddhist narrative, or *setsuwa*, for which the illustrated handscroll had emerged as a dominant medium by the twelfth century. Painters such as Toba Sōjō would have devoted much of their practice to such projects, in which the paradigms of continental Buddhist culture—pictorial, calligraphic, technical—were followed and preserved. If Toba Sōjō was an expert brush artist, it was because he knew, and had surely studied, old Chinese prototypes in various palaces and temple collections. There is no evidence that Toba Sōjō ever saw contemporary Chinese paintings. But it is certainly possible, for Chinese merchants had frequented the courts of Japanese emperors since the early eleventh century, and Japanese monks regularly traveled to and from China carrying various goods. One wonders whether the vivid brushwork, as also the evocative modulation of ink tones so reminiscent of later Song-period painters, provide a hint that Toba Sōjō had seen, and studied, new works introduced from the continent in the early twelfth century.

Ultimately, the special significance of this fragment from the *Frolicking Animals Scroll* lies in its freedom of expression within the wider context of the Buddhist visual culture that linked Japan to Korea and China. The handscroll format, and the vocabulary of ink and brush, were continental forms, as also the Buddhist narrative tradition and its local adaptations.

These were the province of a community of highly cultivated men and women at the pinnacle of Kyoto society, where artists like Toba Sōjō plied their craft in the production of cultural monuments for the dominant elite. But the fragment hints at another community, that of the illiterate commoner who was often the subject of *setsuwa* and toward whom the stories were frequently directed as a form of proselytizing. The lack of words, a comment about animals and speech, reminds us also that many Buddhist stories were told through pictures and with considerable good humor.

Who commissioned this funny scroll with its animals and absurdities? Some scholars suggest that it was Go-Shirakawa (r. 1155–58), an emperor very much interested in what might be termed the popular culture of Kyoto in the twelfth century. Others say it was a creation of a painter like Toba Sōjō playing with the skills he had developed as an iconographer and maker of Buddhist images, perhaps to amuse his friends or irritate those in his monastic community who took themselves too seriously. It has even been suggested that the scroll was intended as a political diatribe against the governing classes. Whatever the origins of the *Frolicking Animals Scroll*, in style and theme it makes at least one point very clear. The playful and parodic mode of execution, in which acerbic brushwork matches an equally witty view of human nature through animal bodies, reveals much self-confidence and the courage to laugh at norms. It is the product of a robust national culture at Kyoto that has adapted continental forms to its own ends.

—MHY

BIBLIOGRAPHY

Akiyama Terukazu. "'Chōjū giga' kōhon no zanketsu ni-shu: Shinshutsubon to Masuda-ke kyūzōbon/Two Fragments of the 'Animal Scroll' (*Chōjū Giga*): A Newly Discovered Fragment and the Fragment from the Former Masuda Collection." *Bijutsu kenkyū/The Journal of Art Studies*, no. 292 (March 1974): 223–30.

———, ed. *Emakimono* (Illustrated handscrolls). Zaigai Nihon no shihō (Treasures of Japanese art abroad), vol. 2. Tokyo: Mainichi Shinbunsha, 1980, 146, pl. 50.

Komatsu Shigemi. "'Chōjū jinbutsu giga': Manga no hassei" (*Frolicking Animals and People Scroll*: The birth of *manga*). In *Chōjū jinbutsu giga*, Nihon no emaki (Japanese illustrated handscrolls), vol. 6. Tokyo: Chūō Kōron, 1987, 122–38.

Hamada Takashi et. al. *Genshoku Nihon no bijutsu 27: Zaigai bijutsu (kaiga)* (Art of Japan in color 27: Art abroad [painting]). Tokyo: Shōgakukan, 1980, pl. 36.

Mayuyama Junkichi, ed. *Japanese Art in the West.* Tokyo: Mayuyama & Co., Ltd., 1966, pl. 117.

Ida Ely Rubin, ed. *The Guennol Collection*, vol. 1. New York: The Metropolitan Museum of Art, 1975, 278–82.

Harold P. Stern. *Birds, Beasts, Blossoms, and Bugs: The Nature of Japan.* Exh. cat. Los Angeles: Frederick S. Wight Art Gallery, University of California, 1976, 20–21, cat. no. 5.

Tanaka Kisaku. "Sumiyoshi-ke denrai Kōzan-ji giga mohon ni tsuite/On a Newly Found Copy of the Kozanji Cartoon, Handed Down in the Sumiyoshi Family." *Bijutsu kenkyū/The Journal of Art Studies*, no. 116 (August 1941): 235–47.

Ueno Kenji. "'Chōjū giga' kōhon no fukugen/Compositional Restoration of Scroll I of 'Scrolls of Caricaturistic Animals, Birds, and Human Figures.'" *Bijutsu kenkyū/The Journal of Art Studies*, no. 292 (March 1974): 208–22.

MYŌE KŌBEN (1173–1232)

Section from Dream Diary

Japan, Kamakura period
Fragment mounted as hanging scroll;
ink on paper
30 x 10 cm

Hiroshi Sugimoto Collection

Visionary experience, and the vision quest in general, is central to Buddhism and constitutes an important subject for doctrinal interpretation. Prince Siddhārtha, Śākyamuni or Shaka, is said to have had vivid dreams the night before he attained enlightenment as Buddha. The process of enlightenment itself was accompanied by graphic and violent visions. When Shaka preached his first sermon, later recorded as the *Kegon-kyō* (Flower Garland Sutra), he expounded a silent Cosmic Buddha, Birushana (Sk: Vairocana), who granted a luminous vision when asked for a revelation. None who witnessed the vision could understand the meaning of its many marvelous components. Like a dream, it awaited the analysis and interpretation that would follow in Buddhist commentary.

This fragment of writing comes from a celebrated collection of dreams recorded by the monk Myōe over a thirty-year period, from the age of twenty-three through his death in 1232. Entitled *Dream Diary* (Yume no ki), it documents a passionate engagement with the world of visions as a gateway to Buddhist transcendence. The writing is magical and emotive, but also coolly observant, as Myōe confronts both the beauty and the disturbing nature of the images he sees and experiences in an altered state. Here he describes, in words as cryptic as the visions themselves, his dream of a Zen master and an adolescent female form (possi-

bly a boy) toward whom he feels an attraction; he understands this is shameful because someone called Narichika admonishes him. He dreams the same night of the voices of people, perhaps children, playing at the seashore. In another dream a few days later, a monk comes to accompany him somewhere.[1]

Myōe is a remarkable presence in the history of Japanese Buddhism. Although trained as a monk in the Shingon sect, and an expert in its Esoteric rituals and doctrines, Myōe was an ardent and passionate advocate of visions as central to the quest for Buddhist insight. In particular, he was a proponent of the *Kegon-kyō*. The primary role of dreams and visions in his practice, and their deep relevance to the apprehension of illusion so important to Buddhist wisdom, gave Myōe a unique role — as dreamer, as scholastic, as curmudgeon — in a period of sometimes violent social change and military conflict. In 1206 the retired emperor Go-Toba (r. 1183–98) gave Myōe some land on the outskirts of Kyoto, in the vicinity of Mount Takao. There he established Kōzan-ji, the monastery where he would live out the rest of his life as a seeker of visions. From around 1212 until his death, he devoted himself, through fasting and intense concentration enhanced by chanting, to a quest for dreams. Visitors to Kōzan-ji today can see the places where Myōe meditated among the trees.

The *Dream Diary* still exists in its original manuscript form, in the hand of Myōe, but has been divided over the centuries into sections and fragments. Most of the diary remains at Kōzan-ji, but many pieces are also found in private collections and museums. An eloquent testimonial to the dreams and desires of the monk Myōe, it is in a sense a window into the

heart of a man devoted to the vision quest that has sustained Buddhist practice for nearly two millennia. The trace of Myōe's hand, and the fleeting nature of dreams and life, make this fragment a precious document of faith and humanity. It is well to recall the opening lines of the *Dream Diary* manuscript, added by an anonymous reader worried that it would disappear like the dreams themselves, and the man who noted them down: Hold on to this and do not lose it.[2]

— MHY

NOTES

1. Professor Karen Brock kindly provided a rough translation and interpretation of the recorded dream, which is extremely difficult to make sense of, not simply because it is a dream, but also because of its fragmentary condition. The "female form" may refer to a boy dressed as a girl, possibly accompanying the Zen master.

2. George Tanabe, Jr., *Myōe the Dreamkeeper: Fantasy and Knowledge in Early Kamakura Buddhism* (Cambridge, Mass. and London: Harvard University Press, 1992), 160.

一同廿雪之夜苦夢を
有之候得共是こ又々又十六七之歳けり用せ候歌流十十候
らそ三元脇し不空力不唐江なな珠ゎ甚佳と候
シもフ又々海遇こ知らさ迚戲ミ詰ち竒又方者冤隆と
一同せれり夜苦夢を
有之候信ち省寺水太信
ちりわ
今ち高こ竒利到こる

HAKUIN EKAKU (1686–1769)

One Hand Clapping

Japan, Edo period
Hanging scroll; ink on paper
91.1 x 27 cm

George Gund III Collection

A hunched figure looms at the bottom of the painting below a rapidly brushed inscription in six lines. He holds one hand up with palm outward, a mischievous smile on his face. His fat stomach bulges like the round bag atop which he stands on his absurdly abbreviated feet. Seals to the right of the inscription indicate that the author of this preposterous image and the accompanying inscription is the Zen master Hakuin Ekaku. At first glance ridiculous and funny, the painting also reveals a profound teaching through the typical mix of facetious and serious that is a hallmark of Zen instruction.

The salient features of bald head, fat stomach, and enormous bag identify the figure as Hotei, one of the most popular subjects in Zen visual culture. Hotei (Ch: Budai)—whose name translates as "Burlap Sack"—was an eccentric Zen monk of tenth-century China. Hotei always carried an enormous bag full of alms. The bag, like his stomach, is filled with goodies, but it also symbolizes the "storehouse consciousness" that sustains all phenomena including Zen insight. Thus Hotei stands atop his bag, the foundation of his wisdom, as he gestures upward. In many depictions of Hotei, he is shown pointing into space, as if to draw his viewer into the contemplation of emptiness that is at the heart of Zen practice. In a sense, such a painting is an analogue to the *kōan*, or "test case," whose exegesis is so important to Zen training. Images

of Hotei pointing into space can be directly linked to *kōan* that pose riddles about Zen masters who raise their fingers, or point into space, as answers to queries about the meaning of Zen.

The inscription indicates that here Hakuin has used Hotei—whose iconography includes the gesture of pointing—as a thematic device in the explication of his famous *kōan* "What is the sound of one hand clapping?"

> All you clever young people—
> No matter what you say,
> If you don't hear the sound of one hand,
> Everything else is rubbish![1]

Hakuin invented this *kōan* in his later years as an encapsulation of the form of Rinzai Zen that he advocated. The emphasis on sound, or hearing, relates to the moment when Hakuin attained enlightenment, after several days of intense meditation, on hearing the sound of a distant temple bell.

Hakuin resolved at an early age, after training at several monasteries, that he would live and practice in the venerable Buddhist tradition of mendicancy and poverty. Although he served as chief priest at various monasteries, he never settled long at any one institution, and developed a practice focused around exegesis of *kōan* and instruction of commoners in the teachings of Zen. As part of his practice he distributed paintings such as this one, often inscribed with his Zen sayings. The naïve and artless brush that sketches Hotei here, and the scribbled inscription, conceal deeper meanings that reveal themselves through insight into Zen tradition. The single hand clapping is also the pointing hand of Hotei, which gestures at the

emptiness of things, but also at the inscription. Perhaps Hakuin saw parallels between his own erratic life in Zen and that of Hotei. Certainly both painting and poem reveal a strong personality behind the brush. It is a tribute to Hakuin that he manages here to convey not only his own concerns but also those of Zen practice. The gesture toward emptiness signals the point of departure in all of Zen teaching: the struggle to understand *mu*, or the void. The single hand clapping reflects the personal concern with sound and silence that seems to have inspired Hakuin throughout his life. He once wrote that Kannon, the bodhisattva "who sees and hears all things," is capable of seeing sound. Thus to know the sound of one hand clapping, in effect to see it in a moment of insight, is to attain enlightenment, to have the eyes opened, and to know "the whole world as one singularity of seeing sound" (*sekai ichimen kannon*).[2]

—MHY

BIBLIOGRAPHY
Stephen Addiss. *The Art of Zen*. New York: Abrams, 1989, pl. 62.

NOTES
1. Translation by Addiss, 121.

2. See Tanahashi Kazuaki, *Hakuin no geijutsu* (The Art of Hakuin), (Tokyo: Geiritsu Shuppan, 1980), 96.

Sutra Fragment

Korea, Koryŏ, possibly Unified Silla, dynasty
Handscroll fragments; gold on indigo paper
29 x 13 cm each page

Robert Hatfield Ellsworth Collection

The longstanding tradition of reading and
copying sutras and Buddhist doctrine was an
important part of Buddhist practice in Korea,
from the time of Buddhism's introduction in
the fourth century. The most secure evidence
of this practice dates from the Koryŏ dynasty
when many illuminated sutras were produced,
some of which exist today in collections world-
wide. Sutra copies could be commissioned
to insure the patron's happiness in this world
and rebirth in paradise.

Early sutras are believed to have been formatted
as handscrolls or rectangular accordian-folded
books. Often illuminated by a frontispiece or
with symbolic images interspersed in the text,
they were written in Chinese and often drawn in
expensive pigments on indigo-dyed paper.

The Ellsworth sutra fragments are written in
gold on indigo-dyed paper. The section shown
at the right consists of six lines of standard
script, listing twelve names of Buddhas. An
apsaras (Sk; heavenly being) is rendered with
refined and fluent lines above the text, and
a *kinnara* (Sk; heavenly bird-headed musician)
is depicted below. The second fragment, shown
at the left, is decorated in gold with a scrolling
floral vine motif.

Only one documented Buddhist sutra, now
in the Ho-am Museum, Yong'in city, Kyonggi
province, is known from the Unified Silla
dynasty.[1] Fragments of its frontispiece have
been designated a National Treasure of Korea.

Stylistically, the sutra fragments are character-
ized by a similar illumination technique, with
figures drawn in flowing lines in gold and silver
on indigo-dyed paper. An inscription attached to
the piece dates its commission to ca. 754–55.

The Ellsworth sutra fragments are painted in a
related style. They are not part of a frontispiece,
which would traditionally have represented
the Buddha preaching to bodhisattvas; because
they are fragmentary and not a complete narra-
tive representation, it is difficult to assign a
definite date. The line and form of the scrolling
floral vine and the *apsaras* and *kinnara* may be
compared to the style of the Ho-am piece,
which has designs painted in silver and gold
pigment on an indigo-dyed paper.

The text of the sutra on these two fragments
has not been identified. It is drawn in Chinese
characters in standard script, which was cus-
tomary for early sutra texts and inscriptions in
Korea as well as in China and Japan. The text
here is limited to the names of the Buddha. The
fragmentary condition of the Ellsworth frag-
ments and the scarcity of comparable Buddhist
scriptures from such an early date make it
difficult to confirm an early attribution.

This fragment was among the finds of the
Ōtani Expedition. Under the initiative of Ōtani
Kōzui (1876–1948) of Nishihongan-ji in Kyoto,
three expeditions were launched in 1902–14 to
trace the eastward transmission of Buddhism
from India to Japan. In their travels across
Asia, expedition members accumulated signi-
ficant Buddhist artifacts and archival docu-
ments, many of which now reside in national
collections in Japan. —AGP/HW

BIBLIOGRAPHY

*An Exhibition of Chinese and
Korean Sutra Manuscripts
from the Collection of Robert
Hatfield Ellsworth*. Exh. cat.
Hong Kong: Fung Ping Shan
Museum, University of Hong
Kong, 1987, cat. no. 44.

NOTES

1. *Koryŏ, Yŏngwŏnhan mi/The
Koryŏ Buddhist Paintings*,
exh. cat. (Seoul: Ho-am Art
Museum, Samsung Founda-
tion of Culture, 1993), 109–13,
cat. nos. 37–38.

Seated Lohan

China, late Tang–Northern Song period
White marble with traces of polychrome
pigment
h: 56 cm

Robert Rosenkranz Collection

This Buddhist image represents a robed *lohan* seated on a rock in a meditative pose that is at once composed and intense. In a gesture of unusual naturalism, he leans upon his right arm, his left leg crossed and his right foot resting casually over the rocky perch. His head, tilted slightly, emanates the *lohan*'s iconic state of introspection and active thought. The realism of his form and psychological characterization of his expression represent less a stylized type of deified image than a specific individual existing on the earthly plane.

Lohan (Sk: *arhat*) form an important part of the Buddhist pantheon. Originally humans who attained enlightenment and transcendent wisdom through their own efforts, they were elevated to a superhuman level and endowed with magical abilities. Their iconographic attributes sometimes took on the appearance of demonic sorcerers, but they also continued to be depicted in a simple, human form characterized by unique and highly expressive features. *Lohan* most commonly refer to a group of sixteen disciples selected by Shajiamouni (Sk: Śākyamuni) to dwell on the human level of existence and protect the Dharma, or Buddhist Law, for the edification of sentient beings. They fulfill their role, even in times of social disorder and religious disintegration, until the advent of the redeeming Buddha of the Future, Mile (Sk: Maitreya). The number of *lohan* was expanded to eighteen in the tenth century, while depictions of five hundred *lohan* derived from canonical descriptions of the first

Buddhist council were commonly found in Chinese and Japanese monasteries.

Lohan were first widely depicted in Chinese Buddhist art during the Tang period. Records indicate the earliest known depictions of groups of sixteen *lohan* are by the eighth-century painting master Lu Lengjia, a student of the great Wu Daozi (died 792), with another set painted by the better-known *chan* (Zen) master Guanxiu (832–912).[1] From the tenth century onward, the cult devoted to *lohan* worship became even more widespread. Because *lohan* dwell on the earthly plane and, like saints, are not deified, they became a primary vehicle of veneration specifically for the *chan* school. This figure may have been part of a group of sixteen or more placed in a temple hall devoted to *lohan* in a larger temple complex, although no comparable images from such a set are known.

The Rosenkranz *lohan* may have originated from the Wuqi area in present-day Hebei province. The stylized naturalism of the figure, with its head tilted slightly forward, and the softness and ryhthmic folds of the drapery is somewhat characteristic of Tang Buddhist sculpture.[2] However, in the overall shape and pose of the figure, and details of the drapery, this *lohan* appears closest stylistically to Buddhist sculpture dating to the Liao and Northern Song periods.[3]

As a medium for Buddhist sculpture, white marble had been used in Northern China since the Northern Qi period (550–77). One known white marble *lohan* which recently came to light is inscribed and dated to 963.[4] In comparison, the Rosenkranz *lohan* is over twice the size of the recent find and exhibits a more advanced aesthetic sensibility in its pose and carving.

—RAP/AGP

NOTES

1. Osvald Sirèn, *Chinese Painting: Leading Masters and Principles*, vol. 3 (London: Lund Humphries, 1956–68), 114–15, pl. 89.

2. See *Kaogu*, no.7 (1992): 9, pl. 7, for an example of a stone *lohan* dated to the Tang period, 8th–9th century, from Qinglong Temple in present-day Xian in Shaanxi province.

3. The Rosenkranz *lohan* may be best compared to a bronze sculpture of Dizang (Sk: Ksitigarbha; J: Jizō) seated in a half-lotus position, dated to the Northern Song period, currently in the Zhejiang Provincial Museum. The distinctive curvature of the sides of the head, the fall of the drapery, the deep cuts of the drapery folds along and below the legs, and the sharply defined knotted sash around the figure's midsection all point to similar stylistic origins. See Matsubara Saburō, *Chūgoku bukkyō chōkoku-shi ron* (History of Chinese Buddhist sculpture), vol. 3 (Tokyo: Yoshikawa Kōbunkan, 1995), 820.

4. "A Garden Show," *Kaikodo* 9 (Fall 1998): entry 58.

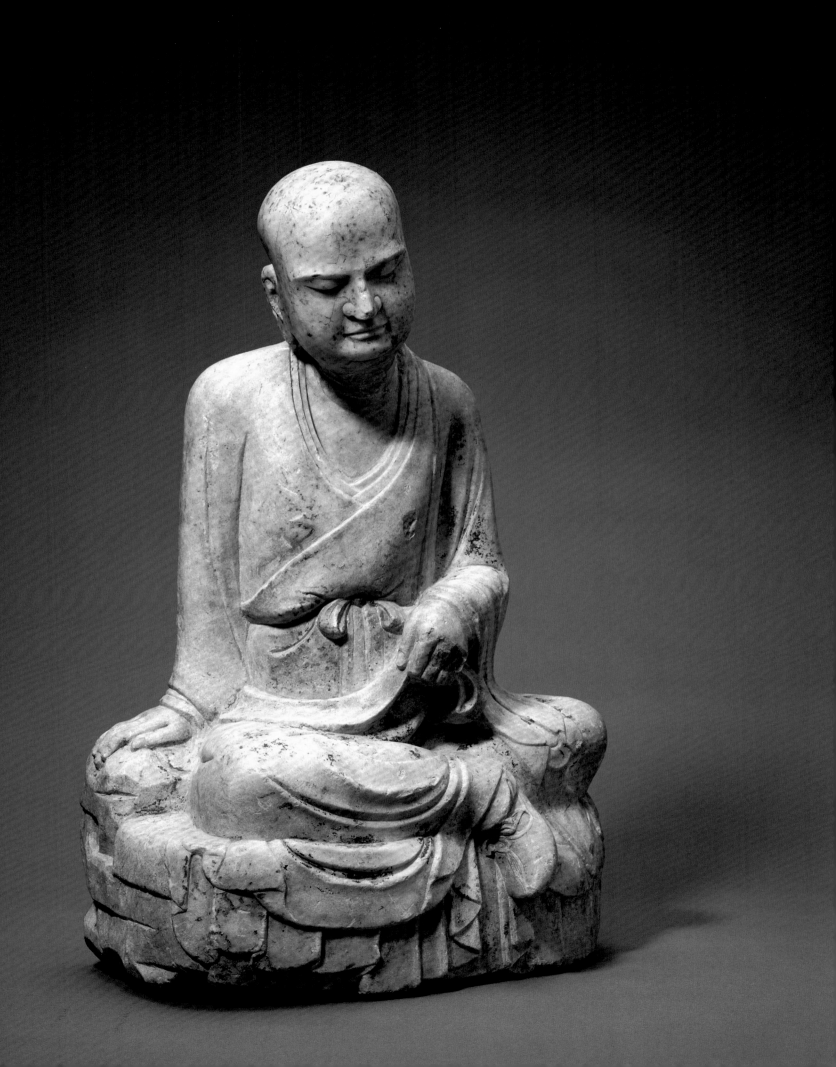

CAT. NO. 11

Seated Avalokiteśvara

Dali Kingdom, 11th–12th century
Gilded bronze
h: 38.1 cm

Anonymous Loan

Avalokiteśvara (Ch: Guanyin; J: Kannon) is one of the two principal bodhisattvas (the other being Manjuśrī) of the pantheon of Mayahana Buddhism, the "Great Vehicle" of Buddhism that opens the way to enlightenment for all beings. Avalokiteśvara is most easily distinguished by the image of the seated Buddha Amitābha, the Buddha of Infinite Light, in his headdress. Known as the Bodhisattva of Compassion, his limitless empathy is expressed in his wonderful ability to care for and help all beings who turn to him. There are over one hundred different incarnations of Avalokiteśvara known, from a human form to multi-armed and multiheaded manifestations.

Typically, the bodhisattva is shown using specific hand gestures or *mudrā* as represented here. The raised right hand, palm out with the thumb touching the first finger, is the *vitarka-mudrā*, which indicates teaching or discussion. The left arm down with the palm out and fingers extended in the *varada-mudrā* indicates the bestowing of a wish and the promise of salvation and rebirth in the Western Paradise of Amitābha.

Worship of the Bodhisattva Avalokiteśvara was widespread in the independent Dali Kingdom (937–1253), located in present-day Yunnan province in southwestern China. During its greatest period, from the tenth to the twelfth century, Avalokiteśvara was the central deity of veneration.

The high level of craftsmanship evidenced in the robes, the headdress, and the adornments of this image are characteristic of the twenty or so known gilded standing images of Avalokiteśvara from the Dali Kingdom.[1] This spectacular example, which compares quite closely stylistically to these other known images, is unique because the figure is seated in a *virāsana*, a half-lotus position with one leg pendant, and because of its size and the quality of its gilding.

Perhaps the most important discovery this century about the Dali Kingdom of the twelfth century was Helen Chapin's publication of the Yunnanese artist Zhang Shengwen's *Long Scroll of Buddhist Images* dated to 1173–77 and 1180.[2] It was through the images in that handscroll that figures of Avalokiteśvara, like this one, were confirmed to come from Dali. In addition, there is a handscroll dated 947 that illustrates the legend of the founding of the Nanzhao Kingdom, also in present-day Yunnan province.[3] From the tenth-century handscroll we learn that this is a specific manifestation called the Ajaya (All-Victorious) Avalokiteśvara. According to the legend, Ajaya Avalokiteśvara, a transfiguration of an Indian monk, brought Buddhism to the location of present-day Yunnan in the seventh century. At that time, a bronze likeness was cast before he vanished.[4] This manifestation of Avalokiteśvara, unique to the Dali Kingdom, was later repeatedly copied and became its most popular object of worship.

—RAP

BIBLIOGRAPHY

Arts for the Emperors: Visions of the Buddhist Paradise and Fine Chinese Works of Art. Hong Kong: Christie's, 26 April 1998, lot 606.

NOTES

1. For three examples, see the Asian Art Museum of San Francisco standing Avalokiteśvara in *Chinese, Korean, and Japanese Sculptures in the Avery Brundage Collection* (San Francisco: Asian Art Museum of San Francisco, 1988), pl. 140. For the Victoria and Albert standing Avalokiteśvara see *Chinese Art and Design: Art Objects in Ritual and Daily Life,* ed. Rose Kerr (Woodstock, N.Y.: The Overlook Press, 1992), 98, pl. 37. The Yunnan Provincial Museum image is solid gold and the only one with a full silver mandorla. See Albert Lutz, "Buddhist Art in Yunnan," *Orientations* (February 1992): fig. 5.

2. This handscroll is currently in the National Palace Museum in Taipei. See Helen B. Chapin, "A Long Roll of Buddhist Images," revised by Alexander Soper (in 4 parts), *Artibus Asiae,* no. 32 (1971–72).

3. Known as the *Nanzhao tuzhuan* (Nanzhao handscroll), this document is now in the Fujii Yūrinkan museum in Kyoto. See Lutz, 48.

4. Ibid.

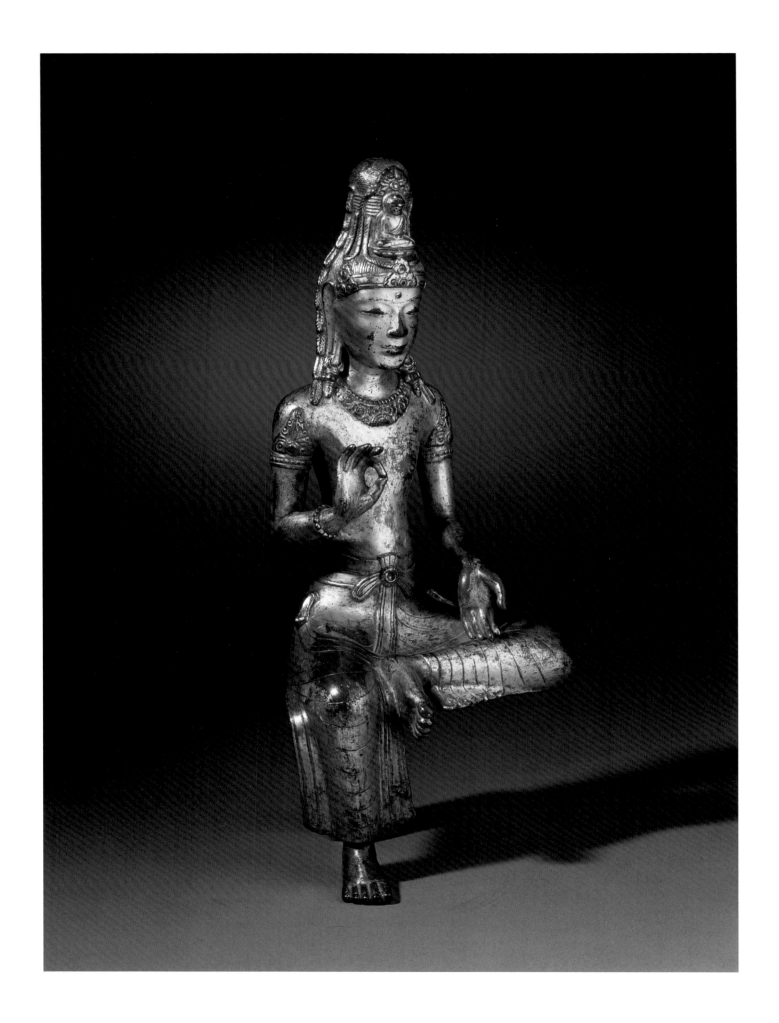

CAT. NO. 12

Pair of Votive Panels with Seated Deities

China, Yuan period, 13th–14th century
Hanging embroideries; silk and gold threads
on silk
40 x 18 cm each

Judy and Michael Steinhardt Collection

Votive Panel with Śākyamuni

China, Yuan period, 13th–14th century
Hanging embroidery; silk and gold threads
on silk
51 x 24.5 cm

Judy and Michael Steinhardt Collection

During the Yuan and early Ming periods, Chinese silk textiles were indispensable in maintaining the Mongols' foreign relations with Tibet.[1] Tibetan Buddhist monasteries became important treasuries of silk textiles and other objects. Their dark and dry storehouses provided the ideal environment for preserving many of the textiles in a pristine or near-pristine state.[2] Textiles such as the votive panels shown here were most likely products of imperial or professional embroidery workshops and would have been given to specific monasteries or Buddhist personages as state gifts.

The pair of tapestries shown here depict Lokapāla Virūpākśa, the Guardian King of the West, and possibly Kubera, the God of Wealth. The single panel, from a related set, shows the historical Buddha, Śākyamuni.

These extraordinary embroidered panels of Buddhist deities represent only three examples of a much larger set of religious textiles.[3]

They are all embroidered with polychrome silk floss and couched gold thread on a deep blue silk ground. The panels are unmistakable, distinguished by their high technical quality and the vast repertoire of stitches used to execute their complex designs. A prime example is the coherent and vibrant rendition of the red-faced Virūpākśa shown here. The details of his armor are not forsaken, yet they neither dissolve nor compete with the intricate decoration of the surrounding archway and lotus throne. In terms of refinement and artistry, these small panels are comparable to the larger votive panels

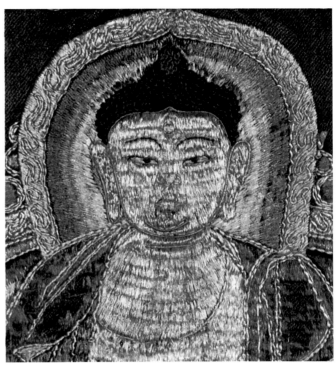

DETAIL OF CAT. NO. 13

and *thankha* of the period.[4] Adding to their significance is the immaculate state of many of these works. Although radioactive carbon 14 testing has dated certain images, including the present Virūpākśa, to around the thirteenth and fourteenth centuries,[5] the vibrancy of their colors and their virtually untouched condition belies their age.

Generally speaking, each panel is divided into three registers demarcated by borders of vine-like scrolls in gold couching. The middle register portrays an enthroned Buddha, bodhisattva, guardian king (Sk: *lokapāla*), or other deity.[6] The thrones and arches that frame the deities vary according to their status within the Buddhist pantheon. The upper registers contain the motif of the sacred umbrella, while the lower registers show encircling lotus blossoms supporting either auspicious Buddhist symbols or Sanskrit letters.

Virūpākśa is one of the four celestial guardians who governs in the West. Presiding over autumn, he is identified as a warrior seated in a martial pose and dressed in Mongol-style armor. A tiara crowns his head, and he wears arm-guards, greaves, breastplates, and boots. Celestial scarves extend from behind his armor. He wears a fierce expression on his red face, and brandishes his emblems, a serpent in his right hand and a jewel in his left.

As for the yellow-faced, crowned deity seated in the position of relaxation on a recumbent brown horse, it is plausible that this figure is Kubera, the God of Wealth and a manifestation of Vaiśravana, Guardian of the North and the chief of the four guardian kings. Here he is depicted as triumphant, holding a golden staff in his right hand and a mongoose spewing jewels (Sk: *nakula*) in his left hand, and seated on a horse and a lotus throne.

Virūpākṣa and Kubera, as minor deities, are flanked by beribboned vases with lotus flowers and archways of overlapping stylized cloud forms. In the lower registers, five-character Sanskrit inscriptions in Lantsa script are embroidered with gold couching.

The embroidered panel of Śākyamuni belongs to the same general family of textiles as the images of Virūpākṣa and Kubera. Yet in this representation of a major Buddhist deity there are recognizable differences, not only in the portrayal and iconography of the figure and in the depiction of the elaborate environment surrounding him, but also in the quality of execution, dimensions of the textile, and general condition. The panel's dimensions are larger than those representing the other Buddhist deities, thereby suggesting Śākyamuni's importance within the Buddhist pantheon and possibly within a set of textiles if the various embroidered representations belonged together. The slightly darkened surface also indicates that this panel received greater exposure than the other two.

The panel depicting the historical Buddha follows the same general composition, design, and embroidery techniques as the previous works. In the central register, Śākyamuni is depicted in a red robe and sitting in a lotus position on a lotus throne, which is placed upon a tiered, ornamented base. His right hand is in the earth-touching gesture (Sk: *bhūmisparśa-mudrā*), while his left hand, palm up, supports a begging bowl (Sk: *patrā*). An intricate archway of two columns at either side, ornamented with lotus blossoms, frames the Buddha. These columns issue from vases and extend upward to support sea creatures (Sk: *makara*) spewing jewels. Above the Buddha is a *garuda*,

a mythical half-human, half-bird creature, who grasps a stylized snake in each hand. The snakes, in turn, are intertwined with the tails of the *makara*.

In the upper panel an elaborate canopy is flanked by the sun and moon amid multicolored clouds, while the lower register depicts lotus flowers encircled by flower stems and bearing Buddhist symbols. In the central column are several of the eight Buddhist emblems—from bottom to top, the conch shell and double fish, the endless knot, the canopy, the Wheel of Law, and the umbrella. On the right, the lotus flowers bear a ritual bowl of curds, a garlanded jar, and a lute. On the left, the blossoms support a conch shell, a flower, and a jeweled disk.

The function of these panels within a ritual context remains an open question. Although it is accepted that the panels were part of larger sets, the exact groupings of these embroidered panels remain unknown. Various groupings of sixteen and twenty-four panels have been suggested.[7] Commissioned for a special monastery or given by a donor, the panels might have created a decorative scheme for an interior. Another theory holds that these textiles may form a mandala. A stylistically similar embroidered altar valance exists in the Asian Art Museum of San Francisco. This large embroidered panel with six pendants may represent the outer terrace of a mandalalike arrangement.[8]

— FY

BIBLIOGRAPHY

Francesca Galloway and Jacqueline Simcox. *The Art of Textiles*. London: Spink and Son, Ltd., 1989, 25, no. 21.

Jin xiu luo yi qiao tian gong/ Heavens' Embroidered Cloths: One Thousand Years of Chinese Textiles. Exh. cat. Hong Kong: Hong Kong Museum of Art, 1995, 118, 124, 125, cat. nos. 22a, 22g, 22h.

NOTES

1. Morris Rossabi, "The Silk Trade in China and Central Asia" in *When Silk Was Gold: Central Asian and Chinese Textiles*, ed. James Watt and Anne Wardwell, exh. cat. (New York: The Metropolitan Museum of Art, 1997), 15.

2. Dale Carolyn Gluckman, "Chinese Textiles and the Tibetan Connection" in *Heavens' Embroidered Cloths*, 25.

3. Several known panels have been cited from different sets. See *When Silk Was Gold*, 207–9; J. Keith Wilson and Anne E. Wardwell, "New Objects/New Insights: Cleveland's Recent Chinese Acquisitions," *The Bulletin of The Cleveland Museum of Art* 81 (October 1994): 344–45. In the Steinhardt Collection, there are eight votive panels, depicting Buddhist gods and guardian kings and a Buddha Śākyamuni. The Cleveland Museum of Art has a panel portraying the Seventh Bodhisattva, possibly Amitprabha. The Indianapolis Museum of Art has an image of Manjuśrī, and the Los Angeles County Museum of Art has one representing Jambhala, a Buddhist god of wealth who is closely associated with Kubera. See Patricia Berger's catalogue entry in *Latter Days of the Law: Images of Chinese Buddhism, 850–1850*, ed. Marsha Weidner, exh. cat. (Lawrence: Spencer Art Museum, University of Kansas, 1994), 245–47.

4. Valrae Reynolds, "Fabric Images and Their Special Role in Tibet" in *On the Path to Void: Buddhist Art of the Tibetan Realm*, ed. Pratapaditya Pal (Mumbai: Marg Publications, 1996), 257. *Thankha* are Buddhist paintings on cloth hung in Tibetan temples.

5. *Heavens' Embroidered Cloths*, 118.

6. *When Silk Was Gold*, 209.

7. It has been suggested that the two panels depicting bodhisattvas from the Cleveland Museum of Art and Indianapolis Museum of Art may form a set of sixteen bodhisattva panels. See *When Silk Was Gold*, 209.

8. *Latter Days of the Law*, 246; Valrae Reynolds, "Silk in Tibet: Luxury Textiles in Secular Life and Sacred Art" in *Asian Art: The Second Hali Annual*, ed. Kil Tilden (London: Hali Publications, 1995), 94.

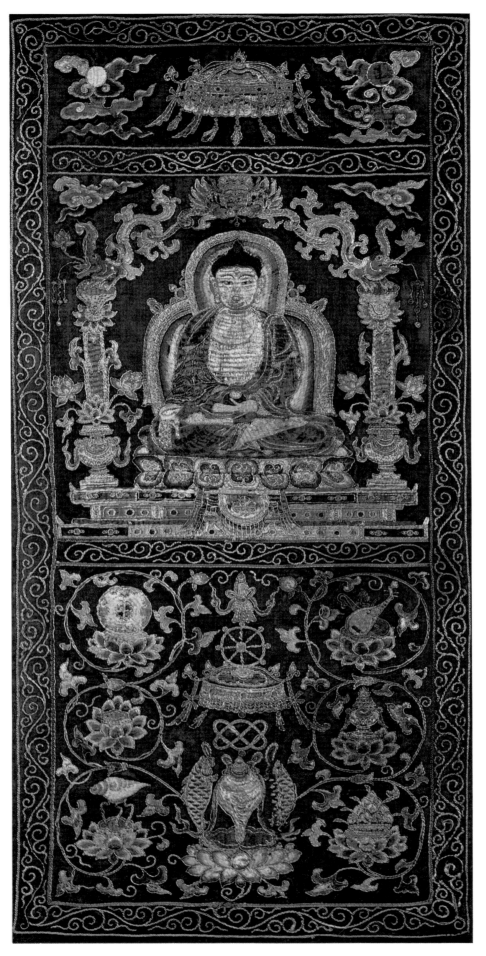

CAT. NO. 13

Fujiwara no Kamatari as a Deity

Japan, Nanbokuchō period, early 14th century
Hanging scroll; ink and color on silk
97.3 x 40.1 cm

Private Collection

A male figure in ceremonial court dress sits on an ornate stool at the center of the composition. His black outer robe falls loosely over his bent leg to reveal sumptuously decorated brocade pants. At his chest he grasps a courtier's wand, and a dress sword swings from his left hip. Below him, to the right, sits a monk wearing the costume of a high-ranking prelate; to the left, another male figure in full ceremonial court dress. The three are arranged in triad form against lush, new *tatami* matting with colorful borders.

Behind the group, framing the central figure, are thick curtains held in place with elaborate ribbons. The curtains open on an image of a pine tree with wisteria hanging from its branches. Above the curtains, in a separate horizontal register akin to a transom, hang three golden discs, suspended by cords. The painting is hieratic and posed. Its iconicity is well suited to its role as an object of veneration associated with the aristocratic Fujiwara family and their places of worship.

Iconographic analysis reveals that the central figure is Fujiwara no Kamatari (614–669), founder of the powerful Fujiwara house, and cultural hero in the early formation of the Japanese state and its religious institutions. Kamatari was instrumental to the development of the Kasuga cult in the Nara region and claimed its principal *kami* (spirit), a Shinto deity called Ame no Koyane, as progenitor of

the Fujiwara line. By the time the great shrine Kasuga Taisha had been built in Nara, in the early eighth century, two regional *kami* affiliated with the Fujiwara house—Futsunushi and Takemikazuchi—had been introduced into the cult. Subsequently the three *kami* of Kasuga Taisha were worshipped as the tutelary gods (*ujigami*) of the Fujiwara family.

After Kamatari's death, his wife memorialized him by sponsoring the construction of the Buddhist temple Kōfuku-ji, which was eventually moved to a location not far from Kasuga Taisha. The temple was further developed by Kamatari's sons Fuhito (659–720), an influential statesman in the Nara government, and Jōe, a high-ranking monk at Kōfuku-ji, as the tutelary Buddhist institution of the Fujiwara household. In 706 Fuhito instituted an annual lecture series at Kōfuku-ji in memory of his father. Called the *Yuima-e* (Yuima Assembly), it celebrated a Buddhist sutra about the wise man Yuima (Sk: Vimalakīrti) in India who debated the bodhisattva Monju (Sk: Manjuśrī) and won. In 656 a reading of the sutra, known as *Yuima-kyō* or *Vimalakīrti Sutra* had cured Kamatari of illness, and he became linked with the sutra and its wise man.

With Kamatari at its center, the painting pictorializes this narrative of Fujiwara religious practice and family deities. The monk and courtier are Jōe and Fuhito respectively, through whose efforts Kamatari was memorialized and deified. Behind the group, in the opening framed by the curtains, pine and wisteria establish yet another Fujiwara association: the surname translates as "field of wisteria," which typically grows entwined around pines. The three golden disks refer to the Buddhist and Shinto deities, often symbolized by

mirrors, that are the true forms of Kamatari, Fuhito, and Jōe. They are believed to represent the three *kami* of Kasuga Taisha.

Paintings such as this, of Kamatari with his sons enshrined against a backdrop of pine and wisteria, were used in Fujiwara memorials to Kamatari and also displayed at the *Yuima-e*. But the work is interesting for other than ritual and iconographic reasons. The painter shows us, both in style and content, the syncretism of Japanese taste under the military regimes of the fourteenth century. In a period noted for avid patronage of Chinese painting and continental Zen culture, patrons and artists continued to produce works of this type, where native gods in native dress figure in Buddhist ritual based on continental texts and prototypes. It is an amalgamation well worth our close attention as we seek to understand the crosscurrents of cultural exchange. —MHY

SACRED AND RITUAL ARTS

Kasuga Deer Mandala

Japan, Muromachi period, 15th century
Hanging scroll; color on silk
73.7 x 33 cm

Hiroshi Sugimoto Collection

The picture is striking for its elegant simplicity and for the fine craftsmanship with which the forms are presented. The deer strides with delicate precision along a cloud at the lower register of the painting. It turns its head back to gaze at what rests atop its back: a splendid saddle, etched with strips of gold from which rises a wisteria in full blossom. A golden disk hovers within the wisteria in a pool of yellow radiance. Above the disk stretches a panoramic view of low hills with trees in full flower beyond which the moon rises on the horizon. Above this are five gold-edged disks on whose red ground five Buddhist deities are drawn in gold and black. The painting is at once a landscape of spaces and depth, with rolling hills in the distance, and a flat surface organized by the planar forms of deer and circles.

This evocative picture of white deer and golden disk has a specific history and iconography as one of the most celebrated cult images of Kasuga Taisha, a shrine on Mount Mikasa in Nara. Established in the eighth century by the influential Fujiwara family of courtiers and statesmen, Kasuga Taisha was home to the five *kami* (spirits) who were brought to Nara as the tutelary gods of the clan. According to legend the shrine was officially founded only with the arrival on Mount Mikasa of one of the *kami*, the powerful Takemikazuchi, riding on the back of a white deer. A citation in *Kasuga Gongen genki* (Miracles of the Kasuga Deity), a fourteenth-century pictorial history of the cult, suggests that paintings of deer were used as objects of devotion as early as the twelfth century and that the deer represented Takemikazuchi.[1]

In such paintings, which became one of the principal art forms of the Kasuga cult, a complex iconography accompanies the engaging formula of deer and disk. As in this representative example from the fifteenth century, the deer signifies Takemikazuchi on two levels, as his vehicle, and as a manifestation of the god himself at his shrine. The deer also points to Kashima ("Deer Island") whence Takemikazuchi came to Kasuga, and the many deer that to this day live in herds at the foot of Mount Mikasa. The golden disk represents the Buddhist form of Takemikazuchi; as such, it signifies either the bodhisattva form of the god, Fukūkenjaku (Sk: Amoghapāśā), or his Buddha form as Shaka (Sk: Śākyamuni). In the circles along the uppermost register of the painting are more Buddhist gods, to represent the five Kasuga deities in their Buddhist manifestations. The rolling hills with their groves of flowering trees picture Mount Mikasa as the beautiful landscape it remains today. And the wisteria symbolizes the Fujiwara family — whose name means "field of wisteria" — and their role in the founding of Kasuga Taisha when Takemikazuchi came from afar to protect the clan.

A painting like this one is called a mandala because it pictorializes a body of teachings or legends in schematic form, in this case the founding of the Kasuga shrine by the Fujiwara family with Takemikazuchi the pivotal *kami* in their devotional activities. Everything about it calls to mind the indigenous visual culture of ancient Japan: the technical and formal elements that derive from court painting; the attention to landscape as a panoramic expanse framed at the horizon by distant rolling hills; the textured and opulent surface. There is also the evocative nature of the subject matter. Takemikazuchi is present in the white deer; in the empty space atop the saddle; in the golden disk; and in the fields of Kasuga that stretch to the horizon. If there is a continental component to the imagery, it is found among the Buddhist deities represented by the golden disk and the five circles. But here, too, the native and the traditional are at work in the syncretism of iconography that makes a god at once a *kami* and a Buddha.

— MHY

BIBLIOGRAPHY

Denise Patry Leidy and Robert A. F. Thurman. *Mandala: The Architecture of Enlightenment*. Exh. cat. New York: Asia Society Galleries, 1997, 122, cat. no. 45.

NOTES

1. Royall Tyler, *The Miracles of the Kasuga Deity* (New York: Columbia University Press, 1990), 188–89.

Mountain Spirit

Korea, Chosŏn dynasty,
late 18th–early 19th century
Framed hanging scroll; ink and color on silk
85 x 99 cm

Private Collection

Korea is a country defined by mountains, physically and spiritually. From the earliest times, mountains have been worshipped; a formation myth of Korea reveals that even by the third century BCE, they were seen as supernatural beings. The choice of a mountainous locale for most Buddhist temples can, among other things, be associated with the reverence for mountains and their connection with the divine.

Initially, the mountain itself was represented as a divine image. This identity was later transferred to the image of a tiger, a powerfully symbolic animal and inhabitant of the high terrain. Eventually, the deity of the mountains was symbolized as an old man accompanied by a tiger, known in the Shamanist pantheon as the Mountain Spirit or *sanshin*.

As a Shamanist deity, the Mountain Spirit embodied abundance and fertility. When integrated into Buddhism, he took on a new meaning as a patron spirit who brings babies and grants protection from misfortune. Most Korean Buddhist temples have a separate shrine containing images dedicated to the local Mountain Spirit.

The Mountain Spirit would typically be shown in the guise of an old man with a white beard, flanked by a tiger. In temple images, he might be shown with altar attendants. The Mountain Spirit always appears seated as a judge or king, with a *jui* scepter or other symbol in his hand. A striking palette of red, blue, and green pigments is also typical.

This large and impressive image is an unusually fine depiction of the subject: within the familiar iconography of the Mountain Spirit, the artist has sensitively represented a refined portrait of an old man and a tiger. The seated sage in red robes and official cap dominates the remote mountain landscape conveying the auspicious nature of his dwelling. The tiger assumes an exaggerated pose, commonly seen in folk paintings (*minhua*) and other Korean works of art. The attentive portrayal of detail in facial features and the refinements of the costume and undergarment, juxtaposed with the bold brushwork picking out the tiger's form and bulging yellow eyes all contribute to the elegance and power of this painting.

Although there are many recorded references to the Mountain Spirit since ancient times, the date of its initial representation in painting is not known. However, it is believed that Korean Buddhist temples began to have special shrines for this deity beginning in the eighteenth century, and most extant paintings of this type date from the nineteenth century. A Mountain Spirit image in the temple museum of Eunhae-sa in North Kyŏngsang province, created in 1817 according to its inscription, is considered the earliest dated painting of the subject. Most of the Mountain Spirit paintings are unsigned, and are the works of monk-artists of Buddhist temples. Although these paintings were outside the mainstream practices of Confucianism or traditional Buddhism, they are significant to an understanding of the religion of the general populace of the late Chosŏn dynasty. —HW

BIBLIOGRAPHY
Robert Moes. *Auspicious Spirits: Korean Folk Paintings and Related Objects.* Washington, D.C.: The international Exhibitions Foundation, 1983, 72, cat. no. 23.

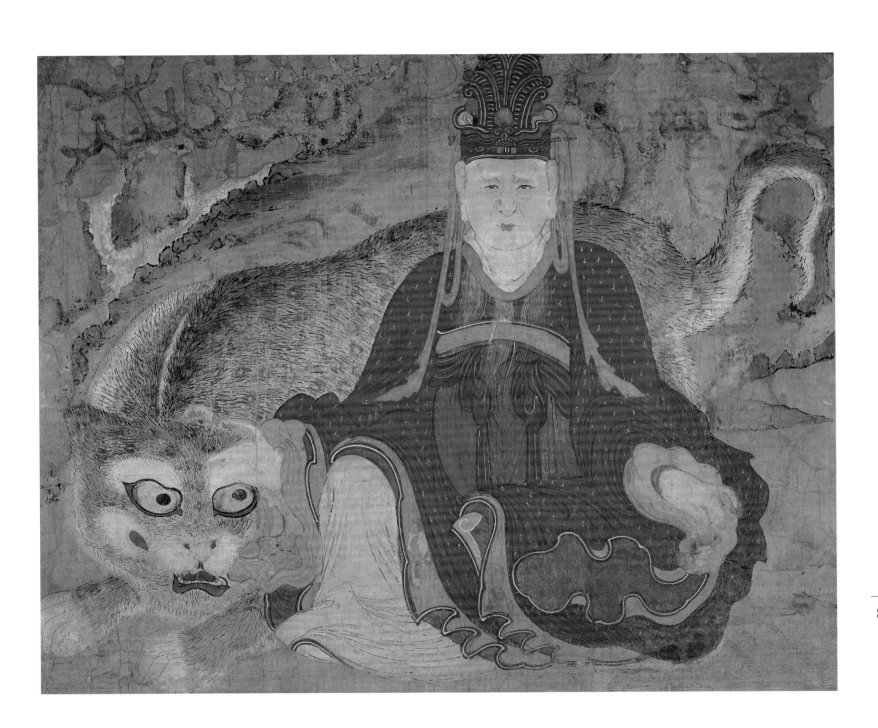

Guang

(ritual pouring vessel)

China, Shang period, 13th century BCE
Bronze
length: 27 cm

Private Collection

Elaborate bronze vessels have played an important role in defining China during the Shang period. Taking the form of food and wine containers, these bronze objects were integral to the rituals related to ancestor worship. The sheer quantity of bronzes interred in Shang tombs indicates the significance of ritual among the Shang people and the general social organization to accommodate this demand. The consummate handling of cast bronze and the diverse and complex imagery of the vessels also conveyed sophisticated technological achievements and aesthetic sensibility. In addition, archaeological material and historical sources regarding Shang ritual bronzes often expressed issues of social status and political power, as these precious vessels were emblematic of the strength of the ruling class.

This extraordinary *guang* is a testament of monumentality in both form and surface design. Its function as a wine-pouring vessel is visually subsumed by its powerful sculptural qualities. The head of a tiger, with protruding eyes and toothy expression, shapes the front of the elongated lid, while the face of a wide-eyed, horned bird constitutes the back. While their heads are sculpturally represented in the cover, the bodies of these two animals are defined in shallow relief by the shape of the vessel. The tiger's powerful body sweeps down on each side of the vessel, ending with an upturned tail and folded hind legs at the base. The bird's body covers the vessel's back, with its wings as

particularly dramatic features. Attached to the bird's chest is a loop handle topped with a stylized squat-nosed animal head. Spirals, scales, and various curves decorate the tiger and bird. Square *leiwen* (thunder-pattern) motifs cover most of the space between the two creatures and are intermittently interrupted by bodiless *kui* dragons and stylized birds in relief. A pictogram with four footprints is engraved in the center of the vessel's interior. Possibly a clan sign, it consists of the character *ce* (register) and is interpreted as "footprints around a sanctuary in which two hands are offering important documents."[1] The patina has a mottled green color.

Among the large repertoire of ritual bronze vessel types, the *guang* has a relatively short existence, first appearing at the late-Shang capital of Anyang at about 1200 BCE, and lasting only into the Western Zhou period. This vessel belongs to a small group of particularly rare and early *guang* with well-integrated tiger and owl motifs that have been associated with Anyang.[2]

Later versions carried less-identifiable zoomorphic imagery and strong vertical and horizontal demarcations along the vessels' visual planes. While the exact meaning of the tiger and bird is unclear, some scholars believe the strong zoomorphic shape and decoration of this early *guang* type is a Shang response to and adaptation of animal-shaped bronzes from non-Shang cultures in the South.[3] —FY

BIBLIOGRAPHY

James J. Lally. *Early Dynastic China: Works of Art from Shang to Song.* Hong Kong: Pressman, 1996, no. 44.

NOTES

1. Lally notes a similar pictogram is found on a Shang bronze *yu* in the Cernuschi Museum in Paris. See Vadime Elisseef, *Bronzes archaïques chinois au Musée Cernuschi*, vol. 1 (Paris: L'Asiathèque, 1977), no. 48, pl. 134, with a rubbing of the pictogram on p. 172. He also refers to another in the Asian Art Museum of San Francisco, illustrated in René-Yvon Lefebvre D'Argencé, *Bronze Vessels of Ancient China in the Avery Brundage Collection* (San Francisco: Asian Art Museum of San Francisco, 1977), xv, front, with the pictogram on p. 139, fig. 18.

2. Two important comparable tiger and owl *guang* were discovered at the tomb of Fu Hao, the powerful consort of the late-Shang king Wu Ding. As sound archaeological evidence, the date for similar *guang* is around the time of Fu Hao, approximately thirteenth century BCE. Another closely related example is the *guang* in the Grenville Winthrop collection at the Arthur M. Sackler Museum, Harvard University, Cambridge, Massachusetts. See *Harvard Art Museums: One Hundred Years of Collecting* (Cambridge: Harvard University Museums, 1966), 52–53.

3. Jessica Rawson, *Mysteries of Ancient China: New Discoveries from the Early Dynasties* (New York: George Braziller, 1996), 101–3.

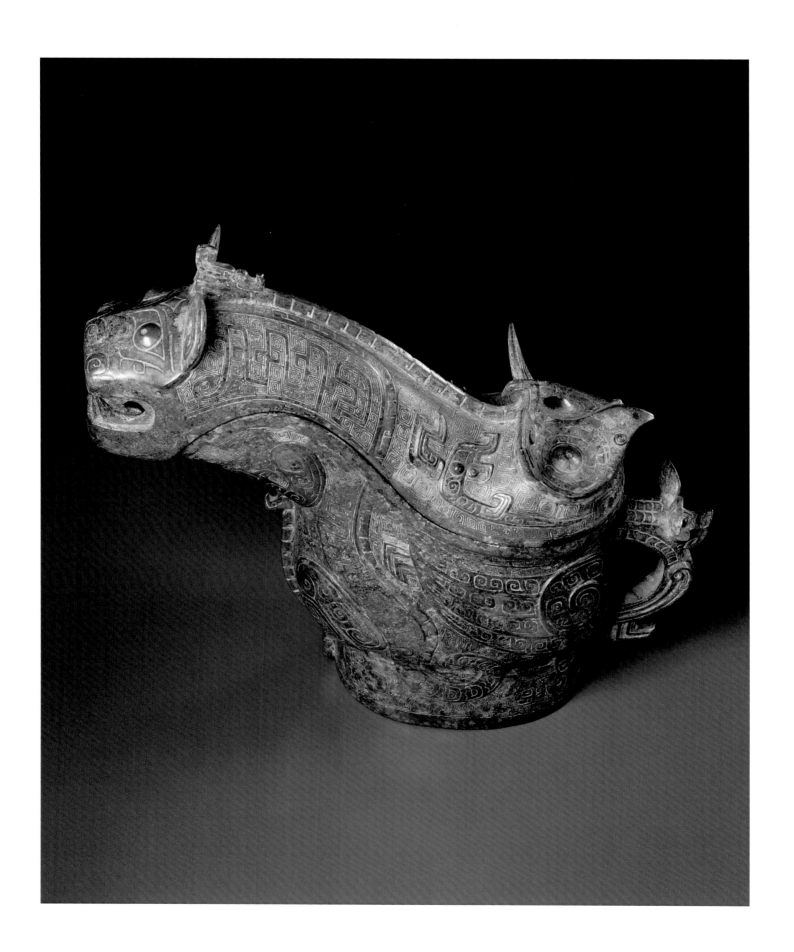

Sacred and Ritual Arts

Gui

(ritual food vessel)

China, early Western Zhou period,
11th–10th century BCE
Bronze
h: 38.2 cm

Mr. and Mrs. Leon Black Collection

With the conquest of the Shang by the Zhou in the eleventh century BCE, ritual bronzes underwent several changes. The increase in the number of bronze food vessels and the decrease of wine vessels, as well as the need for sets of vessels as opposed to singular creations signaled changes in ritual practices. Inscriptions on bronzes became lengthier and distinctly commemorative. Often recording historical events, they were expressive of the owner's social and political accomplishments. A great variety in ritual bronze designs also characterized this period, drawn from a wide range of sources—the preceding Shang tradition, the remote past, regional variations of Shang styles, and designs developed in Sichuan and the South.[1] Such heterogeneity is evident on many levels, across sets of vessels and within individual objects. Particularly distinctive in early Western Zhou bronzes is a bold, exaggerated style which Western specialists have described as grotesque, baroque, flamboyant, or transitional.[2]

During the Western Zhou, *gui* and *ding* ritual food vessels were favored bronze types, bearing the most important inscriptions.[3] Although the *gui* shape had existed earlier in the Shang, the early Western Zhou introduced a new variation, with the round grain vessel integrally cast to a rectangular base. Previously, the base was a separate entity and not always constructed of bronze.[4] This *gui*'s commanding ritual iden-

tity is further emphasized not only by its sturdy vertical profile, created by the massive handles and the emphatically sculptural surface design, but also by a small hidden bell. Suspended from the inside of the hollow base, the bell is characteristic of several *gui* from this early period.[5]

Monumental in form and bold in expression, this vessel epitomizes the exaggerated style of the period. Perhaps the most striking feature is the delineation of the animal or monster faces, often called *taotie*, on the bowl and pedestal. Here, they take on a strong frontal appearance, embracing a representational impulse, perhaps suggesting the image of an elephant. Rounded volumes contour and integrate the features of each face. A pair of horizontal S-shaped horns sit above the well-modeled almond-shaped eyes and incised eyebrows. The curve of the upper lip, which ends in two protruding tusks, smoothly connects to the bulbous sphere of the nose. The flange that would usually divide the surface plane and *taotie* is incorporated into the design, sweeping up vertically as an elephant's trunk. Identical *taotie* motifs are presented on each panel of the high rectangular pedestal, albeit rendered in shallower relief. The truly remarkable quality of the design motif on the bowl is the seeming dematerialization between figure and ground. The *taotie* masks go beyond high relief to transform the vessel into sculpture, and may reflect the influence of bronze traditions from the South. A comparable example with a dynamic, exaggerated style and strong animal imagery is a Western Zhou *gui* excavated from tomb no. 1 at Zhifangtou in Baoji city, Shaanxi province.[6]

Equally bold in expression are the C-shaped handles, splendid in their own right, with magnificent birds in profile surmounted by animal

heads capped with upright, shieldlike horns. Rectangular pendants hang beneath, embellished with the birds' tail feathers and claws in shallow relief. This type of handle with its zoomorphic motif originated in the Shang and was widely featured in early Zhou bronzes; however, while there are many contemporaneous handles with similar bird and animal forms, the pair on this *gui* is unique in depicting entire bird forms rather than headless bodies.

The vessel has patches of green and burgundy patina. A five-character inscription on the interior of the vessel may be read "Shan Zhong made this precious *gui*." —FY

BIBLIOGRAPHY
This-Life and the After-Life: From Archaic Ritual Bronzes to Tang Mural Paintings. Brussels: Gisèles Croës, 1996, 56–61.

NOTES
1. Jessica Rawson, *Western Zhou Ritual Bronzes from the Arthur M. Sackler Collections,* vol. 2b (Cambridge: Harvard University Press, 1990), 30.

2. William Watson, *The Arts of China to AD 900* (New Haven: Yale University Press, 1995), 31.

3. Edward L. Shaughnessy, *Sources of Western Zhou History: Inscribed Bronze Vessels* (Berkeley: University of California Press, 1991), 129.

4. Rawson, 33.

5. Ibid.

6. *Zhongguo wenwu jinghua: 1993* (Gems of China's cultural relics: 1993), exh. cat. (Beijing: Cultural Relics Publishing House, 1993), cat. no. 75.

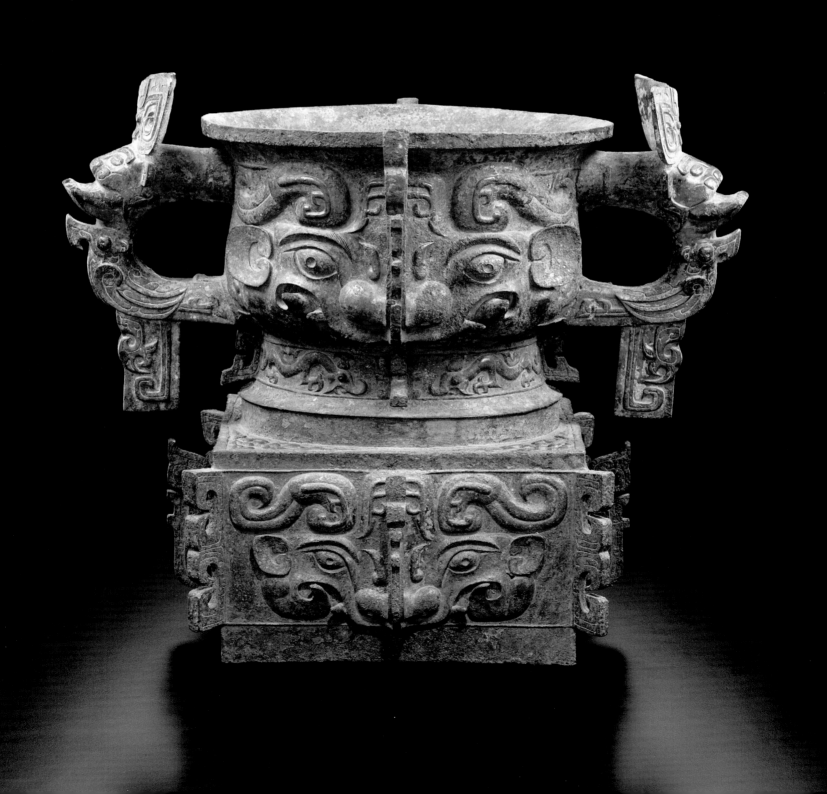

Qin Tuning Key

China, late Eastern Zhou–early Western Han
period, 4th–2nd century BCE
Bronze with gold and silver inlay
h: 15.5 cm

Shelby White and Leon Levy Collection

The rectangular plucked-string musical instrument called the *qin* is often emblematic of Confucian and Daoist notions about the function of music in early Chinese aesthetic thought. Whereas music in the moral codes of Confucianism was essential in self-cultivation, upholding the social order, and normative values, music within the Daoist tradition became a vehicle of personal expression and was the mystical link between the human world and nature.[1] The *qin* held a special position in Chinese culture and had long been associated with the scholarly elite. As a symbol of the sage or superior man, it denoted the scholar-literatus in his relationships, within the natural world or the fellowship of friends and scholars.

While the *qin* is considered one of the most ancient musical instruments in China, the earliest archaeological evidence, from the Southern tomb of Marquis Yi of Zeng in Sui county, Hubei province, dates from the late fifth century BCE. Legendary historical figures—Fuxi, Shen Nong, and the "sage king" Shun—have been variously named as inventors of this instrument, indicating the *qin*'s importance in constructing the concept of Chinese civilization. However, a recent theory states that the *qin* was first introduced through early contact with Eurasian groups in the Northwest. This conjecture derives from the portability of the instrument and the predominance of extant *qin* fittings and tools bearing Northern or Northern-inspired motifs.[2]

This inlaid bronze tuning key is one exceptional example that imparts such a cross-influence. Serving to tune the *qin* by tightening the silk strings wrapped around squared-tipped pegs, *qin* tuning keys usually have rather elaborate sculptural tops. Surmounting the cylindrical shaft of the present key are two panels cast by the lost-wax method. A marvelous low open-work relief depicts two identical combat scenes between a tigerlike feline and a large bird. The ears, round eyes, and large hooked beak identify the bird as a raptor, a recurring motif on Northwestern bronzes.[3] However, the raptor is usually portrayed as the predator, not the prey depicted in this tuning key. A stylized elegance underlies the brutal display of the victim, the bird's sinuous body elongated and twisted to frame the teardrop shape of the handle and its beak open along the shaft. The tiger, standing on the bird's back with jaws sunk into its neck, gracefully echoes the coiling contortions of its victim.

Inlaid gold and silver defined the minute features and details of these two magnificent creatures and the geometric patterns that occupy the rest of the key. Touches of the precious metals remain, primarily in sections of the decorative registers of the key shaft and top. Such refined applications indicate the original richness of the surfaces and the status of this tuning key as a valuable luxury item.

Like the *se* peg (cat. no. 20), close comparison may be made with a set of tuning keys found in the second-century BCE tomb of the King of Nanyue in Guangzhou, Guangdong province.[4]

There is a general similarity in the overall shape and decorative motif of an open-mouthed coiling animal; the only distinct differences are the use of inlay on the present key and its depiction of a animal combat scene as opposed to a single coiling dragon. Earlier examples of bronze tuning keys with zoomorphic imagery have close associations with China's Northern borders, but are products of dynastic China rather than artifacts of the Northern steppes.[5]

—FY

NOTES

1. Kenneth J. Dewoskin, "Early Chinese Music and the Origins of Aesthetic Terminology" in *Theories of the Arts in China*, ed. Susan Bush and Christian Murck (Princeton: Princeton University Press, 1983), 192.

2. Emma C. Bunker with Trudy S. Kawami, Katheryn M. Linduff, and Wu En, *Ancient Bronzes of the Eastern Eurasian Steppes from the Arthur M. Sackler Collections* (New York: The Arthur M. Sackler Foundation, 1997), 293.

3. Jenny F. So and Emma C. Bunker explain this motif through their exhibition catalogue on China's Northern frontier. They also refer to several archaeological excavations in far Northwest China. See So and Bunker, *Traders and Raiders on China's Northern Frontier*, exh. cat. (Washington, D.C.: Arthur M. Sackler Gallery, 1995), 121.

4. *Xi Han Nanyue Wang mu* (The Western Han tomb of the King of Nanyue), 2 vols. (Beijing: Wenwu Chubanshe, 1991), 93, pl. 47.1, fig. 62.1.

5. Bunker et al., 293, cat. no. 267. For more examples see So and Bunker, 148–50, cat. nos. 70, 71.

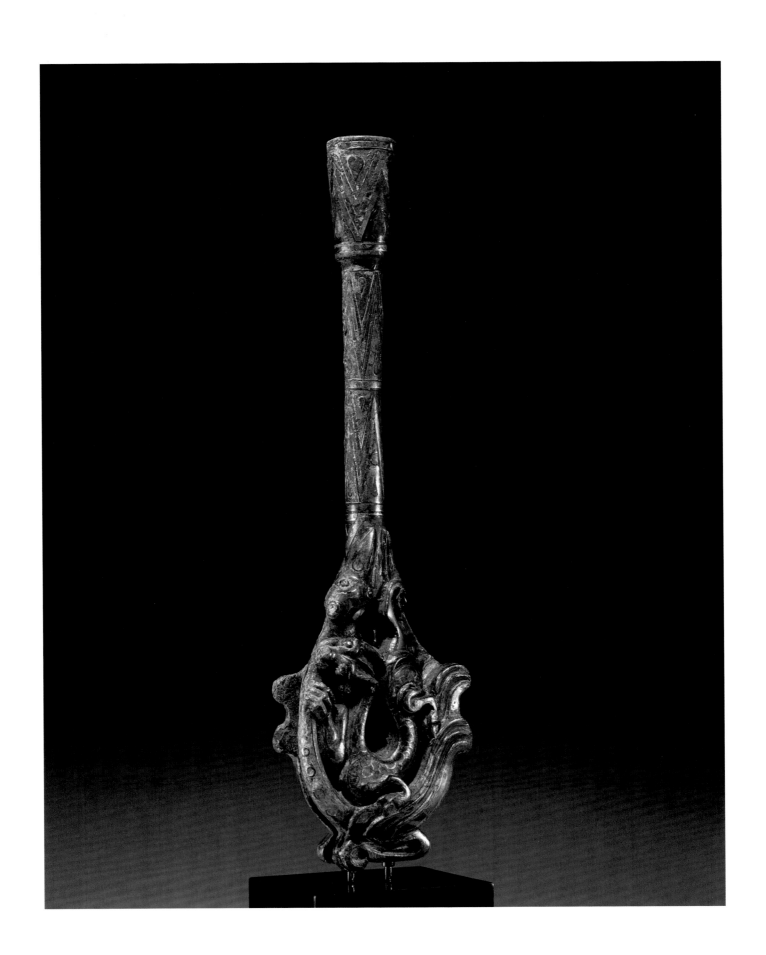

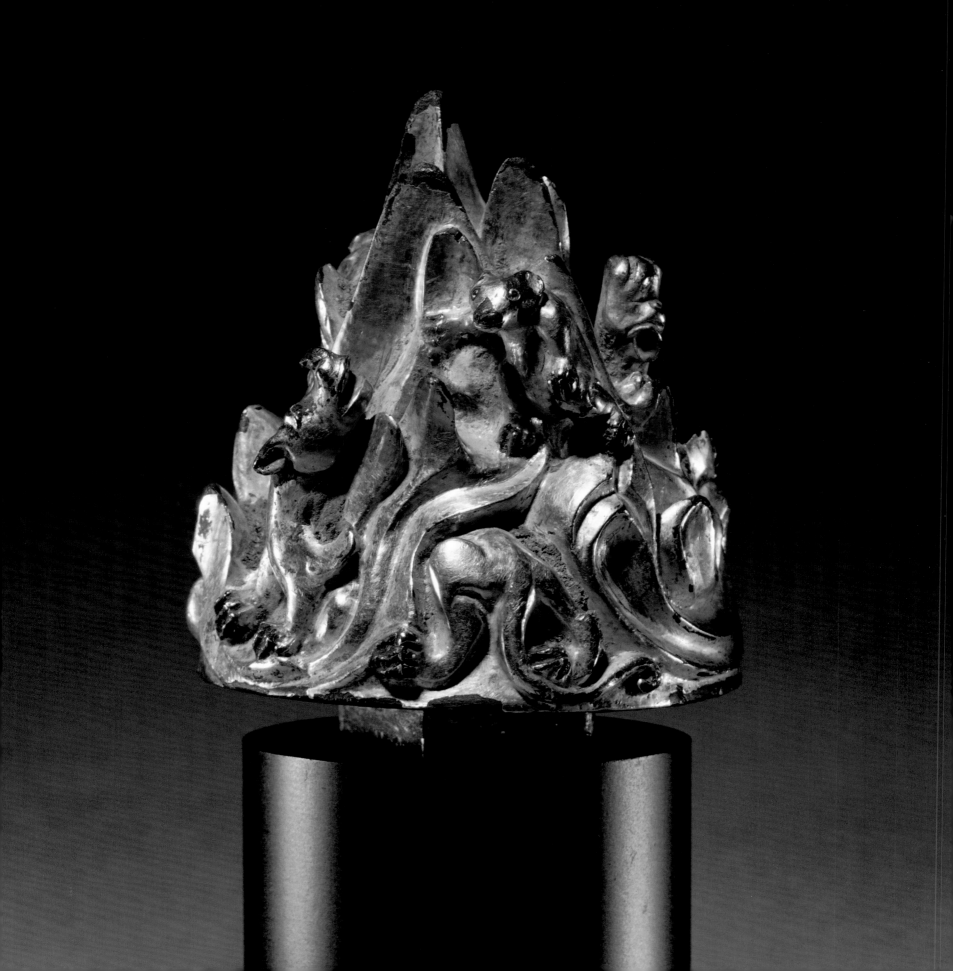

Se Peg

China, Western Han period,
ca. 2nd century BCE
Gilded bronze
h: 9.8 cm

Shelby White and Leon Levy Collection

Representations of mountains or mountain landscapes pervade the visual arts of Han-period China in an abundance of forms, media, and contexts. From as early as the late Zhou period, the theme of the mountain was invested with complex beliefs about the afterlife and the search for immortality.

Two mythical sites where immortality could be sought were the Penglai Island in the Eastern Sea, denoted by three mountain peaks, and Mount Kunlun in the West, believed to be an intermediary space between heaven and earth. Such mystical landscapes were inhabited by auspicious animals living in harmony with their environment, as well as immortals with the key to eternal life. Moreover, these places were said to be covered with mystical cloudlike forces called *yunqi*. Replicas of such magic mountains, along with other representations of divine forms, were auspicious icons, and served to attract these supernatural beings to the mortal realm.[1]

This exquisite gilded bronze peg was used to secure the strings of a large *se*, a musical instrument similar to the *qin* (see cat. no. 19). It repeats the standard dome form of the magic-mountain-shaped lids that gave the hill censers or *boshanlu* and hill jars of the period their name. A hill censer cover would be perforated, allowing smoke to wreath the mountain in imitation of *yunqi*. On the peg, *yunqi* is masterfully incorporated into the design scheme,

revealing and hiding the four creatures residing on the mountain. In spite of this mountain's diminutive size, the undulating sculptural design of the crags and cliffs projects a power and monumentality, an exuberance and visual rhythm, that make this a truly outstanding work of art.

A set of four almost identical late second-century BCE gilded bronze *se* pegs were found in the southern tomb of the King of Nanyue in Guangzhou, capital of Guangdong province.[2] Close stylistic and thematic connections with these pegs are apparent in the shape of the fantastic mountain; the hollow square extension protruding from each rounded form; the motif of realistic animals in a landscape; and the use of the lost-wax method of bronze casting in creating the softly pointed peaks and swirling undercut ledges. In addition, the use of gilding is strikingly sumptuous, emphasizing the pegs' value and status as luxury items. The gilt covering the White and Levy peg is exceptionally well preserved.

Musical instruments have long been associated with funerary culture in China. Evidence of interred stringed instruments, such as *se* and *qin*, exists as far back as the late first millennium BCE. Pegs on early *se* were frequently carved from wood, while examples have been found in cast bronze from the second century BCE. The most popular motifs decorating such pegs —the image of a crouching bear and the mountainous landscape with animals—have strong associations with art of the North.[3] The pegs discovered in the King of Nanyue's tomb prompt questions about the origin of this specific form and object. Since objects from near and distant places have found their way to this Southern tomb, queries about

regional styles, transference, and impact arise. If the motif is Northern in origin, to what extent are the pegs products of artistic traditions beyond the Northern border of China, or are they representative of a Chinese interpretation of a non-Chinese model? As suggested in relation to the *qin* tuning key (cat. no. 19), the Northern motifs on fittings or implements for the *qin* and *se* may be related to Northern traditions, but were produced in dynastic China.

—FY

NOTES

1. Wu Hung, "Beyond the 'Great Boundary': Funerary Narrative in the Cangshan Tomb" in *Boundaries in China*, ed. John Hay (London: Reaktion Books, 1994), 84.

2. *Xi Han Nanyue Wang mu* (The Western Han tomb of the King of Nanyue), 2 vols. (Beijing: Wenwu Press, 1991), 93, pl. 48.1, fig. 62.3.

3. Jenny F. So and Emma C. Bunker, *Traders and Raiders on China's Northern Frontier*, exh. cat. (Washington, D.C.: Arthur M. Sackler Gallery, 1995), 150–51.

Female Dancer

China, Tang period,
ca. 7th century–early 8th century
Molded earthenware with polychrome
pigments and traces of gold
h: 38 cm

Mr. and Mrs. Leon Black Collection

Dance has an ancient history in China. Inextricably tied to music, it was a significant aspect of formal ritual and ceremonial life, as well as the culture of popular entertainment. During the Tang period, when there was an atmosphere of cultural openness, music and dance performances that embraced the sights and sounds of Central Asia were extremely fashionable. Poetry and literary records of the time reveled in the exoticism and splendor of the performing arts, describing in vivid detail the talents of musicians performing imported tunes, or young female dancers from the Central Asian kingdom of Sogdiana whirling on rolling balls.[1] Ceramic models and imagery in Tang tombs visually re-create the colorful and festive entertainments appreciated by the Tang court as well as the public at large. These images of entertainers served to extend the grandeur of the visible world into the afterlife and provide us a glimpse of China as a dynamic cosmopolitan empire.

This figure is one of a small known group of similarly attired earthenware dancers excavated mainly from the Henan and Shaanxi provinces. As with the tri-color Tang horse (cat. no. 22), it is a "spirit object" (*mingqi*), which accompanied and served the deceased in the tomb, providing the amenities of daily existence for the deceased in the afterlife. This remarkable earthenware image of a slender young woman represents a type of dancer in vogue during Tang times. She wears the costume of a Central Asian dancer: a long skirt, tight bodice, deep neckline, winglike shoulder projections, tight sleeves with elongated cuffs, and a V-shaped apron with ribbonlike extensions at the sides. An elaborate, gravity-defying coiffure punctuated by two spoked loops crowns her head, flanking a bun. Although the construction and decoration of this figure is typical of the period, the detailed delineation of her attire, hairstyle, and features is remarkable. Areas of original pigment still exist on her garments, suggesting the lavish multicolored textiles of the actual costume.

Though she is dressed as a dancer, the figure's stance is somewhat static and her demeanor has a delicate, transcendent quality. The identity of the dance this figure would have performed remains unresolved. Analysis of relevant Tang texts, most notably a poem by the famed poet Bai Juyi (772–846), has suggested that this dancer is wearing the "Feather Coats and Rainbow Skirts" (*nishang yuyi*) to enact the famous dance and musical suite of the same name.[2] This dance is inseparably linked to the Tang Xuanzong emperor's (r. 712–56) prized consort Yang Guifei (ca. 713–756). However, some specialists see no connection between the dance and this type of figurine.[3] Secure evidence of the "Feather Coats and Rainbow Skirts" dance in China is elusive. In Japan, images of Tang court women wearing feathered gowns are depicted on a well-known painted screen in Shōsō-in; a dance of the same name is also preserved in Japan in the Noh play *Hagoromo* (Heavenly cloth). Whether the dance in its Japanese form is a "genuine relic or a pleasing but artificial archaism" is also difficult to say.[4] Regardless of the dance she is performing, this marvelous sculpture still has the power to move her viewers, outside of time. —FY

BIBLIOGRAPHY

This-Life and the After-Life: From Archaic Ritual Bronzes to Tang Mural Paintings. Brussels: Gisèles Croës, 1996, 122–23.

NOTES

1. Edward Schafer, *The Golden Peaches of Samarkand: A Study of T'ang Exotics* (Berkeley: University of California Press, 1963), 50–57.

2. Zhou Feng, *Zhongguo gudai fuzhuang cankao ziliao: Sui Tang Wu Dai bufen* (Ancient Chinese costume reference and materials: Sui, Tang, and Five Dynasties), (Beijing: Beijing Yanshan Publishing Company, 1987), 251–52. There are several translations for *nishang yuyi*. Stephen Owen translates it as "Feather Coats and Rainbow Skirts" which I use (see Stephen Owen, ed. and trans., *An Anthology of Chinese Literature: Beginnings to 1911* [New York: W. W. Norton, 1996], 443). Edward Schafer translates it as "Rainbow Chemise, Feathered Dress" (see Schafer, 115).

3. Shen Congwen is skeptical about the association between "Feather Coats and Rainbow Skirts" and the clothing of this type of figurine, viewing this dancing lady more as a grandly outfitted woman with a high coif. See Zhou Feng, 252.

4. Schafer, 115.

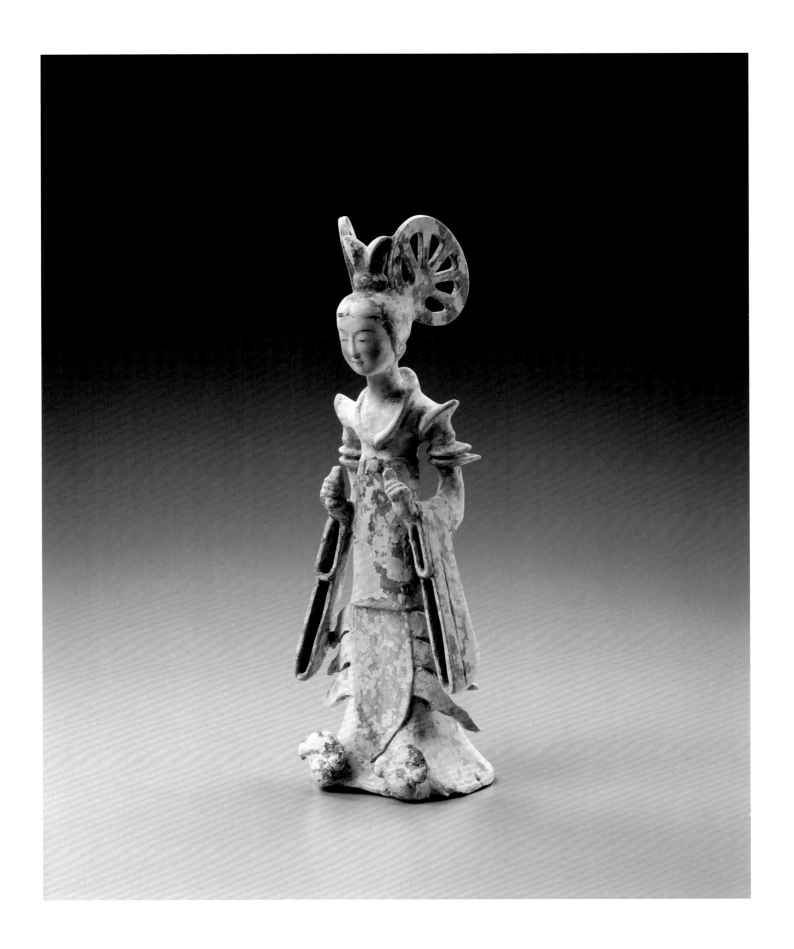

Celestial Horse

China, Tang period, 8th century
Earthenware with three-color lead glazes and
unfired pigments
h: 59 cm

Robert Rosenkranz Collection

During the Tang period, equestrian sports were popular among the aristocracy and remained their exclusive privilege by law. This beautifully sculpted horse is probably modeled after an Arabian, a breed imported in large numbers in the Han and early Tang periods. Arabian horses were believed to be descended from the blood-sweating horses of Ferghana (modern Dawan), in the area of present-day Samarkand. Legendary for their swiftness and strength, they became known in China as *tianma* (celestial horses). Posed in action, his right front hoof raised, his strong neck thrust leftward, and his eyes and nostrils aflame with excitement, this magnificent steed most likely represents one of the great horses from the West so admired by the Tang court.

Its large size, the lustrous quality of the emerald green of its glaze, and the skill of its modeling suggest that this figure was made for a high-ranking official or a member of the imperial family. Such brightly colored figures were produced for tombs in and around the Tang-period capital of Changan, known today as Xian, in Shaanxi province. They expressed the status of the deceased and were meant to provide for their needs after death: horses, camels, guardian creatures, and an array of humans—including equestrian figures of polo players, musicians, warriors, and hunters—testify to the extravagant level of court life the tombs were designed to maintain. Like the tomb figurine of a dancer dressed in the

costume of Central Asia (cat. no. 21), the Rosenkranz horse represents the taste for the exotic West in Tang court culture.

High quality three-color tomb figures such as this horse were made during the late seventh to early eighth century, production having sharply declined after the An Lushan rebellion of 755. The three-color, or *sancai*, lead glazes of the Tang period refer to the three primary colors used: green, blue, and yellow to brown, derived from copper oxide, cobalt, and iron oxides respectively. These glazes tended to run during firing, producing an effect characteristic of this type of ware. A white slip applied under the glazes enriched the overall presentation of the colors. These pieces would be given a preliminary firing and then glazed before being fired again.

The predominance of the copper oxide glaze on this horse has produced a lustrous and translucent green color overall. Additional accents of red pigment were added to the eyes and interior of its mouth, while black pigment was used around the beast's flared nostrils and eyelashes. An ochre glaze accents the hooves and mane, and drips along the creases of the horse's neck and down the contours of its flank and leg. Typical of the period was a greater attention to realism in tomb sculptures. This celestial horse, its animated power so perfectly articulated in the modeling and coloration, is a rare masterpiece of Tang tomb sculpture at its height of production.　　　　　　　　　—RAP

BIBLIOGRAPHY
Chinese Sculpture from Han and Tang China. London and New York: Eskenazi, 1997, no. 16.

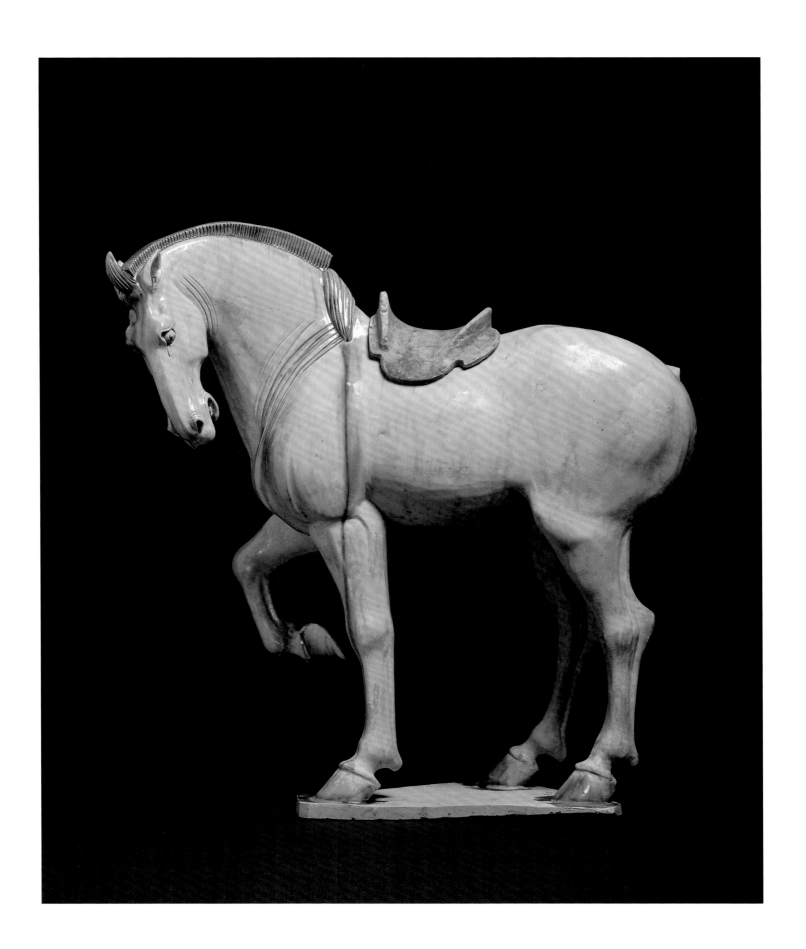

In East Asia, the literati arts and tea connoisseurship are represented by works created and collected for the delectation of an educated cultural elite. These aesthetic practices and objects integrated a wide variety of media: painting, calligraphy, and poetry in the literati arts; and the production and assembly of ceramic, bronze, and lacquerware vessels and other objects for use in the tea ceremony.

The literatus in Asia pursued the interrelated three perfections of poetry, painting, and calligraphy, ideally executed with a refinement of taste, content, and form that would reveal the personality of the artist. Ink paintings of bamboo in particular were used to display expressive combinations of the three arts. Imaginary landscapes rich in literary allusion were characteristic subjects of literati painting. Many literati eschewed courtly and decorative painting techniques, cultivating an amateur spirit in their ink painting and elevating intuition over skill. In China, and later in Korea and Japan, the qualities most sought after in painting and calligraphy were *pingdan*

(plainness) and *tianzhen* (innocence), a carefree, unstudied manner. The emulation of past masters whose works embodied these qualities was a goal of all literati artists, and an essential aspect of their training.

The illustration of classical poetry was a favorite literati subject. Among the most famous literary events depicted was the poetry contest at the Orchid Pavilion in Eastern Jin China, during which a group of sages composed extemporaneous poems while delighting in the spectacle of wine cups floating downstream. The Orchid Pavilion was a Chinese literati subject that gained great popularity in Japan and Korea as well.

Through connoisseurship, the scholar-amateur sought new means of self-cultivation and fresh ways to connect with the classical past. Celadon ceramics, for example, were appreciated for their exquisite form and color, and for their association with the highest achievements of Song-period imperial wares.

The activity known as the tea ceremony (*chanoyu*) is in many ways the ultimate outcome of literati activity in Japan and unique to that culture. *Chanoyu* derived from a Buddhist Zen (Ch: *chan*) practice, introduced from Song China, in which powdered tea leaves were whisked with hot water in a bowl and appreciated for fragrance, appearance, taste, and other sensory and aesthetic qualities. The objects and vessels required for the ceremony were selected for their intrinsic characteristics and their relationships, which could be formal, seasonal, historical, or personal. Tea utensils were antique and new, Korean, Chinese, and Japanese in origin, and sometimes created or adapted for tea use by the tea master. The evolution of *chanoyu* and the assembly of tea objects exemplify the Japanese adaptation of a Chinese tradition. —AGP

Section Two

The Literati Arts and Tea Connoisseurship

Chunhua Pavilion Copybook

China, Northern Song period, dated 993
Rubbings collected in book form,
volumes 4, 6–8; indigo ink on paper
32.2 x 22 cm each page

Robert Hatfield Ellsworth Collection

These four volumes represent great treasures of China's long cultural heritage. Traditionally, whenever a calligraphic work was deemed important it would be immortalized, either on stone in a stele, or as rubbings in a copybook.

The method of creating copies of original calligraphy written on paper or silk through rubbings was developed so that a style of calligraphy determined to be unique and important could reach a larger audience interested in studying and perhaps copying that style. The process involved several steps. First, the original calligraphy was transferred to a stone or wooden slab and then engraved to match the original. Then a sheet of paper was set onto the carved surface and ink applied to it, leaving the carved or recessed areas as white (as in the rubbing technique now used with crayons to copy tomb engravings). The writing appears white against the inked background. The technique is the reverse of the process used in making a woodblock print book. This method was believed to most closely duplicate the original work.

As the impressive collection of imperial seals and inscriptions attest, this text was compiled and published during the eighth month of 993, during the Chunhua period (990–95) of the Taizong emperor's reign (r. 976–99) in the early Northern Song period. Known as the Chunhua Pavilion Copybook or Rubbings Collection, it established the calligraphy of Wang Xizhi

(321–379) and his seventh son Wang Xianzhi (344–388) as the preeminent masters in the history of Chinese calligraphy. Wang Xizhi was considered a master of every form of calligraphy from regular script to the cursive flying white, with his most famous semi-cursive work being the *Orchid Pavilion Preface*. The legendary gathering in the fourth century of Chinese sages at the Orchid Pavilion is one of the most venerable subjects of painting in East Asia, as illustrated by Nakabayashi Chikutō's hanging scroll (cat. no. 30).

The majority of the Wang family's cursive and semi-cursive work was in the form of epistles which were handed down as copybooks or collections of rubbings, and it is primarily these epistles that are recorded in this text. The publication of the copybook, although extremely limited, and the copies made soon after its original issue, caused the two Wangs to become widely known. The study of calligraphy at the time required ownership and close scrutiny of the work of these two masters; research and critical analysis of the copybook has continued unabated since their creation.

In the late Ming and early Qing periods, the calligraphy of the two Wangs, and in particular this text, were again brought to the forefront in what became known as the *tie* (copybook) school, in contrast to the opposing *bei* (stele) school. Both schools looked back to the earliest writing styles of the Han through Six Dynasties periods in order to revitalize their own calligraphic traditions. The *tie* school collected, collated, and published primarily the writings of calligraphers from the Jin (265–419) and Tang periods. These copybooks were used for study and the basis for their calligraphic styles. The *bei* school collected and studied inscriptions

from bronze implements and stone steles from the Han and Tang periods. Members of this school often visited the sites where these steles stood to accurately assess the calligraphic nature and subtle qualities. Both forms of recording important calligraphy were used throughout China's long calligraphic history.

The first significant members of the *tie* school were the seventeenth-century calligraphers Wang Duo (1592–1652; see cat. no. 24) and Fu Shan (1607–1684). Wang Duo in fact owned this very set of three volumes and made a special box, which still accompanies the set, in which to store them. These same volumes 6, 7, and 8 now in the Ellsworth collection are considered the only known volumes still in existence from the original set published in the tenth century. In the history of East Asian calligraphy collection, this is perhaps the most highly prized set of *tie* volumes of all time. —RAP

BIBLIOGRAPHY
The Chunhua Pavilion Copybook and Rare Rubbings from the Collection of Robert Hatfield Ellsworth. Exh. cat. Beijing: The National Palace Museum, 1996.

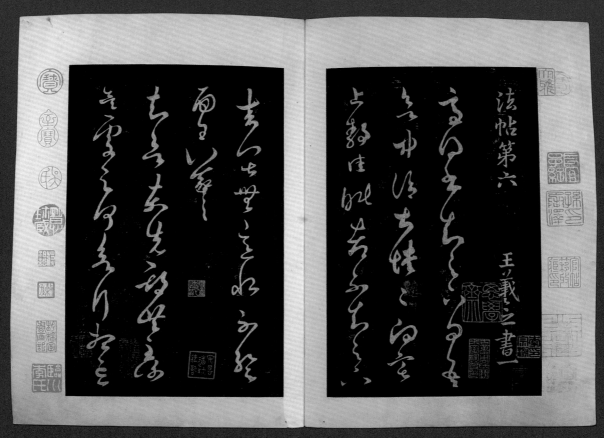

VOL. 6, PP. 1–2

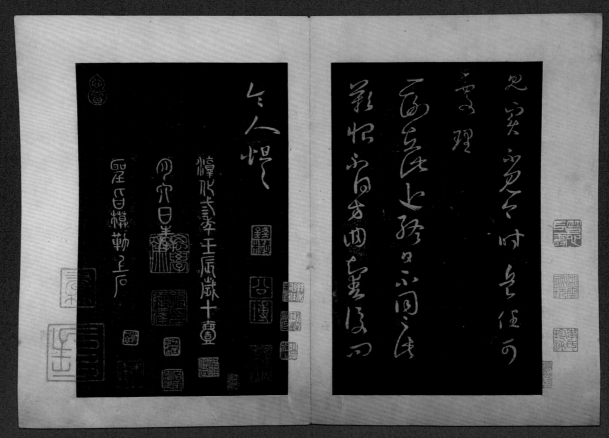

VOL. 6, PP. 5–6

VOL. 8, PP. 5–6

豫章黃太史謂古人作蘭亭叙孔子
廟堂碑皆作一淡墨本盖見古
用筆廻腕餘勢若深墨本但得筆
中意爾觀淳化法帖用潘谷墨作蟬
翼本筆下鋒鍔隱見有若真蹟誠
可寶玩也淳熙癸夘八月晦金華王淮
書于左府之東軒

VOL. 8, INSCRIPTION AND SEALS

On Calligraphy

Calligraphy, considered the highest form of expression in the visual arts of East Asia, can be appreciated on many levels. Fundamentally, it may be viewed as words, as each character signifies a meaning. That meaning can be elevated through the medium of a poem, correct in rhyme and meter and conveying sense through content and form. At still another level, calligraphy represents a visual, aesthetic expression of brushwork, in rhythms and relationships of space created by ink and paper.

To a Western audience, the appreciation and comprehension of Chinese calligraphy may seem daunting. There is the perception that if the meaning of the actual characters is not understood, then something essential to the work will be missed. But this is not necessarily the case: much more fundamental and universal elements can be realized. The spatial tensions and movement of the brush in calligraphy should be viewed as a presentation of forms in a particular time and space: an art with infinite expressive possibilities. To distinguish style, one looks for the different ways elements may be combined in a search for a new effect. A calligrapher demonstrates his virtuosity with the brush by expanding the known visual vocabulary of a character.

In terms of form, each stroke is traditionally observed for itself and how it relates to connecting strokes when combined in a specific order that composes each character and in turn, each line of prose or poetry. This prescribed order should in fact imitate some of the fundamental aspects of nature and create a natural balance in the character. Every stroke may be seen as an extension of nature's forces. There can be no hesitation in the brushwork as,

DETAIL OF VOL. 6, P. 1

in a unique moment of creation, the artist is caught up in the emotion and not consciously thinking of the calligraphy. A viewer can re-create every movement of the brush and mentally follow the actual process of creation in all its consecutive phases. One has the sense of actually watching the calligrapher performing. This is why it is said that the personality of the calligrapher is revealed through his calligraphy.　　　　　—RAP

WANG DUO (1592–1652)

Calligraphy of Tang Poems

China, Ming Period, dated 1641
Handscroll; ink on paper
28.5 x 479 cm

H. Christopher Luce Collection

Wang Duo, Ni Yuanlu (1593–1644), and Fu Shan (1607–1684) are considered the three most important innovative calligraphers of the seventeenth century. Wang undertook the serious study of China's greatest calligraphy masters, from Wang Xizhi (321–379) to Mi Fu (1051–1107) to Dong Qichang (1555–1636). His work on the fourth-century master calligrapher Wang Xizhi and his son Wang Xianzhi (344–388) was so diligent and passionate that he revitalized interest in these great forebears of Chinese calligraphy. His regard for the Wangs is apparent in the inscription at the end of this long handscroll (opposite, bottom), which reads:

> I use the grass-script styles of Bai Ying [Zhang Zhi, died 192], Liu Gongquan [778–865], Yu Shiji [died 618], and others to join into one style. The way of the plain and rustic is merely the method of the former two Wang Family members. On the evening of the twelfth day of the twelfth month of the *xinji* [year] [1641], by night I dedicate this to my old friend. Wang Duo in his fiftieth year did this.

Wang Duo so loved the work of Wang Xizhi that he collected old copybooks or rubbings, known as *tie*, as the only available examples that most closely resembled the original work of this master. Wang was one of the important founders in the seventeenth century of the so-called *tie* school of calligraphy, whose studies centered on these copybooks, and whose influence grew in the late seventeenth and early eighteenth centuries. Wang Duo owned the only three extant volumes of *tie* from the original tenth-century set of the *Chunhua Pavilion Copybook* (now in the Ellsworth collection; cat. no. 23).

Wang Duo produced his greatest work in the cursive running script (*xingshu*) style. This scroll is an excellent example of the master's mature work in *xingshu*. His ability to create a continuous stream of characters with a sophisticated use of thick and thin or slow and fast brushwork, along with his balance of light and dark ink indicates the brush of a master calligrapher. His work flows like music, not a single note at a time, but as entire measures pouring across the paper. Each line appears as a string of characters that stops only with the end of the paper, and continues in this way across the entire handscroll. To maintain such intensity and sophistication through a scroll of this length requires great mastery of technique and style. Throughout East Asia, Wang Duo's calligraphy was greatly appreciated for its distinctive style; in Japan, it was admired for its perceived quality of "awkwardness."

The text consists of five poems, each consisting of four couplets with five characters per line; they were composed during the Tang period, considered China's golden age of poetry.[1] The detail opposite, top, illustrates a poem by

Liu Zhangqing (ca. 710–787) entitled "To the North of Muling Pass, Meeting Someone Returning Home to Yuyang." The poem may be translated:

> I happened upon a gentleman on the Muling road,
> The horses facing the Sanggan River.
> The Kingdom of Chu, its ancient green mountains,
> Yuzhou, its cold bright sun.
> The city moat, the remains of a hundred battles,
> An old man of seventy, remnant of a family.
> Everywhere sails and poles are turning,
> Returning home, the man conceals his tears
> from sight.

—RAP

NOTES

1. Thus far only three of the set of five poems have been identified by this author (the second, third, and fifth). The one translated here is the second; the other two were written by the Tang poets Qian Qi (ca. 722–780) and Keng Wei. See *Quantang shi* (Complete Tang poetry), (Taiwan, 1981), ch. 147: 1492; ch. 237: 2624; ch. 268: 2987.

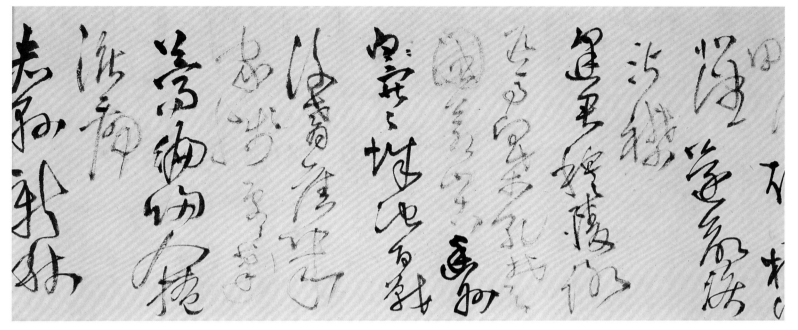

DETAIL: SECOND POEM

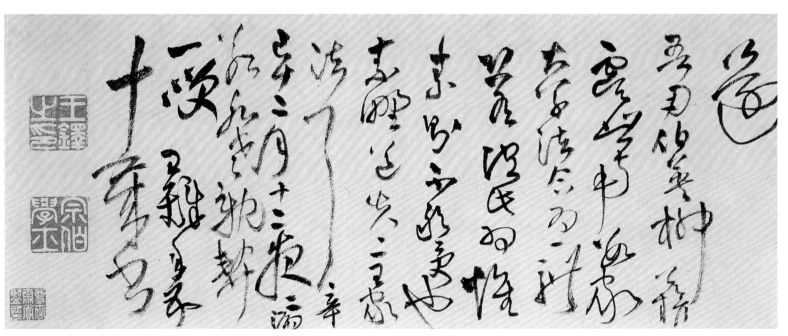

DETAIL: INSCRIPTION

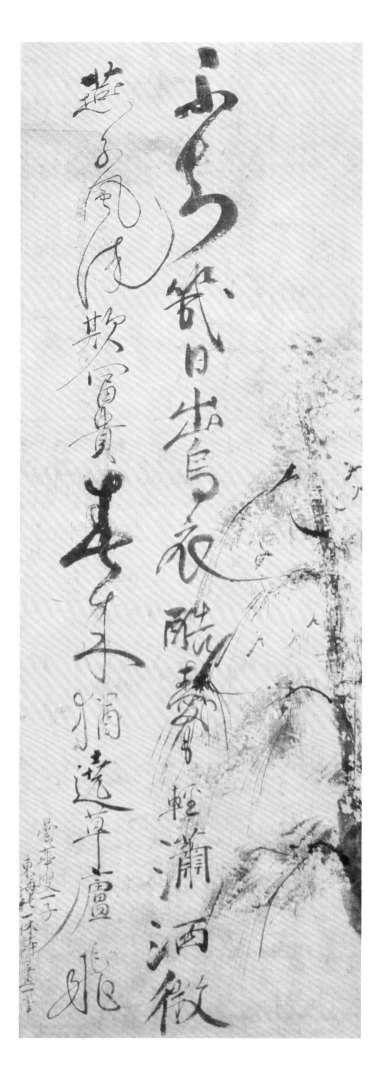

IKKYŪ SŌJUN (1394–1481)

Calligraphy with Pine Tree

Japan, Muromachi period
Hanging scroll; ink on paper
103.8 x 34.9 cm

George Gund III Collection

The impetuous brush that swiftly inscribes a poem over this scratchy image of a pine tree well represents the eccentric and unconventional man who wielded it, Ikkyū Sōjun. One of the great Zen masters of medieval Japan, Ikkyū was also an accomplished poet and calligrapher. His life, his Buddhist praxis, and his art reveal a man of uncommon independence and originality of thought, who tested the limits of convention, and, as monk and painter, left behind a remarkable legacy of intellectual and artistic commitment. The name "Ikkyū," which translates as "One Pause," is taken from a poem that describes a moment of enlightened awareness. It was bestowed on Ikkyū by the Zen master Kasō Sōdon (1352–1428) in 1418. It seems the perfect term for that powerful sense of immediacy—a quality of sudden and surprising creativity—that makes the calligraphy of Ikkyū so memorable.

Ikkyū was born the illegitimate son of Emperor Go-Komatsu (r. 1382–1412) to a lady-in-waiting from the aristocratic Fujiwara family. He was never recognized as a member of the imperial house despite an impressive pedigree. Instead, he was in effect a child of the Buddhist community. At the age of five, Ikkyū entered monastic life at Ankoku-ji in Kyoto, where he seems to have developed the independence of character for which he became renowned. By the age of sixteen, he had become critical of the Kyoto Buddhist establishment, repudiating what he

saw as its laxity, and began living an austere life at a secluded monastery called Saigon-ji. In 1415 he finally found a master that he admired, the exacting and severe Kasō Sōdon. In 1418, Ikkyū attained enlightenment on hearing a crow cry out as he was meditating in a boat on Lake Biwa on a rainy night. He scorned any certification of the event, as was the standard protocol, and instead began a mendicant life with intermittent stays at remote temples in the capital region. But in 1474, Ikkyū was called back to Kyoto, to be named abbot of Daitoku-ji, where he remained until his death at the advanced age of eighty-seven. An independent spirit to the end, Ikkyū took a lover, Lady Shin, in his last years.

Ikkyū referred to himself as Kyōun, "Crazy Cloud," and seems to have relished his reputation as a monk so eccentric as to be nearly mad. He was committed to the practice of Zen, not in the comfortable aesthetic environment of the great Kyoto monasteries, but rather in the tradition of Zen monks of old in China, who lived outside the established monastic community as enlightened men with extreme and sometimes irreverent attitudes and habits. The blunt and occasionally coarse calligraphic style that Ikkyū developed, particularly in his later years, seems to embody an impatience with the beautiful and the formally pleasing as if to obstruct, in a real Zen sense, too facile an appreciation of things. Sometimes his writing is virtually illegible, but the dynamism of his brush—seemingly slapped and dragged over the paper—provides an image beyond words of unique individuality and utter immersion in the act, a Zen act, of creation. —MHY

BIBLIOGRAPHY

Nakagawa Kazumasa, ed. *Bokuseki Ikkyū Sōjun* (Traces of ink by Ikkyū Sōjun). Tokyo: Chūō Kōron, 1985, pl. 188.

MA YUAN (active 1190–1225)

Landscapes and Poems

China, Southern Song period, 13th century
Ten mounted album leaves;
ink and color on silk
approx. 27 x 27 cm each

C. C. Wang Family Collection

Of the ten masters of the Imperial Painting Academy (Huayuan) in the Southern Song capital of Hangzhou, Ma Yuan was considered the premier painter during the reigns of the Guangzong (r. 1190–95) and Ningzong (r. 1195–1225) emperors. Ma Yuan was a fourth-generation member of a lineage of Academy artists trained in the landscape painting styles of the Northern Song, which they adapted to represent the scenery of their native Hangzhou. As in the Wang set of album leaves, Ma often combined scenes of southern China's lakes and rivers with the more mountainous vistas of northern China in panoramic landscapes. He was also fond of depicting gentlemen scholars enjoying nature in intimate settings. The work of Ma Yuan represents a turning point in the history of Chinese painting, as seen through his dense "one-corner" compositions that juxtapose sharp, angular compositional elements and vast empty spaces.

During the Song period, the joining together of words and images became popular in narrative handscrolls and sets of album leaves. The so-called three perfections (sanjue) of painting, poetry, and calligraphy, represented an ideal aesthetic synthesis in a single work. It frequently happened that a member of the imperial family would compose and inscribe a poem to accompany a painting done by an Imperial Academy artist. This is the case in the Wang album: a poem in the style of Empress Yang's

(1162–1232) kaishu (standard script) with two seals indicating that the calligrapher was a member of the imperial family accompanies each painting.

The quatrain entitled "Listening to Bamboo at the Waterside Pavilion" was written for the painting (opposite, top) of a gentleman on a bamboo-edged verandah overlooking a pond of flowering lotus:

> A light rain, xiao xiao, soaks this waterside
> pavilion,
> A flowery breeze, chan chan, breaks up the
> floating duckweed.
> Gazing at flowers, listening to the bamboo,
> my heart is without a care.
> Wind in the bamboo, that sound makes me
> awaken from a drunken nap.

Another leaf[1] and poem (opposite, bottom) bears the title "Gazing at Springtime from a Tower Terrace":

> Quiet mist, beautiful clouds, already the dew
> has dried in the sun.
> Long day, weary people, it is the time of
> apricot flowers.
> Rope swing, leisure ended, gazing from the
> tower terrace.
> The day is finished, without a breeze, the
> variegated ropes hang down.

As with each poem written to match a scene, the tone and mood in the above works are in complete harmony with their paintings. The landscape painting style and techniques of the two great masters of the Southern Song period, Ma Yuan and Xia Gui (active 1190–1230), were highly influential in Japan from the late Kamakura through the Muromachi periods, and many of their greatest works remain in Japanese collections.　　　　　—RAP

BIBLIOGRAPHY

Fine Chinese Paintings. New York: Sotheby's, 4 December 1986, lot 3.

NOTES

1. An album leaf also attributed to Ma Yuan in the Museum of Fine Arts, Boston, entitled "Viewing Sunset from a Palace Terrace" depicts a scene nearly identical to that of this leaf. See Wu Tung, Tales from the Land of Dragons: One Thousand Years of Chinese Painting, exh. cat. (Boston: Museum of Fine Arts, 1997), no. 74.

DAOJI (1642–1707)

Landscapes

China, Qing period
Twelve album leaves; ink and color on paper
24 x 28 cm each leaf

C. C. Wang Family Collection

Long ago I saw the four-word expression, "I use my method" [*wo yong wo fa*], and was delighted with it. Painters of recent times have all appropriated the style of old masters, and the critics accordingly say of them, "So-and-so's style resembles [a particular master] and so-and-so's does not." I could spit on them. Now I have come to realize that this is all wrong. In the broadest sense, there is only a single method [of painting], and when one has attained that method, one no longer pursues false methods. Seizing on it, one can call on one's own method. But in fact I do not know what the old masters' methods were, or what my own method is.[1]

Daoji is considered one of the four great individualist monk-painters of the seventeenth century. The other masters of individual expression were Hongren (1610–1664), Kuncan (1612–1673), and Bada Shanren (1626–1705; see cat. no. 58). Confirmed by the inscription above from an undated painting, his painting style is said to have been based entirely on his own ideas and executed as the spirit moved him. Much of his landscape scenery was inspired by his extensive traveling throughout China, in particular in the Yellow Mountains (Huang Shan) in the late 1660s. He was an individualist in that he broke completely from the orthodox school of painting of the mid seventeenth century. He employed a new style of brushwork and a distinct palette that included an ochre that became very popular among the literati artists of Japan.

This set of album leaves, with its spontaneity, looseness of brushwork and form, and distinctive coloration, is a fine demonstration of Daoji's acclaimed style and its innovations represent a turning point in scholar-amateur landscape painting.

Born into the Ming imperial family, Daoji was hidden away at the age of four to protect him from his father's opponents and the Manchu invaders as the Ming collapsed in the mid 1640s. In order to escape possible persecution, in his early twenties he became a *chan* (Zen) Buddhist monk. By the late 1690s, when this set of album leaves was probably done, he considered himself to be painter only, having given up his position as a monk in the same way he had forsaken his position as a so-called leftover subject, or *yimin*, of the Ming court. He retired to Dadi Tang, the Hall of Great Cleansing, a retreat he built in Yangzhou in 1696, where he lived the remaining decade of his life. His nonconformist, even anti-authoritarian life was very much in keeping with his individualist style and theories of art.

Within the context of his declaration on painting quoted above, we can understand his inscription found on the last leaf of this album. It reads: "The method [used] is no method, accordingly completed in my method. These twelve album leaves I deliver to my elder, old Daoist Yu." In this dedication to his friend Yu, whom he knew from Yangzhou, Daoji informs us that this set of paintings are in his own style. It is this very method of landscape depiction, with its free and expressive brushwork that the *nanga* artists of Japan aspired to in the eighteenth century.　　　　　—RAP

BIBLIOGRAPHY
James Cahill. *The Compelling Image: Nature and Style in Seventeenth-Century Chinese Painting.* Cambridge: Harvard University Press, 1983, pls. 6.32–6.37, color pl. 11.

NOTES
1. Cahill, 185

Landscape

Japan, Muromachi period, 16th century
Hanging scroll; ink and color on paper
87.6 x 34.9 cm

George Gund III Collection

The scene depicted is one of idyllic pastimes: scholars engaged in conversation by riverside pavilions; traveling by donkey; floating in a small skiff being ferried across the lake, bearing pots of wine for some festivities. In the distant mountains temple rooftops nest in the high peaks, a safe haven removed from the mundane world. These are familiar themes, beloved throughout East Asia.

The Muromachi period, named after a district in the great cultural center of Kyoto, was reigned over by the Ashikaga shogunate (begun in 1392). Among these shoguns, Yoshimitsu (1358–1408) and Yoshimochi (1385–1428) were great patrons of the arts, significantly influencing the culture and aesthetics of their time. It was during Yoshimitsu's reign that Kinkaku-ji (Golden Pavilion)—one of Japan's great architectural achievements—was first erected. The restraint and simplicity of that architecture was also reflected in the Noh drama of the period, most notably in the work of its greatest founder, Zeami (1363–1443).

In painting of the Muromachi period there were two major trends: ink monochromes as interpreted by Zen monk-artists such as Shūbun (1414–1463) and Sesshū (1420–1506); and the Kano school, founded by Kano Masanobu (1434–1530) and Kano Motonobu (1476–1559). Although both groups based their styles on those of Chinese masters, it is primarily the masters of the second group that are reflected in the Gund painting.

Based on Chinese landscape-painting styles, this work owes much to the traditions of the Southern Song period. The influence is shown first in the dense vertical stacking of compositional elements along the left side, in juxtaposition to the water and sky along the right. This stacking begins with the foreground pine tree as it twists and turns, carrying the viewer into the landscape; above this appears a prominent waterfall and, finally, the distant soaring mountain peaks. This compositional style, like the famous "one-corner" compositions of Ma Yuan (active 1190–1225; cat. no. 26), is also typical of Southern Song painting. Further references may be seen in the sharp and angular brushwork combined with particular inkwash techniques and color applications so characteristic of these masters. This type of image wonderfully represents the synthesis of Chinese brush techniques and a kind of Japanese stylized precision and perceptive sensory aesthetics.

There is no inscription or signature on this painting, but a seal in the bottom left corner indicates that this was painted by an artist named Judō. Very little is known about this artist except that he was from the eastern region later known as Kantō, worked in the late Muromachi period, and had been a follower of one of the lesser-known Kano masters, Kano Gyokuraku (active 1550–1590).[1] The Gund painting is the only known Judō painting in the United States; only one other known painting by him is now in a private collection in Japan.[2] His use of dull blue and beige coloration in this landscape is typical of the painters of the Kantō region, while his overall style of composition is closely aligned with the prevalent Kano landscape style of the period. The severe ax-cut texture strokes and the heavy outline of

the distinctive foreground rocks and tree trunk with exposed roots also belong to Kano-school landscape traditions. —RAP

NOTES
1. The only known reference to Judō dates from the late Edo period: Asaoka Okisada, *Koga bikō* (Study of old painting), vol. 40, rev. ed. (1904), 1738.

2. For a discussion of both paintings see Gen P. Sakamoto, "Amerika no Kantō suibokuga" (Kantō regional ink paintings in American collections) in *Kantō suibokuga no 200-nen: Chūsei ni miru kata to imēji no keifu/Two Hundred Years of Ink-Painting in the Kantō Region: Lineage of Stylistic Models and Themes in Fifteenth and Sixteenth Century*, exh. cat. (Utsunomiya: Tochigi Prefectural Museum of Fine Arts, 1998), 170.

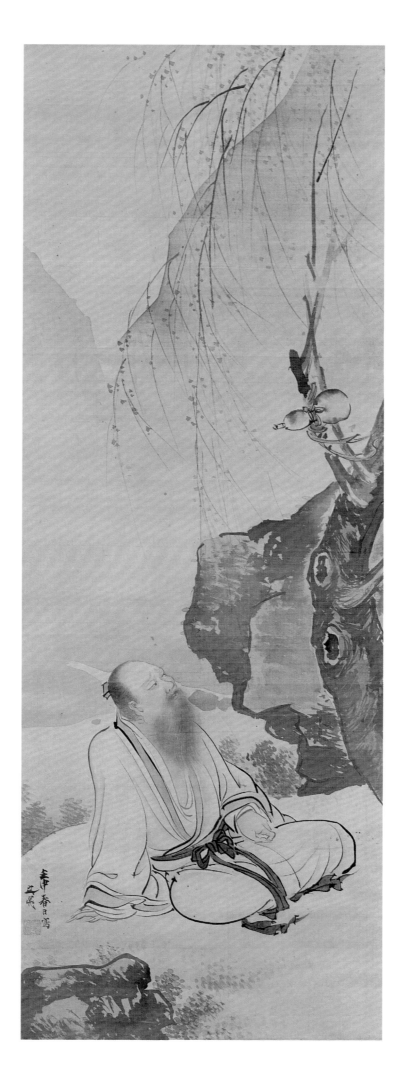

TAKAHASHI SŌHEI (1802–1833)

Bamboo Grove

Japan, Edo period, dated 1831
Hanging scroll; ink on paper
60.3 x 98.1 cm

Alice Brown and Peter Brest Collection

Traditionally, bamboo paintings in East Asian art are less about the subject than about the artist's skill with a brush: the demonstration of control and the mastery of calligraphy.

The nineteenth-century literati painting movement in Japan known as *nanga* or, sometimes, *bunjin-ga*, within which Takahashi Sōhei received his artistic and aesthetic training, concerned itself deeply with continuing a classicized vision of Chinese literati culture and tradition, especially as devised by such late-Ming practitioners as Dong Qichang (1555–1636). Calligraphy and brushwork were essential to their pursuits. Literati art and ideals, part of the nineteenth-century social and political ferment in Osaka and Edo (modern Tokyo), were practiced by a group of men and women from warrior and merchant classes who forged friendships, patronage relationships, and artistic bonds across class boundaries. Many were "intellectual entrepreneurs,"[1] authors, artists, and scholars who traveled from place to place and made their living by instructing others and selling their works, although they maintained a persona of literati removal from the world.

Tanomura Chikuden (1777–1835), Sōhei's teacher and mentor, wrote extensively on connoisseurship and the history and philosophy of art in the literati mode. In one of his treatises on painting, Chikuden wrote of his encounter with a bamboo painting by the Ming painter and calligrapher Zhang Ruitu (1570–1641) in a collection in Osaka:

> I loved his brushwork profoundly. I felt it in my soul and improvised this verse on the occasion.
>
> [Zhang's] bamboo has culms like scribe's script and grass-script leaves; the rocks are in "flying-white" strokes.
>
> The bamboo—howling at the moon and singing in the wind by a stream in the wilderness.[2]

The brushwork, described in terms of calligraphy, provided Chikuden with a link to the past; within it he felt the artist's presence and power. The value placed on artistic exchange—gifts of paintings, the writing of letters, copying paintings and calligraphy of the past, viewing collections—gave the Japanese literati movement a unique personal flavor that reflected the new interest in the individual in the late Edo period.

While we have no record of what, exactly, Sōhei saw on his travels with Chikuden, and whether or not he, too, saw Zhang's bamboo painting, we know that his training consisted in large part of viewing and copying or reinterpreting Chinese paintings and studying and composing Chinese poetry. This hanging scroll of bamboo enlivened by a light breeze along a meandering stream stands as one of his finest works.

Signed "on an autumn day in the *shinbo* year of the Tenpō era [1831], painted at Bamboo Shade Studio, Sōhei u," and impressed with three seals, one of which reproduces or is a seal of Chikuden's, this painting was probably made at a patron's villa near Osaka or, perhaps, near the artist's hometown of Chikushi in Bungo, present-day Ōita prefecture. Chikuden spent time in both places that year. The light simplicity of the brushstrokes and carefully graded tonality of the ink for atmospheric effect, suggestive of mist and shadows pooling on the water, as well as the unique close-up point of view allow us to feel as if we are really present at the making of this picture. There is an especially pleasing balance in this painting between the thick strokes made with the side of the brush that create the bladelike leaves of bamboo and the long, thin strokes made with the brush tip that slide along the paper for the stems.

—DAW

NOTES
1. Term used by David Howell in "Social Disorder and Intellectual Entrepreneurship in Late Tokugawa Japan," a paper given at the Modern Japan Seminar, Columbia University, December 1998.

2. *Sanchūjin jōzetsu* (Ramblings of a man in the mountains), cited in Hugh Wylie, "Nanga Painting Treatises of Nineteenth-Century Japan" (Ph.D. diss., University of Kansas, 1991), 82–83.

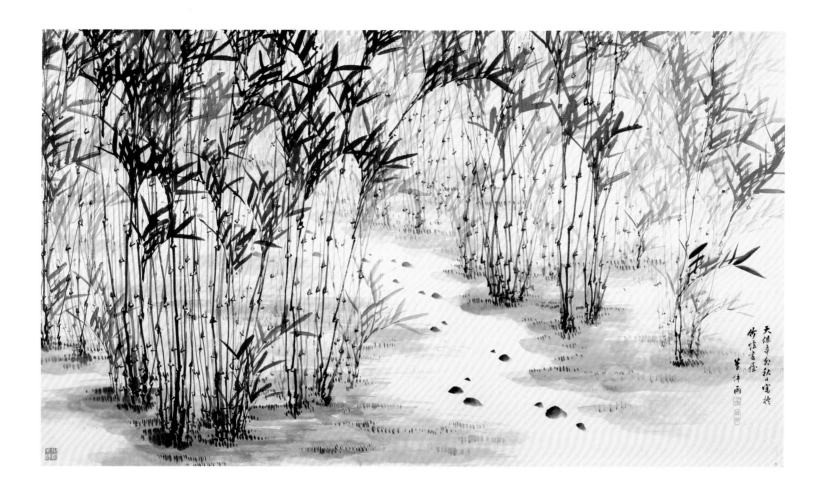

Assembly of Tea Objects (*toriawase*)

CAT. NO. 33

ATTRIBUTED TO ŌNISHI TEIRIN (died 1727)

Kettle with Willow and Cherry

Japan, Edo period, late 17th or
early 18th century
Cast iron with bronze lid
h: 20.3 cm, diam: 16.9 cm

Peggy and Richard M. Danziger Collection

CAT. NO. 34

ATTRIBUTED TO NISHIMURA DŌYA

Brazier

Japan, Edo period, mid 18th century
Bronze
h: 18.5 cm, diam: 35.5 cm

Peggy and Richard M. Danziger Collection

CAT. NO. 35

Brazier Tile

China, Ming period, early 17th century
Porcelain with cobalt pigment and clear glaze
3.8 x 31.7 x 30.5 cm

Peggy and Richard M. Danziger Collection

CAT. NO. 36

Mino Ware Water Jar named "Mino"

Japan, Momoyama period
Stoneware ceramic with Ki-Seto glaze and
lacquered wooden lid
h: 17.5 cm, diam: 14 cm

Peggy and Richard M. Danziger Collection

CAT. NO. 37

Stand for *Tenmoku* Tea Bowl

China, Ming period, 15th–16th century
Carved lacquer over wood
7.5 x 16 cm

Peggy and Richard M. Danziger Collection

CAT. NO. 38

Korean Tea Bowl

Korea, Chosŏn dynasty, second half
of 16th century
Stoneware ceramic with white slip, clear glaze,
and gold lacquer repairs
h: 7.5 cm, diam: 16 cm

Peggy and Richard M. Danziger Collection

CAT. NO. 39

Natsume Tea Caddy

Japan, Momoyama period
Kōdai-ji *maki-e* lacquer on wood
h: 7.1 cm, diam: 7.3 cm

Peggy and Richard M. Danziger Collection

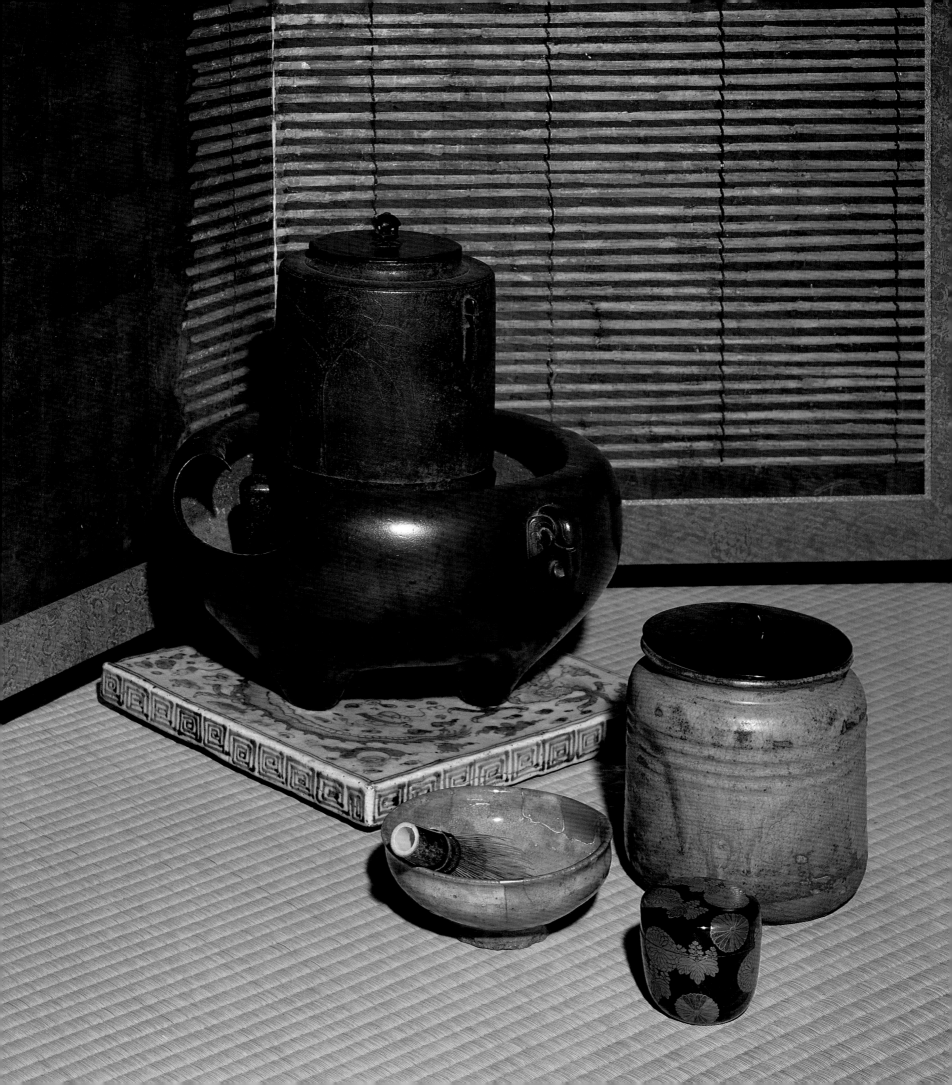

The activity known as *chanoyu*, the tea ceremony, was a central force in the process of incorporating imported objects into the realm of Japanese material culture. Most frequently, *chanoyu* is discussed in relation to the form it took during the course of the sixteenth century and particularly in terms of the philosophical underpinning of that form, centering on the concept of *wabi* (insufficiency, solitariness).[1] The dominant image is of a gathering of like-minded connoisseurs secreted in a dimly lit thatched hut set within a quiet garden to listen to the iron kettle boil, breathe in the aroma of incense, and savor the measured, introspective process whereby tea was prepared and served in treasured utensils.

Less often are we reminded that the garden's gate opened onto a busy urban thoroughfare. Beyond that gateway lay the din and bustle of international trade that affected all of Asia in the sixteenth century. Once the tea ceremony guests exited through the gate, many of them hurried off to their respective businesses, where they dealt with the raw materials and products that flooded Japan's marketplaces from throughout the country as well as from China, Korea, Southeast Asia, and even Europe. The great wealth that accrued to many Japanese of various social classes through participation in this realm of goods and gold underwrote the material and philosophical transformation of *chanoyu*, while the vast pool of foreign and local goods yielded the ceramics, lacquers, metal vessels, textiles, ivory, bone, rare woods, and other materials that greatly expanded the choices for use within the tea hut. Had *chanoyu* retained its earlier form of the fifteenth century, modeled on Chinese tea-drinking practices, the utensils would consist entirely of imported Chinese objects or close approximations made

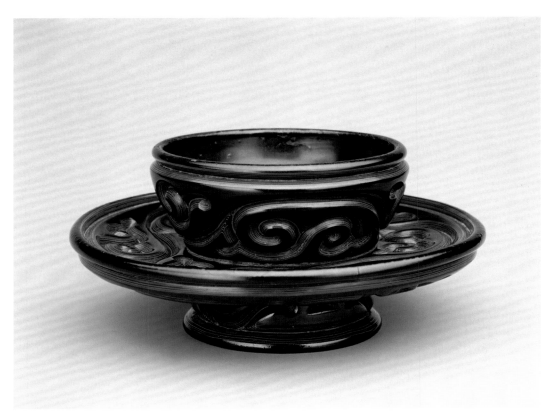

CAT. NO. 37

in Japan. Instead, as the tea utensils assembled here show, *chanoyu* matured as an inclusive universe of diverse materials and forms, giving a home to all manner of foreign goods that reached Japanese shores and stimulating production and inventions within local manufacturing centers. This splendid grouping of utensils (*toriawase*) for preparing tea, each with a pedigree of ownership and tea use since the sixteenth or early seventeenth century, will be discussed in light of the way they illustrate the powerful eclecticism of mature *chanoyu*, which created both a physical and an intellectual context for focused appreciation.

Both Chinese objects in this group were made for tea use, although the bowl stand is a form originating in China while the brazier tile was made to order in accordance with a Japanese form. The carved lacquer tea bowl stand

belongs to the older world of Chinese-focused taste. Its form, combining a hemispherical receptacle attached to a saucer resting on an everted foot, developed in China by the Tang period for use in supporting a ceramic or metal bowl of hot tea; versions made in ceramic, metal, and lacquered wood are known. The various forms of ornamentation used on lacquer bowl stands include the carved polychrome lacquer technique represented by this stand, known as *tixi* in Chinese, *guri* in Japanese. The *tixi* technique involves building up thin coats of lacquer in two or more colors over the wooden core, then carving a pattern into the lacquer surface to reveal the striped layers. On this bowl stand, a somber, lustrous black surface conceals strata of red, green, and ochre, which become visible upon close inspection within the deeply beveled curvilinear motifs. In Japanese heirloom collections of *chanoyu*

utensils, lacquered stands with *tixi* ornamentation or with mother-of-pearl inlay predominate. Known as *tenmoku-dai*, they are associated specifically with the type of black- or brown-glazed tea bowl with upright, indented rim known in Japan as *tenmoku* (see cat. no. 44). The classic form of the *tenmoku* bowl was made at the Jian kilns in Fujian province during the Song and Yuan periods, after which production is thought to have ceased. Nonetheless, Japanese heirloom collections preserve numbers of Chinese lacquered bowl stands, in *tixi* and other formats, dating to the fifteenth and sixteenth centuries of the Ming period and paired with Jian ware or other *tenmoku* bowls. Such bowls and stands continued to have an important role in the presentation of tea to high-ranking dignitaries; thus the Japanese context preserved the use of lacquered bowl stands long after they had disappeared from use in China.

Given the importance of lacquered bowl stands in the China-focused tea presentations of fifteenth- and early sixteenth-century Japan, it is not impossible that some stands were made to order in China for the Japanese market, although no documentary proof exists for such orders. The ceramic brazier stand, on the other hand, is a form specific to Japanese *chanoyu* usage.

During the summer months, instead of resting on or over charcoal placed in a sunken hearth, the metal tea kettle was placed in a metal or ceramic brazier (*furo*, or "wind hearth"), which in turn rested on a ceramic tile (*shikigawara* or *kawaraita*). As the name implies, tiles made from the same low-temperature clay as roof tiles (*kawara*) may have been the original form, but from the Momoyama period onward many

variations were produced at regional Japanese kilns. This tile probably was made to order for the Japanese market, since its dimensions exactly match the requirements of tea brazier use. A considerable body of cobalt-decorated porcelain, most notably in sets of small molded shapes suitable for use as individual serving bowls in the tea ceremony meal (*kaiseki*), was produced in China on Japanese order during the early decades of the seventeenth century, both at the commercial workshops of China's foremost porcelain center, Jingdezhen in Jiangxi province, and at kilns in southern Fujian province.[2] Evidence that such orders continued, on a much reduced scale, following the contraction of official foreign trade to Chinese and Dutch merchants operating through Nagasaki harbor, is provided by five identical *shikigawara* preserved in Japan (a sixth is in the Shanghai Museum) that bear a detailed inscription showing they were made in China in 1813 after a design provided by a Kyoto Kano-school artist.[3] This tile bears a dragon that may also be drawn after a Japanese design, since many details of the dragon—its long lower jaw and projecting tongue, and its body curled in a relaxed ring rather than tensed in an S-shape—as well as the rendering of the clouds and auspicious emblems crowding around the beast depart from late Ming conventions. The blue-gray coloration of the poor-quality cobalt pigment suggests that the order may have been filled at a private kiln near the coast of Fujian province; many wares from these kilns have been identified in Japanese heirloom collections and archaeological sites.[4] The muted color of the pigment and the sketchy, folkish painting (probably by an artist little accustomed to such detailed rendering of a dragon) were perfectly at ease, however, within the *chanoyu* framework of *wabi*.

The impact of *wabi* taste upon the selection of tea utensils from the cargoes of overseas goods is exemplified by the Korean bowl, an example of a ceramic made for utilitarian purposes but converted to a tea utensil. In this unusual instance the conversion involved not simply a change in definition but an alteration of form. A pouring spout once emerged from the wall of this wide, shallow bowl, equipping it for use in drawing off liquids—wine, vinegar, or sauce—from storage casks and transferring them to smaller serving vessels. From prolonged use, the coating of white clay slip beneath the transparent glaze has become darkened and stained, creating the cherished patina characteristic of this type of Korean ware, known as *kohiki* (powder-drawn) in Japan. Although the kitchen utensil could have been used intact as a serving vessel for the *kaiseki* meal, quite possibly an owner forcibly removed the spout and adjacent segment of the rim to create a tea bowl. The gap was filled with gold lacquer. Around the turn of the seventeenth century, this Japanese procedure for repairing tea-ceremony ceramics was exploited in a short-lived fad for intentionally breaking and rejoining pieces to make more "interesting" tea bowls. This bowl's physical alteration had taken place by the time the inscription on the lid of the wooden storage box, describing it as a tea bowl, was written by the tea master Yamashina Sōho (died 1666).

At the time that the Korean tea bowl was made, very few kilns were making glazed ceramics of comparable quality in Japan. The two primary locations were Seto and Mino, lying back-to-back on either side of a provincial border and over a vast bed of good-quality clay. The original ash-glazed, and later iron-glazed, ceramic products of the two kiln centers were closely

patterned in shape as well as glaze after Song- and Yuan-period Chinese ceramic prototypes. Toward the end of the fifteenth century, however, a change in approach began to become apparent, as a new type of kiln was introduced that enabled the Mino potters to control the firing process and aim more precisely for varied glaze effects. Mino potters developed a warmer, intensified variant of the standard ash glaze by adding a small percentage of iron-bearing clay and firing in oxidation. This rare fresh-water jar (*mizusashi*) bears such a glaze, which appeared more frequently on tea bowls in classic Chinese shapes. The jar's stable form, with broad base, massive cylindrical body, constricted neck, and everted rim, evokes the shape of a contemporaneous Chinese bronze water jar, but the undulating finger marks intentionally left by the potter pulling up the clay hint at an imminent break with Chinese tradition. Eventually the Mino glaze repertory would expand to include white, lacquer black, yellow, and copper green—the famous glazes now known as Shino, Black Seto or Setoguro, Yellow Seto or Ki-Seto, and Oribe, for which inspiration may well have come from the bright colors of newly imported Ming blue-and-white porcelain and lead-glazed tableware in shades of yellow and green. On this earlier jar, the incipient form of Yellow Seto glaze looks backward to an older prototype of glaze embodied in the thick olive-green coating of Ming-period Longquan celadon. The jar is called "Mino" (straw rain cape), perhaps because of its resemblance in glaze texture and coloration to this rustic means of protection from the rain. The lid is black-lacquered wood, following a custom established to adapt lidless utilitarian ceramics for use as water jars.

The *chanoyu* kettle (*kama*) was created through the utilization of a longstanding Japanese craft production directed to a new purpose. The technology for manufacturing utilitarian cast-iron kettles is said to have been introduced to Japan by immigrant Korean metalworkers who first settled in the vicinity of the old capital of Nara, although Chinese models also influenced some Japanese kettle shapes. Early *chanoyu* kettle production flourished in the provincial centers of Tenmyō in eastern Japan and Ashiya in the west, but in response to growing demand *chanoyu* kettles began to be made within Kyoto itself, at foundries operated by members of the Sanjō guild of metalworkers.[5] One such workshop was established by Ōnishi Jōrin (1590–1663); it continues to operate today under the direction of the sixteenth-generation master.

Tea participants who commissioned kettles from these urban workshops enjoyed the opportunity for close interaction with the metalsmiths, and Kyoto kettles became known for their innovative forms reflecting clients' personal tastes. After the political center of Japan shifted to the eastern city of Edo in 1603, many Kyoto metalworkers also established branch workshops in the new capital. The Edo Ōnishi workshop was founded by Ōnishi Gorozaemon, a son of the second master of the Kyoto workshop who took the professional name Teirin. This kettle is attributed to Teirin by a recent master of the Kyoto Ōnishi workshop, whose work includes authentication of antique kettles. Both faces of the narrow cylindrical form bear relief pictorial motifs, features associated with Teirin's style. The graceful willow tree on one side and the spray of cherry blossoms on the other are emblematic of spring, when the pale green new leaves of the willow appear at the same moment as the pink blossoms. The polished-bronze lid bears a knob in the shape of a thatched cottage, suggesting an agreeable setting in which to prepare tea while enjoying the seasonal scenery. The paired lugs, through which spiral ring handles are inserted to lift the kettle, take the form of bolts, which seemingly bear no relationship to the theme of the other decor but whose elongated rectangular shapes emphasize the kettle's slenderness.

On this kettle, the large-scale pictorial motifs standing in relief against an evenly textured ground, the sculpted imagery of the lid knob, and the graphic treatment of a commonplace object for the lugs all represent a thoroughly Japanese reworking of a form that originated on the continent. The formal elements of the brazier on which the kettle rests, on the other hand, depart little from the Chinese prototype, and the brazier's abstract simplicity provides a foil for the kettle's visual complexity. The pair of large, elephant-headed lugs echoes conventional bronze design of the Ming period, while the vessel's alloy is characterized as "Chinese bronze" in the certificate of authentication prepared by Ōnishi Jōchō (1866–1943), twelfth master of the Kyoto Ōnishi workshop. Jōchō attributed the brazier to Nishimura Dōya. Fourth head of a Nara workshop specializing in braziers, Dōya moved to the Kyoto Sanjō center and worked closely with the Omote Senke school of tea during the middle decades of the eighteenth century.

The luxuriously patterned surface of the lacquered container for powdered tea (*natsume*) represents a type of lacquer decoration unique to Japan. Such lacquered objects were among the most sought-after Japanese exports in the sixteenth century and were also created for an elite domestic market. While the *natsume* form, so named for its resemblance to the fruit

of the Chinese date, is intended specifically for tea use, the style of its ornamentation associates it with a wide variety of lacquered objects made in Kyoto in the decades before and after the turn of the seventeenth century. The lacquer style is termed Kōdai-ji *maki-e* after the site of its most dramatic and extensive use, the mortuary temple Kōdai-ji, built in 1605 in eastern Kyoto by the widow of the civil and military ruler Toyotomi Hideyoshi (1537–1598) to honor his memory. On this container the ground is lustrous black lacquer, while the *maki-e* technique of sprinkling fine metallic particles on lines or areas rendered in damp lacquer is confined to the decorative motifs, deftly irregular groupings of chrysanthemum and paulownia blossoms in stylized crestlike form. Occasional petals are rendered with reddish *nashiji* (pear-skin ground), which adds rhythmic contrast to the predominantly smooth gold surfaces. Both flowers in this crest form are closely associated with the Toyotomi family, which was finally defeated by the Tokugawa government in 1615. Other Kōdai-ji *maki-e* objects combine the crest-form flowers with naturalistic floral designs or omit them altogether. — LAC

NOTES

1. Dennis Hirota, comp. and ed., *Wind in the Pines: Classic Writings of the Way of Tea as a Buddhist Path* (Fremont, Calif.: Asian Humanities Press, 1995), 27. Outstanding recent discussions in English of the *wabi* aesthetic are Raku Kichizaemon XV, "Raku Tea Bowls: the Essence of the Form. The Evolution of Wabi" in Hayashiya Seizō, Akanuma Taka, and Raku Kichizaemon XV, *Raku: A Dynasty of Japanese Ceramists* (Tokyo: The Japan Foundation, 1997), 53–65, and Hirota, 21–116.

2. *Nihonjin ga kononda Chūgoku tōji/Chinese Ceramics: The Most Popular Works Among Japanese*, exh. cat. (Kyoto: Kyoto National Museum, 1991), cat. nos. 137–78. This publication identifies all such blue-and-white wares as Jingdezhen products, but subsequent excavations of the Zhangzhou kiln sites in southern Fujian have clarified the roles of those kilns in supplying the Japanese market.

3. Ibid., cat. no. 235.

4. The excavation of an important kiln group producing ceramics for export in southern Fujian province is reported in Fujian Provincial Museum, *Zhangzhou yao/Zhangzhou Kilns* (Fuzhou: Fujian People's Publishing Company, 1997). Finds of Zhangzhou ceramics in Japan are documented in *Gosu-akae, gosu-sometsuke, mochibana-de: Suwatō uea no sekai/Swatow Ware*, exh. cat. (Nagoya: Aichi Prefecture Ceramic Museum, 1996).

5. A short history of *chanoyu* kettle production appears in Ryōichi Fujioka, *Tea Ceremony Utensils*, Arts of Japan 3, translated and adapted by Louise Allison Cort (New York: Weatherhill; Tokyo: Shibundō, 1973), 59–71.

Hon'ami Kōetsu (1558–1637)

Calligraphy (letter)

Japan, Edo period, ca. 1615–35
Hanging scroll; ink on paper
27.5 x 44.5 cm

Peggy and Richard M. Danziger Collection

CAT. NO. 41

Raku Sōnyū (1664–1716)

Raku Ware Tea Bowl named "Surusumi"

Japan, Edo period, ca. 1691–1716
Earthenware with black glaze
h: 8.5 cm, diam: 10.2 cm

Peggy and Richard M. Danziger Collection

CAT. NO. 42

Raku Sōnyū (1664–1716)

Raku Ware Tea Bowl named "Ikezuki"

Japan, Edo period, ca. 1691–1716
Earthenware with clear glaze
h: 9 cm, diam: 8.9 cm

Peggy and Richard M. Danziger Collection

If the sixteenth century in Japan witnessed the creation, through the tea ceremony, of a new awareness on the part of urban tea participants of the affective qualities of individual ceramic objects, as discussed above in relation to the Korean tea bowl and the Mino-ware water jar, the seventeenth century opened the possibility, with the emergence of pottery workshops within Kyoto itself, of an entirely new type of engagement in the production of ceramics for tea use. Interacting with professional potters, *chanoyu* participants commissioned ceramics or even contributed to their production— whether that meant altering the form of a just-thrown vessel, adding the painted decoration, or even shaping the vessel by hand. As such vessels proliferated, a place was made in *chanoyu* usage for the work of the amateur potter, which was valued not for the proficiency of its execution but for its direct expression —however clumsy—of personal taste. Nowhere is this distinctive process better demonstrated that in the relationship between the Kyoto calligrapher Hon'ami Kōetsu and the Raku workshop of professional potters.

These two bowls made by Raku Sōnyū, fifth head of the Raku workshop, illustrate the technical qualities of the Raku tea bowl that enabled such unprecedented collaboration to take place. Both bowls were formed entirely by hand, without a potter's wheel, using a variety of metal blades to scrape and carve a thick-walled clay cylinder into a vessel with thin walls of subtly varied thickness, soft curves, and sculpted foot and lip. The subtly asymmetrical, hand-carved qualities become apparent to the person who holds the bowl to drink tea. The black bowl takes its color from ground manganese- and iron-bearing rock, the red bowl from a red clay body or from iron-bearing clay slip applied

beneath a clear glaze.[1] Use of this combination of hand-forming technique and monochrome glazing to produce a new manner of tea bowl began in the 1570s and 1580s through collaboration between a Kyoto roof tile maker of Chinese or Korean descent named Chōjirō and the tea master Sen Rikyū (1522–1591).[2] The sources of the technologies for Raku glazes are still poorly understood, although the black and the red wares apparently derive from quite distinct continental ceramic technologies, one related to procedures for producing hard-fired gray roof tiles, the other for colorful lead-glazed table wares made in southern Chinese kilns.

Rikyū's role seemingly did not go beyond verbal instruction and supervision of Chōjirō's production. Unlike the demands of wheel-thrown ceramics, however, the forming techniques used by the Raku workshop were accessible to amateur lovers of pottery, and from the early seventeenth century at the latest a unique and fruitful partnership was established between the professional heads of the Raku workshop and tea masters who wished to make their own bowls. Hon'ami Kōetsu is the first person with whom such activity can be associated, and this letter is one of several such documents revealing its exact nature. Remarkable as a surviving example of the informal jotting of a man known as one of the "three great brushes" of his era and famed for his inscription of classic court poetry on handscrolls and screens, this letter is also treasured for the light it sheds on this emerging form of collaborative artistic production.

The brief letter—perhaps more properly called a note—is dated to the tenth month, eighteenth day of an unspecified year assumed to be sometime later than 1615, when Kōetsu

CAT. NO. 40

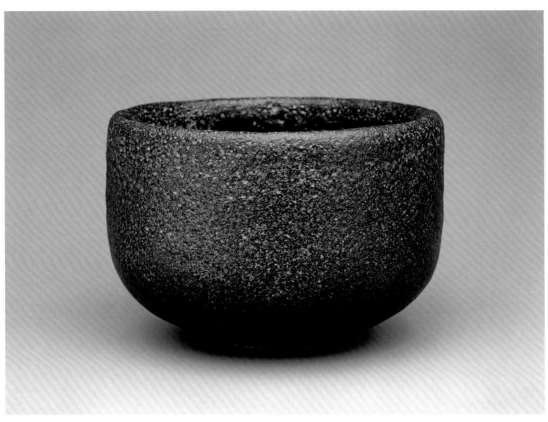

CAT. NO. 41

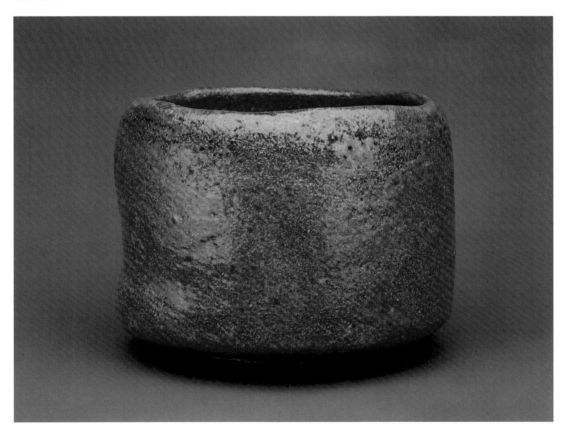

CAT. NO. 42

moved to a plot of land in Takagamine, north of Kyoto, granted to him by the Tokugawa government. The letter is addressed to the workshop staff of "Tea-bowl maker Kichiza[emon]." Successive heads of the Raku workshop used the name Kichizaemon during their tenure, although they are known posthumously by the lay Buddhist names they adopted after retirement; this Kichizaemon was the second-generation master later known as Jōkei (died 1635). The text reads:

> The tea bowls are ready!
> Your visit yesterday was most satisfying.

It can be inferred that Jōkei's assistant had gone to Takagamine the previous day to assist Kōetsu with the production of some tea bowls. Since Kōetsu pronounces the visit "satisfying," perhaps it is fair to imagine that the potters helped him to overcome some obstacles experienced in the unfamiliar process.[3] After they left, Kōetsu completed the work, then sent this note indicating that he was ready for the bowls to be picked up and taken to the Raku workshop for glazing and firing.

The note does not reveal what color the bowls were to be, but another extant letter instructs Tea-bowl maker Kichizaemon: "Supply both red clay and white clay sufficient for four bowls. Come as soon as possible."[4] The red clay could have been used to make a bowl intended for black glazing, while both red and white clay could be used for bowls that would appear red, either by applying a clear glaze directly over a red clay bowl or by using clear glaze over red slip brushed onto a white clay bowl. The writing in that letter, which is dated to the first month, sixteenth day, is similar to that of the Danziger document, so this request may have been issued earlier the same year or just a few months later. Still another surviving Kōetsu note simply requests Kichizaemon to "choose a glaze appropriate for this bowl."[5]

While Kōetsu's letters showed that he deferred on technical issues to the professional Raku workshop potters, his surviving tea bowls demonstrate his own distinctive notions of form, which in turn influenced the work of later Raku potters. The red bowl shown here by the fifth-generation Sōnyū shows the impact of Kōetsu's Raku tea bowl in its voluminous, cylindrical body with undulating, incurving rim and swelling base concealing the nearly flat foot rim. Sōnyū's black bowl, on the other hand, with its plain rim, rounded base, and neatly articulated foot rim, harks back to the prototype of such black bowls created by Chōjirō. Thus these two bowls, now boxed as a pair, represent the extraordinary collaboration between professionals and amateurs that helps to account for the Raku workshop's exceptional longevity, continuing to the present day.

The names given to the two bowls reveal a second rationale for their pairing, however, based on their glaze colors. Ikezuki and Surusumi were the names of a roan and a black horse, respectively, which figure in a famous episode from the wars of the twelfth century. The two mounts had been presented to the warriors Sasaki Takatsuna and Kajiwara Kagesue by the general Minamoto Yoritomo. In 1184, when their troops were held back on the banks of the Uji River, the two warriors riding their powerful horses courageously led the decisive charge across the river to engage in battle.

—LAC

BIBLIOGRAPHY

Akanuma Taka. *Kōetsu, Dōnyū.* Tōji taikei (Ceramics survey), vol. 18. Tokyo: Heibonsha, 1977, fig. 9.

Isono Nobutake. *Chōjirō.* Tōji taikei, vol. 17. Tokyo: Heibonsha, 1972, pls. 108–9, figs. 67–68.

NOTES

1. Raku Kichizaemon XV, "The Techniques of Raku Ware" in Hayashiya Seizō, Akanuma Taka, and Raku Kichizaemon XV, *Raku: A Dynasty of Japanese Ceramists* (Tokyo: The Japan Foundation, 1997), 73–76.

2. Various genealogical documents describe Chōjirō as the son of a *karabito* father (which could indicate either Chinese or Korean origin) and a Japanese mother. In the sixteenth century, use of ceramic roof tiles was still restricted to Buddhist temples, castles, and warrior-class residences, so the role of a roof-tile maker in Kyoto would have been a significant one.

3. Another message from Kōetsu to Kichizaemon's workshop staff, also announcing that "the tea bowls are ready," is written in a more robust hand and using somewhat more polite language. It suggests an earlier date for the calligrapher's direct instruction: Akanuma Taka dates the letter to the 1620s (Akanuma, 85–86).

4. Ibid., 76.

5. Ibid., 85.

OGATA KENZAN (1663–1743)

Five Square Dishes

Japan, Edo period
Stoneware with underglaze iron oxide and
overglaze enamels
3.5 x 16.7 x 16.7 cm each

Private Collection

Kenzan, younger brother of the artist Ogata Kōrin (1658–1716) and often his collaborator, was a gifted painter, calligrapher, and designer whose greatest achievements lay in the creative innovation he brought to Kyoto stoneware. In his early years, Kenzan worked closely with Raku ceramicists and the calligrapher Hon'ami Kōho (1601–1682), grandson of Kōetsu (1558–1637), at Takagamine. His most important relationship, however, was with the potter Nonomura Ninsei (active 17th century), working at his kiln near Ninna-ji in western Kyoto where Kenzan also established a kiln (the Hall of Quiet Learning) in 1688. Kenzan even acquired Ninsei's secret manuals after his death and incorporated them into his 1737 treatise *Tōkō hitsuyō* (The potter's essentials).

Ninsei produced a wide variety of tea-related ceramics, especially wares for *kaiseki* (tea cere-mony meals), and was known for his revolution-ary use of colorful overglaze enamel designs. Ninsei's legacy is easily seen in this group of five square dishes, most likely part of a much larger set, yet the formal innovation is entirely Kenzan's. He transforms the three-dimensional plates into poem cards. The spatial conceit is further enforced by stylistic allusions. The seasonal motifs on the interiors recall the tra-ditional small-painting conventions used by *Yamato-e* artists to illustrate the thirteenth-century poem sequence "Flowers and Birds of the Twelve Months" (Tsukinami kachō uta-e) composed by the famed poet and calligrapher Fujiwara Teika (1162–1241). The poems, traced in a heavily syncopated hand on the reverse of each dish, are enveloped in a light blue pattern that is deliberately reminiscent of the cloud-dyed decorative papers used in the Heian and Kamakura periods for poetry anthologies.

The selection of poems from a variety of late thirteenth- and fourteenth-century anthologies on these ceramics remind us how indebted Kōrin and Kenzan's Rinpa style was to classical Japanese art and how closely bound this tradi-

tion was to the city of Kyoto. While Kenzan successfully moved his kiln and artistic career to Edo (modern Tokyo) after Kōrin's death in 1716, his aesthetic sensibilities were grounded in a courtly culture preserved in the aristocratic houses of his birthplace. Although impover-ished, the members of the imperial court played an important role in the revival of inter-est in classical poetry and literature during the Edo period. As teachers and transmitters of traditions to the new warrior and merchant classes, especially within tea circles, they first made old texts and commentaries accessible. Kenzan's genius—in both ceramic design and in painting—was in refashioning the older tradition of seasonal inflection and surface pat-tern into a bolder style filled with life and movement that tested the boundaries of con-vention. The idea of returning to the past to find a new direction for the present is a very old one in Asian art traditions and was one of the finest inspirations for the artistic achievements of the Edo period.

—DAW

CRANES

HILLS AND MAPLE LEAVES

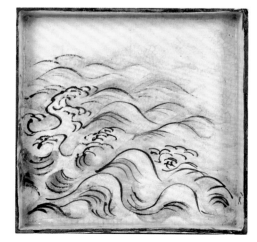

WAVES

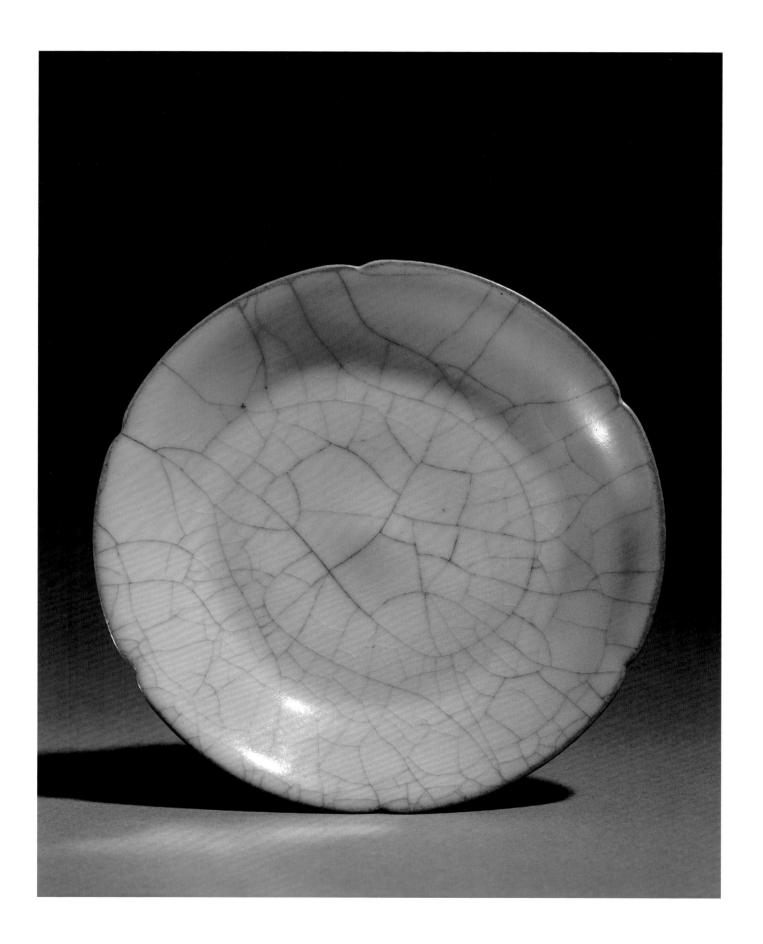

Longquan Ware Octagonal Dish

China, Southern Song period
Celadon ware with fine crackle
h: 2.6 cm, diam: 15.5 cm

Dr. George Fan and Mrs. Katherine Hu Fan
Collection

During the twelfth and thirteenth centuries, the high-fired green-glazed wares produced at the Longquan kilns in the southern Zhejiang region attained great prominence domestically and abroad. Influenced by certain techniques from Southern Song Guan ware such as multiple glazing and slight underfiring to create a thick and lustrous glaze,[1] Longquan ware was transformed and the industry prospered. As perhaps the most admired type of Chinese ceramics, this ware was exported throughout Asia and parts of the Middle East. The multitude of kilns during the middle and late Southern Song period, numbering over 100 sites, and the sheer magnitude of the special dragon kilns (*longyao*) that could accommodate up to 10,000 items per firing illustrate the immense popularity of and demand for this ware. Ostensibly considered non-imperial or non-official wares, Longquan wares nevertheless were greatly admired by Chinese aristocrats. The highest-quality celadons never reached the export market as they often served instead as tribute gifts (*gongfeng*) to the imperial court.[2]

A particularly fine example of Southern Song Longquan ware, this dish with a broad octagonal rim was not destined for the export market. Its well-formed, light-gray stoneware body is covered with a thick, vitreous, blue-green glaze with a web of fine ice-like crackles. Spots under a slip which has turned brown in the firing and on the narrow, unglazed foot rim reveal the color of the stoneware body. A similarly shaped dish with a crackle pattern, designated as Guan-type ware, is located in the Avery Brundage Collection at the Asian Art Museum of San Francisco.[3]

High-fired green wares from Longquan kilns have long been a popular trade ceramic to Japan. Continuing the lucrative export business of the earlier, high-fired green Yue wares, celadon trade flourished during the late Southern Song and Yuan periods. Shards of Longquan wares are common at many Japanese sites, and have been found at Nagasaki, Kumamoto, Kyoto, Nara, Wakayama, and forty other counties, seaports, and cities. Intact export Longquan dishes contemporaneous to the octagonal dish have either incised or molded surface decoration and are not as neatly shaped; their glazes are a thick, translucent grayish-green devoid of crackle.

The Japanese taste for Song Longquan celadons was not only manifested through continuous market demand, but also by a collective cultural fascination or appreciation that developed for celadon and the blue-green color of the glaze. Many heirloom ceramics are Longquan pieces and have assumed legendary status. This may be reflected by the term *kinuta seiji*, used to describe high-quality Longquan celadon with a highly esteemed bright blue-green glaze. The word *kinuta* literally translates as "mallet," and the term may have originated in reference to a type of Longquan vase of this shape. (The best representative of this type is a vase with phoenix handles, named "Bansei" [One Thousand Voices], preserved at Bishamon-dō in Kyoto.) It is also suggested that the term derived from a famous vase named "Kinuta" which was owned by Sen Rikyū (1522–1591).[4] —FY

NOTES

1. James C. Y. Watt, "Antiquarianism and Naturalism" in *Possessing the Past: Treasures from the National Palace Museum, Taipei*, ed. Wen C. Fong and James C. Y. Watt, exh. cat. (New York: The Metropolitan Museum of Art, 1996), 245.

2. Len Shilong, "The Dual Nature of Longquan Wares: Further Discussion" in *New Light on Chinese Yue and Longquan Wares: Archaeological Ceramics Found in Eastern and Southern Asia, A.D. 800–1400*, ed. Chuimei Ho (Hong Kong: The University of Hong Kong, 1994), 39–40. Liu Lanhua, "Tang Song yilai gongting yong cide laiyuan yu shaozao" (The sources and production of imperial porcelains after the Tang and Song periods), *Wenbo* (Relics and museology) 72, no. 3 (1996): 16.

3. René-Yvon Lefebvre d'Argencé, *Chinese Ceramics in the Avery Brundage Collection* (Berkeley: Diablo Press, 1967), 100.

4. Seizo Hayashiya and Henry Trubner, *Chinese Ceramics from Japanese Collections: T'ang Through Ming Dynasties*, exh. cat. (New York: The Asia Society, 1977), 129.

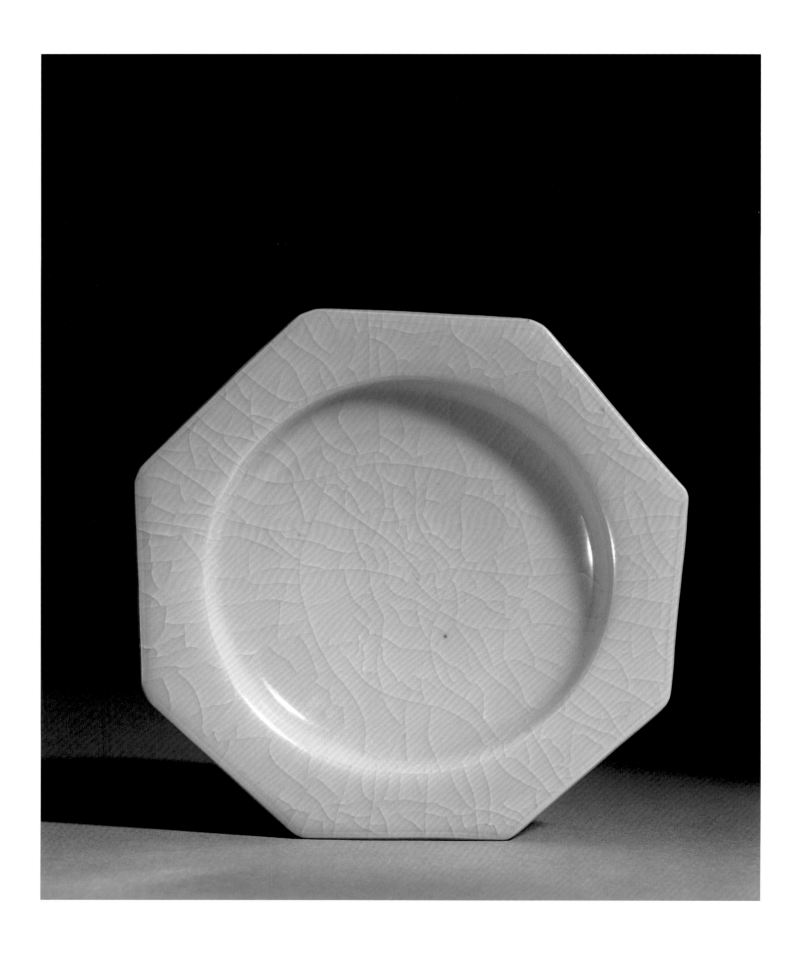

Celadon Cup and Stand

Korea, Koryŏ dynasty, early 12th century
Celadon with clear glaze
cup, h: 5.8 cm, diam: 9.1 cm;
stand, h: 4.2 cm, diam: 17.6 cm

Lee and Ahn Collection

Among the most important artistic and techni-cal achievements in the arts of Korea are the renowned *Koryŏ ch'ŏngja*, celadons of the Koryŏ dynasty, produced from the ninth or tenth to the fourteenth century, and greatly esteemed in China and Japan as well as Korea. Although opinions differ on the date of celadon's earliest production in Korea, most scholars agree that the technique was adopted from China. This theory is supported by celadon kiln sites discov-ered in southwestern Korea, where there was an active trade relationship with southern China. Moreover, the excavation of Chinese-style celadon wares in these kilns suggest the immigration of Chinese potters.

Celadon wares are, most familiarly, green-glazed ceramics; a range of colors from greens to grays to blues were developed within this genre. Originally, it is thought, this translu-cent-glazed ware was prized for its similarity to jade. According to the twelfth-century chronicle *Xuanhe fengshi Gaoli tujing* (Illustrated record of the Chinese embassy to the Koryŏ court during the Suanhe era),[1] the subtle and beautiful color of Koryŏ celadon was called "kingfisher," after the blue-green color of kingfisher feathers. The chronicle also mentions that vessels for everyday use were made of metal, while celadon wares were used for special occasions. It is obvious that such precious ceramics were produced for the upper class, even for the royal family.

To create a good blue-green celadon, fine gray clays containing a small amount of iron must be used. After the clay vessel is formed on a potter's wheel, a glaze also including iron is applied. If this glazed clay body is fired inside a reducing-atmosphere kiln at around 1200°c, the iron in the clay and the glaze turns a beautiful, translucent blue-green color. Koryŏ potters per-fected this technique, and brought the production of celadon to its glory by the early twelfth century, with a high-quality clear glaze and unique decorations. At first, Korean potters only executed pure, undecorated celadons in the manner of Chinese wares. Gradually, how-ever, in a refinement of decorative techniques and a reflection of indigenous tastes, potters began to embellish wares by means of inlay, incising, carving, and painting.

Despite their fame during the Koryŏ dynasty, by the 1800s Korean celadons were nearly forgotten. Although they were described in a few literary works, most surviving examples were hidden away in tombs. At the end of the nineteenth century, however, as tomb excava-tions progressed, these magnificent buried treasures were unveiled, confirming what the historical sources had proclaimed. The Korean government-supported excavations and surveys of the known kiln sites since the 1950s provided evidence of the abundance of Koryŏ celadon production. When these wares became available on the art market, they were widely collected within Korea, Japan, and the West.

This magnificent cup and stand, which were probably made for drinking tea, are exemplary for their intrinsic artistic beauty. The cup was modeled on a wheel and shaped on a small raised foot. The form is perfectly even, and the body very thinly constructed. The stand is raised on a hollow base and finely finished in every detail. The shape of both cup and stand were inherited from China, and appreciated in Japan, as well. Both cup and stand are perfectly plain, with no inlay or underglazed incised decoration, assigning this pair to the early twelfth century, at the beginning of Koryŏ celadon's prime.

We do not know the origin of this cup and stand. The pieces were not originally a set, but were paired by the collector; they fit together beautifully as an ideal match of shape, glaze color, and scale. Like many other Koryŏ celadon pieces, these are thought to have been excavat-ed from a tomb site. There are several sets of similarly undecorated celadon cups and stands preserved in the National Museum of Korea, Seoul. With elegantly shaped bodies and a lus-trous translucent glaze, this pair represents the early perfection of Koryŏ celadon production.

—HW

NOTES
1. One of the most important historical records in the study of Koryŏ celadon, this chronicle was written in 1124 by Xu Jing (1091–1153), a member of the entourage of a Chinese envoy from the Northern Song Huizong emperor's court to Korea in 1123.

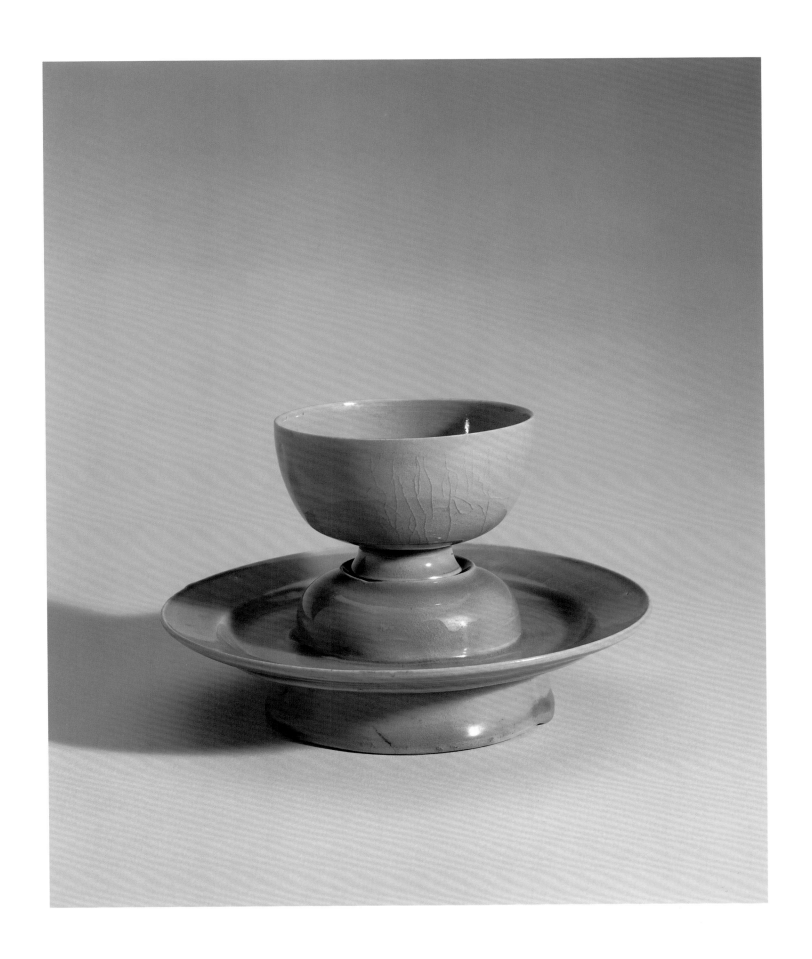

Nature is one of the most enduring themes in the visual arts of East Asia. From the earliest representations of mystical animal forms found on ritual objects, to stylized landscape and bird-and-flower imagery adorning the arts favored by the court and wealthy classes, nature has symbolized the ideal of the cosmic world. Fundamental to Daoist, Shinto, and Buddhist practice is a reverence for nature as the embodiment of universal laws and manifestation of the divine. The ever-changing and evanescent aspect of life, so celebrated in East Asian thought, is expressed in the abundant depictions of the four seasons. Drawn largely from mythology, popular culture, and literary traditions, images of nature thus resonate with specific references that add layers of meaning to their decorative representation.

Celebrated sites (Ch: *mingji*; J: *meisho*; K: *myŏngso*) figure frequently in East Asian painting and decorative arts. Some subjects derive from literary citations, often themes in poetry, that conjure symbolic associations. Celebrated temples, mountain peaks, and other scenic sites with exceptional cultural and historical associations were also favorite subjects. The Chinese topos of the Xiao and Xiang Rivers and West Lake came to be a genre unto themselves in East Asian painting. These venerable subjects, which in effect remained imaginary places to most people outside China, embodied the quintessence of Chinese landscape painting in the Japanese mind.

The perseverence of bird-and-flower (Ch: *huaniao*; J: *kachō*; K: *hwajo*) studies in East Asian art reflects the fundamental concept of the divine in nature. Specific birds, such as the crane—symbol of immortality and longevity—were popular subjects in painting and the decorative arts. Likewise, images of specific plants, such as the bamboo, also represent a celebration of man in nature or nature representing human character and aspirations. Motifs abstracted from nature are also the most popular decorative elements for both lacquerware and ceramic design, where they appear as the structural form or motifs of surface decoration.

While subjects of nature are frequently represented in East Asian art, the forms of expression vary from the rustic and realistic to the deftly refined and artificial. There is an emphatic appreciation of natural materials in the production of art: the quality of local clays in producing refined ceramics; the undisguised beauty of wood; the juxtaposition of precious metals in sculpture and ritual vessels; and silken threads woven into sumptuous textiles. The artist, artisan, or craftsman endorses a special respect for each material and its spiritual content. In Japan, this reflects the association with Shinto in which the divine is embodied in all natural things.

Natural materials are also often recrafted and reinterpreted to convey a sense of artifice. Certain objects, like folding screens with gold-leaf backgrounds, a cabinet decorated with exotic ox-horn panels, or a celadon vessel function to resonate and accentuate the ideals, motifs, or techniques favored in a distant past. —AGP

Section Three
Nature and Artifice

TAWARAYA SŌTATSU (active first half
of 17th century)

Scene from Tales of Ise

Japan, Edo period
Poem card mounted as hanging scroll;
color and gold on paper
24 × 20.7 cm

Rosemarie and Leighton Longhi Collection

One of the most beloved of early Japanese
literary texts is the *Ise monogatari*, or *Tales of
Ise*, traditionally attributed to the courtier-poet
Ariwara no Narihira (825–880). It consists
of some 125 sections, or vignettes, combining
one or more poems with an anecdote, usually
on romantic subjects. The work, written in
classical Japanese using the *kana* syllabary in
combination with Chinese ideographs, was
probably compiled during the late ninth into
the early tenth centuries by several authors.
Narihira, whose poems appear throughout the
work, seems to have been the model for the
various courtly gentlemen whose stories are
told in the *Tales of Ise*.

The poem card belongs to a set of cards of
the type traditionally used in literary games at
court. Each card depicts a scene from *Tales
of Ise* along with the relevant poem. On formal
and technical grounds, the cards have been
identified as the work of Tawaraya Sōtatsu,
dated to the early seventeenth century.
The original size of the set of poem cards is not
known but may have included as many as 125
pieces; of these, forty-seven survive in various
museum and private collections.

The scene derives from the twenty-third
vignette in the *Tales*, illustrating the famous
episode called "Kawachi no koshi," or "Setting
Out for Kawachi." In the story, the husband

has taken up with another woman in the
province of Kawachi near modern Osaka, but
becomes suspicious of his wife for her appar-
ent lack of resentment whenever he leaves.
One day he pretends to set out for Kawachi but
hides in the bushes instead. He sees his wife
adorn herself and then recite this poem:

> Is he journeying
> Alone in the dead of night
> Across that mountain
> Whose name recalls waves at sea
> Rising when the tempest blows?

On hearing the poem the husband renews
his love for his wife and stops the visits
to Kawachi.[1]

Sōtatsu has rendered the scene with the skill,
sophistication, and humor that are his trade-
mark qualities. From the richness of the
surface, with its pooled pigments and uneven
contours, to the abstracted forms of man and
woman in their voluminous robes, the paint-
ing is an exercise in what might be termed
classical pastiche, a new and dynamic system
of abstraction linked to textile design and the
decorative arts. Little is known about Sōtatsu
other than that he was a fan painter in Kyoto
and eventually produced an influential oeuvre
of paintings in a variety of formats. But his
originality of approach in time inspired a
style of painting that emphasized classical
modes of expression adapted to a new formal
vocabulary of abstraction and materiality.
Called Rinpa—the Rin School—after Sōtatsu's
greatest proponent, the connoisseur Ogata
Kōrin (1658–1716), the style came to embody
the strong nativist concerns of a community
of artists and intellectuals faced with the
Chinese-centered interests of the Tokugawa
shogunate.

Virtually every element in the composition
speaks to a native tradition of court painting
linked to classical literary texts written for the
most part in the native script. In a sense, the
work represents a way of seeing, a visuality,
fundamentally distinct from the Chinese
and Korean norms, specifically of brush and
evocative monochromatic ink, that periodically
dominated the high culture of Kyoto in the
late medieval age. —MHY

BIBLIOGRAPHY

Itō Toshiko. *Ise monogatari-e*
(Pictures of the *Tales of Ise*).
Tokyo: Kadokawa Shoten,
1984, 127–53, 259, pls. 14–15.

Nakabe Yoshitaka. "Den
Sōtatsu hitsu Ise mono-
gatari-zu shikishi kenkyū
josetsu" (Introduction
to the study of poem cards
illustrating the *Tales of Ise*
attributed to Sōtatsu).
In Murashige Yasushi, ed.,
Rinpa, vol. 4. Tokyo: Shikōsha,
1991, 241–45, pls. 1–7.

*Special Loan Exhibition:
Art Treasures from Japan.*
Exh. cat. Boston: Museum of
Fine Arts, 1936, cat. no. 74.

NOTES

1. Helen Craig McCullough,
Classical Japanese Prose
(Stanford: Stanford Univer-
sity Press, 1988), 51–52.

RIGHT

LEFT

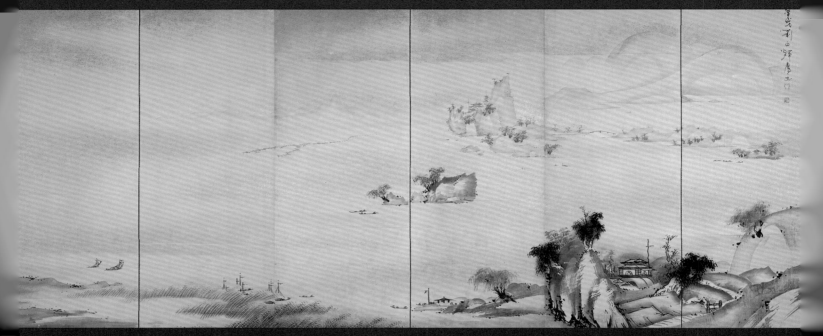

RIGHT

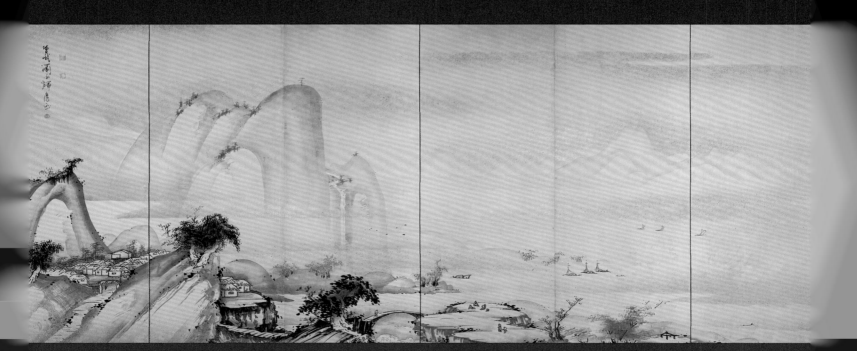

LEFT

SOGA SHŌHAKU (1730–1781)

Eight Views of the Xiao and Xiang Rivers

Japan, Edo period
Pair of six-panel screens; ink and gold on paper
171 x 358 cm each screen

Robert Hatfield Ellsworth Collection

Shōhaku's normally "untrammeled" nature is subliminated to an ethereal otherworldliness in this pair of screens depicting the landscape around the confluence of the Xiao and Xiang Rivers in what is now Hunan province in China.

A landscape of the literary imagination as much as of atmospheric painting and true geography, the Xiao-Xiang Eight Views was a venerable subject for Chinese-style painting in Japan, a continuation of a long tradition that began with a celebrated set of Northern Song landscapes by Song Di (ca. 1015–ca. 1080), an official in the Chinese imperial bureaucracy. Originally a place of exile (Song Di's four-character titles for each of the Eight Views allude to the sorrowful poetic history associated with the landscape),[1] the Eight Views in Japanese art by contrast hold little political connotation. They draw their strength instead from lyric meaning and cultural imagination. The Eight Views were resonant with the Japanese concept of China: its poetry, its grandiosity, and its timelessness.

The Eight Views are traditionally given as Wild Geese Descending to a Sandbar; Sails Returning from a Distant Shore; Mountain Market in a Clearing Mist; River and Sky in Evening Snow; Autumn Moon over Dongting; Night Rain on Xiao-Xiang; Evening Bell from a Mist-Shrouded Temple; and Fishing Village in an Evening Glow. Each view is distinctive for its evocation of sound or silence: the aural dimension possible

within the visual. Shōhaku, instead of marking each view scene by scene, subtly insinuates the motifs throughout his composition. They seem to function, sotto voce, as a simple reminder of the long continental heritage of ink painting from which he drew inspiration.

These screens, like much of Shōhaku's art, are about the power and act of painting. They exhibit the artist's tremendous surety and control and an almost audacious commitment to the open spaces of blank paper. Instead of painstakingly building forms from within through layers of patterned brushstrokes, Shōhaku uses broad single strokes of light ink to define the far distance and mountain forms. The liquidity of the ink tangibly reinforces the representation of the watery atmosphere of Xiao-Xiang. The smaller accents of form within the larger landscape—trees, fishing vessels, houses, and people—are placed in the foreground. Executed in a rapid, broken style—shorthand reference to the signature brushwork of several classic Chinese painters—these elements stand out darkly from the painting surface, setting up the interplay between tonal contrasts and form that holds the composition together and gives this work its peculiar panoramic expanse.

The Ellsworth screens demonstrate Shōhaku's affinities with his contemporaries, especially with the loose landscape style of Ike Taiga (1723–1776), also grounded within Chinese tradition. Yet they also reveal a radical conservatism in his concern with the evocation of space and distance, a metaphysical topography that has clear affinities with the Northern Song origins of the Xiao-Xiang theme.

—DAW

NOTES
1. See Alfreda Murck, "The 'Eight Views of Xiao-Xiang' and the Northern Song Culture of Exile," *Journal of Sung-Yuan Studies* 26 (1996): 113–44.

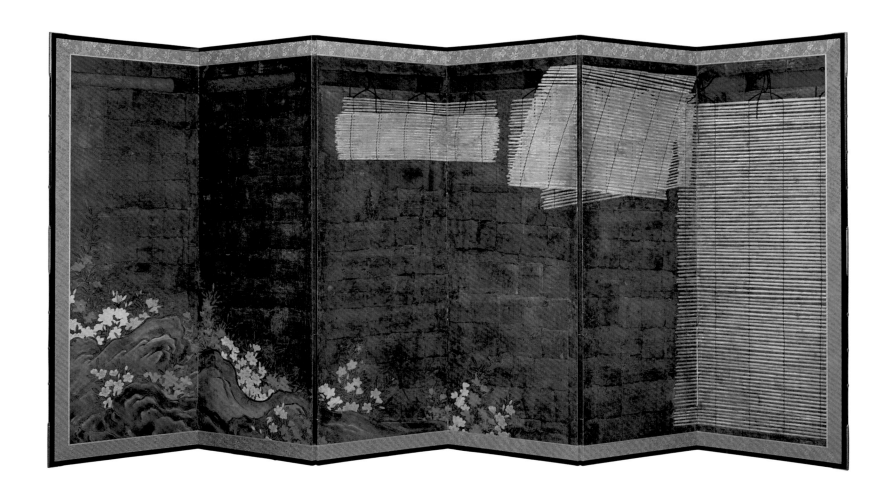

Bamboo Blinds

Japan, early Edo period, 17th century
Six-panel screen; ink, color, gold, and silver
on paper
154 x 362 cm

Peggy and Richard M. Danziger Collection

Folding screens articulate space in the open
interiors of Japanese domestic architecture.
Singly, in pairs, or even in larger groupings,
screens demarcate areas of privacy and regu-
late access within buildings. Sophisticated play
upon the idea of the interior or enclosure in
paintings on screens was one of the most
marvelous accomplishments of the Edo-period
machi-eshi (town painters) who worked in
Japan's burgeoning cities for mainly merchant
patrons and who did not come from an estab-
lished "name" studio.

Interior views such as rows of gorgeous robes
on a clothes rack (known as *tagasode* or "whose
sleeves?") or those depicting bookshelves and
scholarly accouterments were extremely popu-
lar subjects of genre painting on screens during
the Edo period. They allow us to slip into a role,
of a beautiful courtesan, for example, or a
Confucian scholar. This screen artfully recreates
a view from a verandah, a view from the inside
to a private outside, for a similar effect. But in
diametrical opposition to voyeurism, this paint-
ing interiorizes the interior and in its solitude
creates a further privacy. With trompe l'oeil
finesse, the golden bamboo blinds shading the
viewer from the sun are "hung" in the painting
from a pole along the "transom" at the top
of the screen. One blind is tossed carelessly up
over the pole for a casual look into the summer
garden with its mossy rocks and azaleas in
full bloom. An effectual realism is established
by the scale of the elements in the painting

and the equation of the picture plane with the
outer limits of a room opening out upon a
garden, but as we reach the rocks and flowers
the realism is negated by the reassertion of the
painter's world of stylized line and color.

The staging of this scene recalls a comment
by the playwright Chikamatsu Monzaemon
(1653–1725) about theater, that entertainment
lies in the slender margin between the real
and the unreal:

> In view of this we can see that if one makes an
> exact copy of a living being, even if it happened
> to be Yang Kuei-fei, one will become disgusted
> with it. If when one paints an image or carves it
> of wood there are, in the name of artistic
> license, some stylized parts in a work otherwise
> resembling the real form; this is, after all, what
> people love in art. The same is true of literary
> composition. While bearing resemblance to the
> original, it should have stylization; this makes it
> art, and is what delights men's minds.[1]

—DAW

NOTES

1. Recorded in Kan Hozumi,
Naniwa miyage (Osaka
souvenirs), (1738); translated
in Donald Keene, *Anthology
of Japanese Literature*
(New York: Grove Press, 1955),
389. Yang Guifei (Yang
Kuei-fei) (ca. 713–756) was
the concubine of the
Tang Xuanzong emperor
(r. 712–56). She was legendary
for her beauty and was used
as a synecdoche for female
attractiveness in Japanese
literature.

Mount Fuji

Japan, Edo period, 17th century
Pair of six-panel screens; color and gold
on paper
170 x 365.8 cm each

Alice Brown and Peter Brest Collection

> Since the time
> When heaven and earth split apart,
> Fuji's lofty peak
> Has stood in the land of Suruga,
> high and noble,
> like a very god.
>
> . . .
>
> Let us speak of it
> And recount it to the ages—
> Fuji's lofty peak![1]
>
> —YAMABE AKAHITO (active 724–737)

The celestial image of the immortal mountain has figured prominently in the spiritual imagination of the Japanese, from the remotest past to the present. Mount Fuji is both sacred place and celebrated site, and as such belongs to both religious and literary worlds. From the very earliest eleventh-century depictions of the life of Prince Shōtoku (574–622), in which the prince regent's black steed swiftly carries him up and over the mountain, the distinctive three-peaked triangular profile of Fuji, paired with the sun or the moon, has been found in all manner of visual representations, as backdrop to and potent symbol of the god-granted polity that is called "Yamato" or Japan.

There are Fuji mandala: the most famous is the sixteenth-century *Mandala of Pilgrimage to Mount Fuji* (Fuji sankei mandara) at Fujisan Hongū Sengen Shrine in Shizuoka, bearing the seal "Motonobu," most likely of Kano Motonobu (1476–1559) or a close follower. These syncretic

images show the mountain as both Buddhist paradise (*Jōdo*) and Shinto manifestation ("treasure") of the gods and map out the grounds of the shrine and routes to the summit for the viewer to experience a visual approximation of pilgrimage. Sesshū (1420–1506), perhaps Japan's greatest artist, also painted Fuji.[2] The mountain frequently appears in illustrations of the much-loved *Tales of Ise* (see cat. no. 48), from as early as the thirteenth century. The scene of the protagonist Ariwara no Narihira gazing at Fuji, "twenty times higher than Mount Hiei in the capital," is at the heart of the emotion-laden ninth section (*Azuma-kudari*).

By the seventeenth century, when this screen was made, the image of Mount Fuji was replete with many associations, deeply connected with Japan's oldest cultural memory. Many Edo-period artists took Fuji as a personal icon, even as a talisman. Kano Tan'yū (1602–1674), key artist

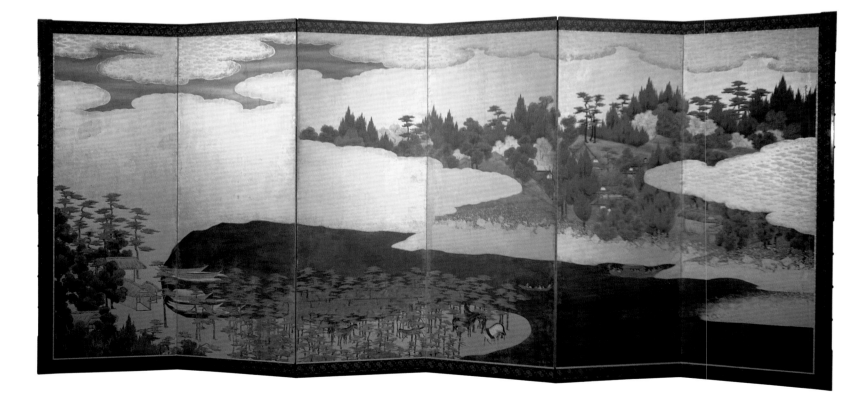

in the official Kano workshop to the shogunate, was one of the most notable. Captivated by the mountain as he encountered it on his many trips between Kyoto and Edo (modern Tokyo), Tan'yū reportedly even kept a Fuji-shaped rock in his possession for sketching.[3] The eighteenth-century literati artist Ike Taiga (1723–1776), who marked a major turning point in his artistic life with a visit to three of Japan's most revered peaks, portrayed Fuji often as one of his topological "true views" (shinkei-zu). For the print artist Katsushika Hokusai (1760–1849), who designed his renowned Fuji series when he was in his seventies, the mountain's associations with eternal life and immutability must have carried an even deeper poignancy (see cat. nos. 70–71).

This pair of screens separates the divine precincts of the mountain, moon, and foothills in the right-hand section from the more secular sites of cherry blossom–wreathed Seiken-ji,

Suruga Bay, and the Miho pines in the left-hand section. The Fuji of this screen is "three-peaked," a stylized image of the mountain as viewed from Fujinomiya, where the Sengen Shrine is located. The panoramic composition is richly colored and simplified in form. Gold clouds embossed in a moriage technique (color applied over outlines of raised underpainting) alternately reveal and conceal the landscape. The strength and sweep of this screen implies that the artist may have trained in one of the studios associated with the Kano school, although the execution is quite within the style of painting usually called Yamato-e or "Japanese pictures." —DAW

BIBLIOGRAPHY

Mildred Friedman, ed. Tokyo: Form and Spirit. Exh. cat. Minneapolis: Walker Art Center, 1986, 24–26.

NOTES

1. This celebratory nature poem comes from the third book of Man'yōshū (The collection of ten thousand leaves), Japan's first anthology of poetry, compiled in the eighth century. Ian Hideo Levy, The Ten Thousand Leaves, vol. 1 (Princeton: Princeton University Press, 1981), 178.

2. A copy of his Fuji Miho Seigen-ji zu (Views of Mount Fuji, Miho, and Seigen-ji) is in the Eisei Bunko collection.

3. See Yamashita Yoshiya, "Fujisan-zu to kanrensaku" (Painting of Mount Fuji and related works) in Kano Tan'yū no kaiga/The Masterpieces of Kano Tan'yū, exh. cat. (Shizuoka: Shizuoka Prefectural Museum of Art, 1997), 36–54.

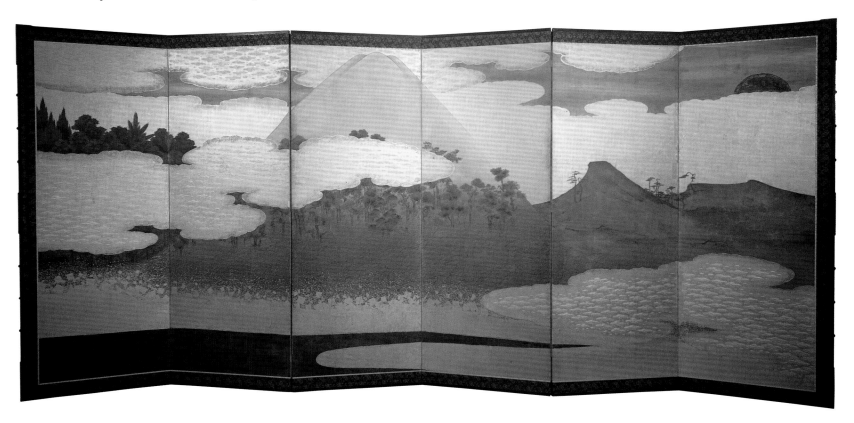

Mount Kŭmgang

Korea, Chosŏn dynasty, 19th century
Ten-panel screen; ink and color wash on paper
114.5 x 340 cm

Yoon Sang Kim Collection

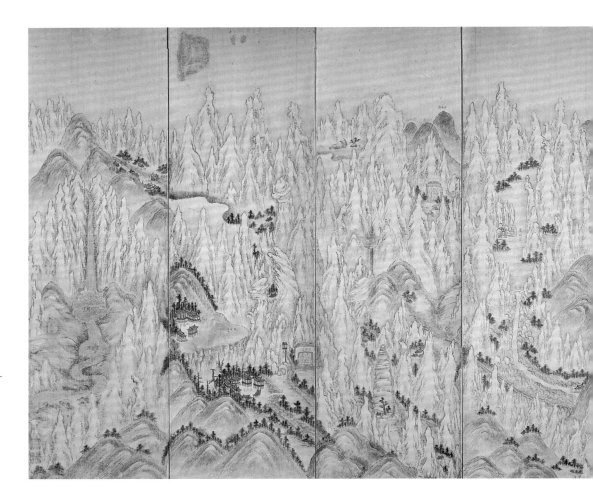

Mount Kŭmgang is one of the most famous sites in ancient and modern Korea, long considered a symbol of the national spirit. The name Mount Kŭmgang has been traditionally applied to a range of peaks in the T'aebaek Mountains, in the northeastern part of the Korean peninsula near the east coast.

The name of Mount Kŭmgang, widely used from the late thirteenth century to the present, has Buddhist connotations. *Kŭmgang* is a translation of the Sanskrit word *vajra* (diamond), signifying the strong nature of the mountains and possibly the dazzling array of sharp peaks. An association was made between Korea's Mount Kŭmgang and the Diamond Mountain (Sk: Vajrāmaya-parvata) described in the Buddhist *Avatamsaka sūtra* (*Hwa'ŭm-kyŏng*; Flower Garland Sutra), referring to the ideal land of Avatamsaka, a dwelling place of the bodhisattva Dharmōdgata. Kŭmgang is also a seasonal name for the range, used in the spring; other names are Bongnae (in summer), P'ung'ak (in fall) and Kaegol (in winter).

From the fourteenth century, a visit to Mount Kŭmgang as a Buddhist pilgrimage site became a life's ambition for many travelers, including those from China and Japan. Envoys from China without fail wanted to visit the site, or asked for paintings of the mountains for their emperor. Paintings of Mount Kŭmgang were also essential gifts for the Chinese imperial court whenever Chosŏn royal envoys went to China. It was likewise common for those who

did not have the chance to visit Kŭmgang, or for those who wanted keep the impression of their visit alive, to own paintings with images of the mountains.

The oldest surviving representation of Mount Kŭmgang appeared in the painting of Dharmōdgata attributed to Noyŏng (active early 14th century), which is dated 1307. However, it was in the eighteenth century that this kind of painting became extremely popular, due to the rise of true-view landscape painting (*chin'kyŏng sansuwha*) which took its subjects from native Korean scenery.

Increasingly, in the late seventeenth and eighteenth century, artists turned their eyes to the beauty of their native scenery in their land-

scapes instead of basing their works on Chinese models. One of the most important artists of the true-view school was Chŏng Sŏn (1676–1759), whose favorite subject was Mount Kŭmgang. On his many paintings of this subject, whether panoramic views or selected sites, he always wrote the names of peaks, temples, or places, giving these works a strong underlying realism.

True-view landscape painting began to decline in the nineteenth century. However, the spreading popularity of excursions to Mount Kŭmgang among commoners made paintings of the Diamond Mountains more popular than ever. Paintings of Mount Kŭmgang became the most common subject for paintings in households of the general populace; even folk paintings were mass produced to meet the demand.

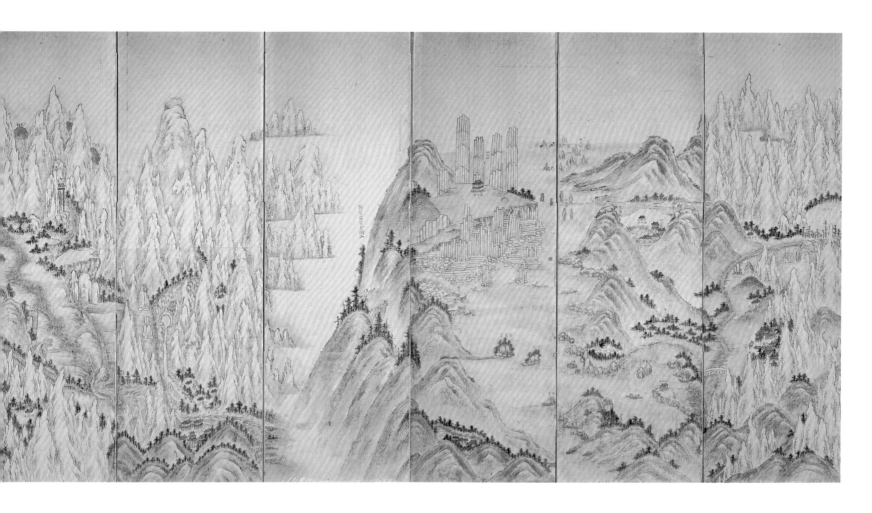

With delicate brushwork and subtle ink wash, the present ten-panel screen depicts a panoramic view, providing the whole vista of Mount Kŭmgang. In light of other complete views of Mount Kŭmgang in hanging scrolls or album leaves, it is remarkable in its spectacular and narrative view of this popular subject in the format of a large screen.

The mountain is traditionally divided into three parts: Coastal Kŭmgang (Hae-gŭmgang); Outer Kŭmgang (Oegŭmgang); and Inner Kŭmgang (Naegŭmgang). The dividing point of Inner and Outer Kŭmgang is Piro-bong Peak, shown in the eighth panel from the right in this screen. Reading the screen in an East Asian convention from right to left: from the first to the third panel is a view of Coastal Kŭmgang; from the fourth to the seventh is Outer Kŭmgang; and from the eighth to the tenth, Inner Kŭmgang. On the fourth panel, there is an inscription in red ink, reading: "the view of Mount Kŭmgang from Danbal-ryŏng Ridge," and each spot is identified by name in red ink. However, this painting contains no artist's signature. The two seals at the lower left corner of the tenth panel are illegible. —HW

Lotuses

Korea, Chosŏn dynasty, 19th century
Ten-panel screen; ink and color on paper
170.2 x 325.1 cm

The Kang Collection

A favorite motif in both pictorial and decorative arts in Korea, the lotus first appeared in fifth-century murals of the Koguryŏ Kingdom (37 BCE – 668 CE). Its popularity and iconographic emphasis increased greatly with the expansion of Buddhism in the Koryŏ dynasty. Usually considered as symbols of purity in Buddhism, lotuses were metaphors of the upright and faithful scholar. Therefore, it was common for Chosŏn

scholars to have a lotus pond in their gardens. Lotus paintings were executed for those who could not afford to have a real lotus pond.

Lotuses also bore a secular symbolism, as demonstrated by this undulating panorama of lotus leaves and flowers in a luxurient pond, with symbols of luck, fecundity, and love woven in an elegant interplay of nature and art. Traditionally, lotuses embodied abundance and fecundity because of their seedpods crammed with seeds. In Chinese, the words for such lucky omens could be read as rebuses of their pronunciation: the Chinese character for "lotus," pronounced *lien* in Chinese and

yŏn in Korean, for example, has the same sound as "continuity," and so the meaning of lotus could be expanded to suggest the potentiality of many sons.

In keeping with the connotation of good luck, many paintings executed in the late Chosŏn dynasty combined the motif with auspicious symbols of birds and animals. This lotus screen is a whole symbolic complex of lucky omens. Water birds—Chinese mandarin ducks and egrets—in several of the panels enhance the waterscape. These were included not only for their naturalism but as auspicious symbols well known in any Korean household. The

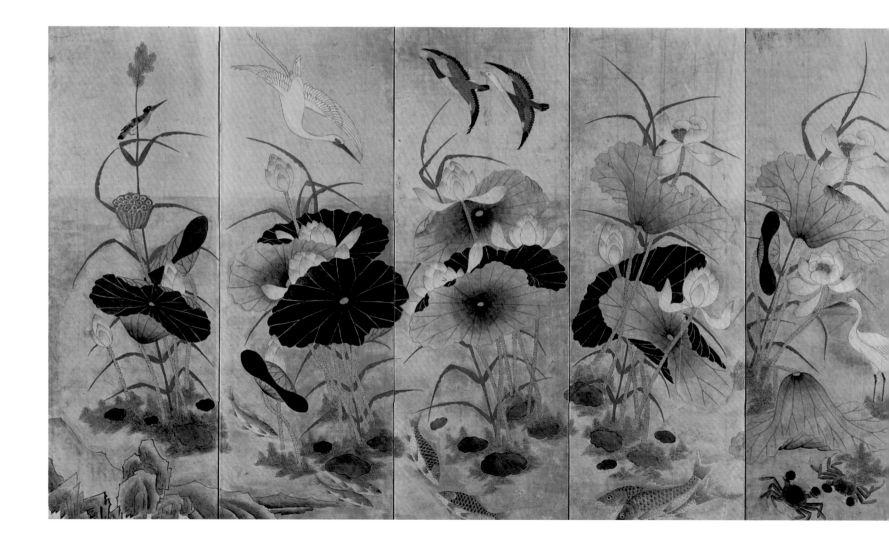

combination of different kinds of birds and fishes with lotuses is furthermore an expression of compound wishes. Because the symbolic meaning of the painting was significant to the patron, flowers and birds which would never occur together in the same season are shown together in this screen. Lotuses blossom in July, but Chinese mandarins, as migratory birds, are not found in the summer in Korea. However, since these ducks are symbols of love between husband and wife, they are portrayed with lotuses to convey the hope for fecundity.

Lotus paintings frequently took the form of hanging scrolls or folding screens; this ten-panel grouping of images follows a popular format of multiple views connected to form one continuous scene. The lotus flowers and leaves have been rendered in fine lines, with colors filled in. The shoreline is indicated at the two end panels, demonstrating that the panels were intended to be shown together in this order. Although the artist who created this screen is unknown, its balanced composition and pictorial realism make it one of the finest exemplars of the lotus theme. — HW

BIBLIOGRAPHY

Kumja Paik Kim. *Hope and Aspiration: Decorative Painting of Korea*, Exh. cat. San Francisco: Asian Art Museum of San Francisco, 1998, 56–57, cat. no. 13.

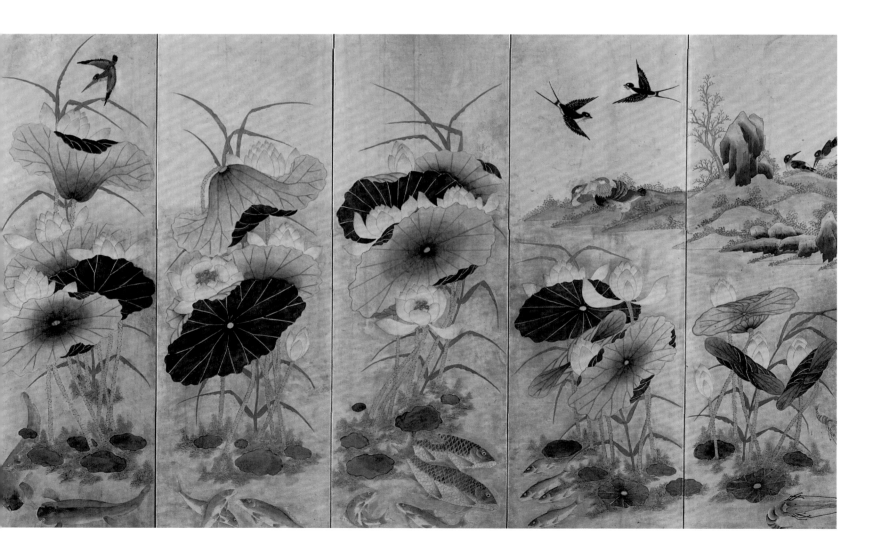

ITŌ JAKUCHŪ (1716–1800)

Chrysanthemums and Brushwood Fence

Japan, Edo period
Hanging scroll; ink on paper
109.3 x 29.7 cm

Mr. and Mrs. Richard Fishbein Collection

Itō Jakuchū was one of Japan's most original painters. First son of a prosperous Kyoto green-grocer, Jakuchū inherited the family business in his early twenties. While it provided him with a comfortable income, the records we have of Jakuchū's life reveal how ill-suited he was to business.

Around 1755 Jakuchū turned everything over to his younger brother so he could live as a lay monk and pursue art as a full-time profession. The great explosion of work Jakuchū produced in the years immediately following this decision attests to the marvelous freedom he must have finally felt.

Jakuchū's greatest work was in the bird-and-flower genre. He was a master at capturing the near-at-hand and finding the otherworldliness within it. Equally proficient in the highly colored technique of Ming and Qing court painting (particularly as interpreted by Nagasaki-school realists) and the more subjective ink style of the Ming literati and their successors, Jakuchū had a unique vision, one that eschewed simple naturalism for a more penetrating view into the phenomenal world.

Jakuchū's strong sense of artistic design and his consummate skill in ink are evident in this seemingly ingenuous painting of double chrysanthemums along a garden fence. As in this work, Jakuchū innovatively used soft absorbent *gasenshi* paper for many of his experiments with a "boneless" style, one that created form without outline. He excelled at exploiting the grays that radiated out from the ink as it pooled on the surface of the paper for their rich tonality and shading. The liquid, mordant effect he was able to achieve is singularly disturbing and removes the subject emotionally far from its traditional courtly associations of poetry and autumnal reverie.

Although there is some indirect evidence that Jakuchū had training with at least one artist associated with the Kano school, his paintings suggest that his greatest education of eye and hand came from studying and copying old Chinese works. Jakuchū enjoyed a close association with Daiten Kenjō (1719–1801), a leading literary monk and scholar of Chinese at the temple Sōkoku-ji. Daiten's connections appear to have made many painting collections in Kyoto available to Jakuchū and the cleric's artistic and religious encouragement sustained the artist throughout his life. Daiten wrote Jakuchū's epitaph and most likely gave him his artist name, drawn from a line in Laozi's *Teaching of the Way*, or *Dao de jing*: "the greatest fullness is like a void."[1]

Like many Kyoto artists, including the supreme realist Maruyama Ōkyo (1733–1793), Jakuchū lost everything in the 1788 Tenmei fire. He increasingly turned to religion for solace and inspiration in his final years, taking up residence with his younger sister (who became a nun) and one of her children in a house with a "time-worn garden of great charm"[2] at the gates of Sekihō-ji in Fushimi, south of the city. His last work was a series of roundels for the coffered ceiling of the temple. Each under-stated composition depicts a flowering plant, several of them chrysanthemums that recall the imploded forms developed in the Fishbein painting.[3] Jakuchū pursued his own truth in an unconventional vocabulary of images from nature, many from his own garden. Despite his reclusiveness, he became a major figure in the eclectic world of eighteenth-century Japan.

—DAW

NOTES

1. Money L. Hickman and Yasuhiro Satō, *The Paintings of Jakuchū* (New York: The Asia Society Galleries, 1989), 20.

2. Hiraga Hakusan, entry for 1794 in *Shōsai hikki* (Shōsai journal); reprinted in *Jakuchū tokubetsu tenkan/Special exhibition of Jakuchū*, exh. cat. (Tokyo: Tokyo National Museum, 1971), 94.

3. Most of these were moved in the nineteenth century, in the early years of Meiji, to Shinkō-ji in the Higashiyama section of Kyoto. See Ōtsuki Mikio, *Itō Jakuchū to "Jakuchū gafu"* (Itō Jakuchū and *Jakuchū's illustrated album*), a leaflet accompanying *Jakuchū gafu* (Kyoto: Binobi, 1976), a facsimile edition of reproductions originally published in 1890.

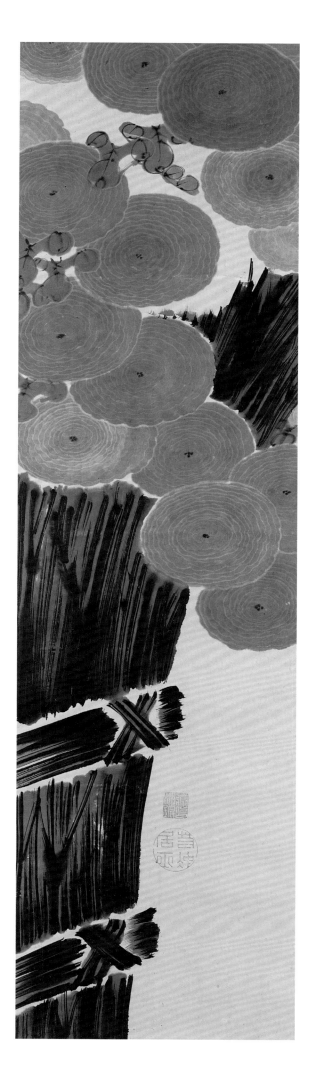

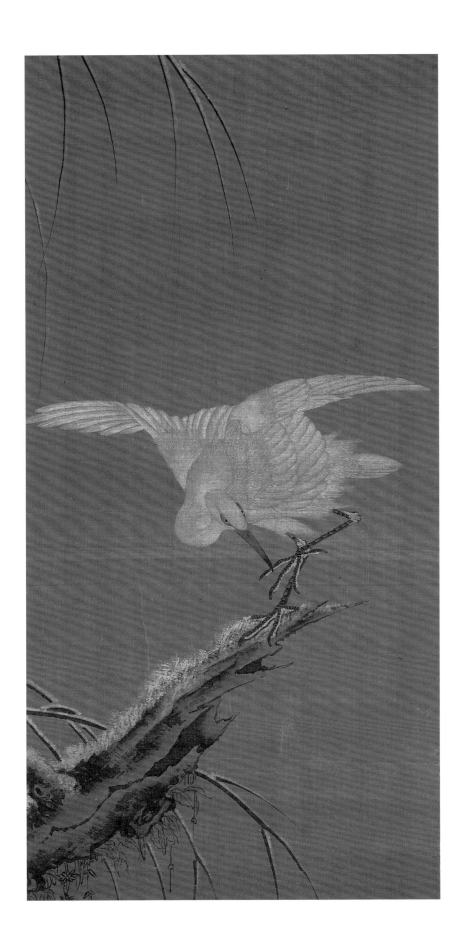

White Heron on a Snow-Covered Branch

China, Yuan period, 14th century
Hanging scroll; ink and color on silk
90 x 42.5 cm

Rosemarie and Leighton Longhi Collection

The large, jagged-edged willow branch that surges diagonally upward and the thin hanging willow wisps are freshly dusted with snow. A heron has just alighted, its explosive energy a wonderful contrast to the fragile stillness of the snow-covered tree. Paintings such as this present spare but rich images that require no poetic inscriptions and reward the viewer when thoughtfully approached.

Bird-and-flower painting in China was perhaps the most constant ongoing tradition of painting from the Song through the early Ming periods. The style emerged from the Imperial Academies of the Southern Song court. In general, court painters did not work with ink and paper but with silk, using ink and color, which demanded greater technical skill. In addition, there was an emphasis on finely detailed realism in bird-and-flower painting, promoted by the founder of the Imperial Painting Academy, the Huizong emperor (r. 1101–26). During the Yuan period, the academies were suspended but their traditions were carried on through the work of professional painting masters in the city of Hangzhou.

It is precisely this type of image that profoundly influenced the early Ming court artists such as Bian Wenjin (ca. 1354–1428) and Lü Ji. Unfortunately, we have very little biographical information about these early Ming court painters. As artists, they were highly skilled craftsman

who painted in the manner of their Song ancestors. Richard Barnhart has stated that because the Longhi painting is so technically fine, it could arguably be a Song painting, but he feels that it truly represents the transition from the Song to the Ming periods in professional painting of bird-and-flower images.[1]

The stark elegance, simple yet sophisticated composition, and surely rendered texture of this painting appealed greatly to Japanese sensibilities. Artists such as Itō Jakuchū (1716–1800; see cat. no. 56) seemed to have studied closely such compositional arrangements, in which strong diagonals are juxtaposed to create dynamic energy and tension. This work was long in Japanese collections. Kano Tsunenobu (1636–1713) saw this painting and mistakenly assigned it to the Chinese master Xu Xi (active 10th century). During the late Meiji period the Longhi painting was in the collection of Count Yanagisawa Yasutoshi and may have been seen by the *Nihonga* artists whose marked realism owes much to the traditions established by painting of this kind.[2]　　　　—RAP

BIBLIOGRAPHY

Sōgen meiga-shū (Masterpieces of Song and Yuan paintings). 1930–32, pls. 53, 54.

Richard M. Barnhart. *Painters of the Great Ming: The Imperial Court and the Zhe School*. Exh. cat. Dallas: Dallas Museum of Art, 1993, cat. no. 12.

NOTES

1. See Barnhart, 45–48.

2. *Nihonga taisei* (Survey of *Nihonga*), vol. 2 (Kyoto: Shinbi Shoin, 1901), 103.

CAT. NO. 58

Two Eagles

China, Qing period, dated 1702
Hanging scroll; ink on paper
185.5 x 90 cm

Oscar L. Tang Collection

Bada Shanren was born under the name Zhu Da into the Ming imperial family as a ninth-generation descendent of the Yiyang branch. In the early Qing period, being of Ming noble birth was a liability, so in 1648 he entered a *chan* (Zen) Buddhist monastery. For more than thirty years he lived as a successful and recognized *chan* monk. But in 1680 he tore off his monk's robes and burned them, then wandered the streets hysterically crying and laughing until a nephew recognized him and brought him home. From 1681 onward, he led a secular life, focused on painting and poetry.

There were two primary influences on Bada's depictions of eagles. The first was *chan* painting of the Southern Song period. Bada's mature style is closely aligned with masters such as the famous thirteenth-century monk Muqi (ca. 1200–1270), who was known for his ink monochromes and unique use of blank space.[1] The second was the court painters of the late Yuan and early Ming periods who painted birds of prey, probably as a result of a highly military patronage.[2] In particular, the work of the court painter Lin Liang (ca. 1416–1490), who worked in ink only, in a very dramatic style with strong graphic contrasts of light and dark ink washes, bears strong similarities to this work.[3]

Bada's artistic originality can be seen in his visual spontaneity and daring. There is a genuine tension created within his paintings, as his birds and fish stare out at the viewer. The words "brooding" and "angry" are often used to describe their expressions. At various times in his life, he had either feigned madness or was genuinely unbalanced; in either case his painting reflects his inner psyche. His masterful combination of light and dark ink and his wonderful juxtapositions of positive and negative space ensure his place as one of the great painters of the seventeenth century.

Two Eagles is one of Bada's most famous late paintings. This was the third and last time Bada executed this theme in some three years. The other two are now in the Shanghai Museum of Art, one of them dated to 1699. It has been suggested that the first image was done immediately after the Kangxi emperor's (r. 1662–1723) southern inspection tour of 1699 and represents Bada's still-lingering resentment of the Manchurian Qing rule. As in the past, Bada sees this emperor as an enemy, but now in his mid seventies Bada is almost defiant as his powerful and proud eagles glare down at the viewer. It is impossible to confirm this as he only inscribed the date on this hanging scroll, "In the *renwu* year [1702], the sixteenth day of the third month." He also includes one seal that reads "lotus garden," a theme current throughout his career in his poetry and painting. Bada probably identified with the lotus flower as symbolic of his own life in a twofold way— perhaps as the symbol of his Buddhist faith, and also as a symbol of his transcendance, as the beautiful lotus flower that emerges from the mud and mire of the pond.

It is interesting to note that the other artist whose life is often compared with Bada's is Daoji, whose set of album leaves exhibited here was probably done within ten years of this painting (cat. no. 28). Both were members of the Ming imperial house in the period of transition into the Qing; both became *chan* Buddhist monks and practitioners; and both developed important painting styles independently of one another at exactly the same time.

—RAP

Wang Fangyu and Richard M. Barnhart. *Master of the Lotus Garden: The Life and Art of Bada Shanren*. Exh. cat. New Haven: Yale University Art Gallery, 1990, cat. no. 64.

1. See *Mokkei: Dōkei no suibokuga/Ink Mists: Zen Paintings by Muqi*, exh. cat. (Tokyo: Gotoh Museum, 1996).

2. For a late-Yuan image, see the anonymous painting of "Hawk and Pheasant" in Richard M. Barnhart, *Painters of the Great Ming: The Imperial Court and the Zhe School*, exh. cat. (Dallas: The Dallas Museum of Art, 1993), cat. no. 13.

3. Numerous paintings by Lin Liang present the theme of birds of prey. There are close similarities between this painting by Bada Shanren and Lin Liang's painting of "Two Hawks" in the Bei Shan Tang collection. See Barnhart, cat. no. 51.

162

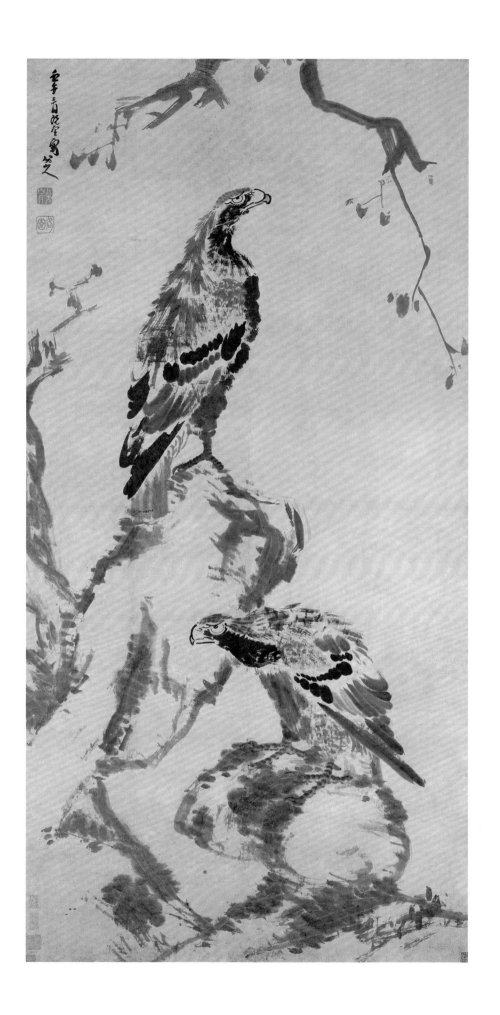

TAKEUCHI SEIHŌ (1864–1942)

Dead Crane

Japan, Meiji–Taishō period,
late 19th–20th century
Hanging scroll; ink and color on silk
154 x 56.8 cm

Robert O. Muller Collection

For sheer technical brilliance there were few challengers to Takeuchi Seihō in the Kyoto world of *Nihonga* (Japanese-style painting). Trained in the Shijō school, Seihō became the preeminent force—as teacher and as artist—in the world of traditional Japanese painting in the first four decades of the twentieth century. His interest in a wide range of styles and subject matter from both East Asia and Europe infused his art with a spirit of experimentation and even, at times, extreme eclecticism, but he never abandoned his firm belief in the power of sketching from life, or *shasei*. He kept many animals at his own home and procured birds on his various "excursions to the Kamo River,"[1] for the express purpose of observing and sketching them.

In many ways, this reliance on empirical observation in preparation for painting was a very conservative aspect of his otherwise quite far-ranging approach to art, for *shasei* is at the conceptual heart of the eighteenth-century origins and traditional techniques of the Shijō school, a tradition that drew equally from Asian academic realism of the Song court tradition and Kano-school practice, and the Western, especially Northern European, approach to the visual recording of nature. Seihō filled book after book with sketches and cartoons for his paintings. A sometimes dispassionate observer, Seihō had an uncommon talent for rendering the material aspects of the animate world. This marvelously disturbing painting of a dead crane is no exception.

The artist's vision of the subject and his rendition appear to clash with long-cherished pictorial traditions. It is rare to find a dead animal as the main subject of a painting in Japanese art. More significantly, the crane is an auspicious symbol of immortality and longevity in Japanese culture and an ubiquitous subject in both Chinese and Japanese painting. On the other hand, cranes were sometimes prepared as food in Japan, mainly on auspicious or felicitous occasions. As the son of a restaurant owner (although his father specialized in fish) and denizen of Kyoto, Seihō would quite likely have encountered cranes, intended for the tables of wealthy patrons, hanging under restaurant or purveyors' eaves. We can imagine how captivating this *manazuru* crane must have been when he happened upon it. Seihō's arresting image, in which he beautifully captured the soft greyness and stiff, inky blacks of the feathers as well as the weight of the bird's body in space as it hangs from the rope, must remain something of a mystery.

Seihō made a trip to Europe to attend the Paris Exposition Universelle of 1900 (he had been awarded a bronze medal for a painting exhibited there). He met Gérôme in Paris, and the paintings of Turner and Corot made a lasting impression on him. He returned determined to revive *Nihonga* through a "return to the thing itself."[2] In one of several lectures he gave after his European trip, he commented:

> I think we must do away with the thinking that there must be a different spirit operating in Western and Japanese art, even while acknowledging there is a different method or approach to painting in each. The degree of weight placed on "capturing the spirit" [*shai*] of a thing notwithstanding, if one knows an object thoroughly the whole, true appearance will be realized in its depiction.[3]

Seihō found himself in later years looking more and more to China, and wrote that he felt *Nihonga* should be grounded in East Asian tradition.[4] Yet he always affirmed the artistic truth available from knowing "an object thoroughly" and portraying it so, a tenet of Seihō's style so aptly expressed in this extraordinary, tactile painting.

—DAW

NOTES

1. *Takeuchi Seihō no shiryō to kaidai* (Annotated documents on Takeuchi Seihō), Kyoto no bijutsu (Art in Kyoto), vol. 4 (Kyoto: Kyoto Municipal Museum of Art, 1990), 10–11.

2. "Seiō kenbun roku (What I heard and saw in Europe)," *Hinode shinbun*, March 5, 1901; reprinted in ibid., 114.

3. Originally published in *Kyoto Bijutsu Kyōkai zasshi* (Kyoto Art Association journal), (August 1901); reprinted in ibid., 118.

4. Untitled article in *Bijutsu no Nihon* (Artistic Japan), (November 1919); reprinted in *Nitten-shi* (The History of Nitten), vol. 6 (Tokyo: Nitten, 1982), 590.

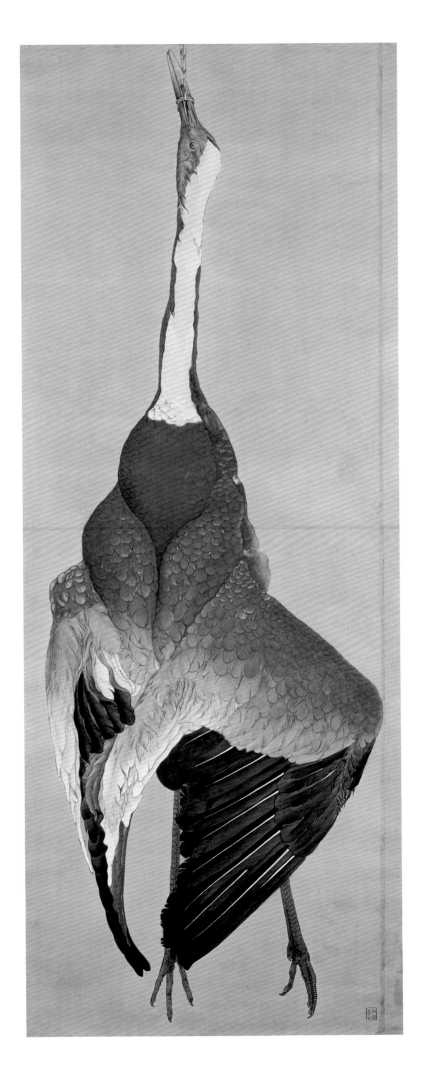

Table with Landscape Design

Okinawa, Ryukyuan Islands, 19th century
Red lacquer on wood with gold paint
and mother-of-pearl inlay
26.7 x 49.5 x 29 cm

Florence and Herbert Irving Collection

Fate placed the Ryukyuan Islands within trading reach of several strong Asian states. Consequently, much of the artistic production of this kingdom exhibited an eclectic flair, drawing on Chinese, Korean, Japanese, and South Asian art, as well as its own deeply colored heritage. This table, a luxurious piece in a Chinese style, is a fine example of the craftsmanship and design acumen of Ryukyuan decorative arts.

Although long an independent kingdom, the Ryukyuan Islands protected their interests by maintaining a tributary relationship with a succession of Chinese dynasties and with the Shimazu clan of the Satsuma fief in southwest Japan. Trade items figured prominently in these relationships, especially sugar, textiles, and, of course, luxury objects. A 1429 Chinese Ming-period document notes the dispatch of an emissary to the Ryukyus to purchase lacquerware. Japanese craftsmen came to the islands in the seventeenth century to give instruction in various decorative techniques popular among Edo-period consumers. Similar imports of technology were made from China. Fostering the growth of the lacquer industry was a major undertaking for the court in Naha in the seventeenth and eighteenth centuries. Beautiful red-colored lacquers with mother-of-pearl inlay from shells native to the Ryukyuan seas were the most distinctive and the most desired objects made for export.

Lacquer-making is a laborious endeavor. The surface is composed of multiple layers of tree sap, clear or pigmented, that must be applied thinly and evenly, allowing as much as five days between applications for each successive layer to dry thoroughly. Application of decorations via inlay, sprinkled gold, and other techniques has to be carefully planned and executed when the surface is exactly ready to receive them. Durable yet fragile, lacquerware has been found in many ancient archeological sites and historically prized at least since the Zhou period in China, the date of the earliest records of lacquer tree cultivation in Asia. References to lacquer appear in *Shijing* or *The Book of Songs* (ca. 500 BCE). Documents relate that the sixth-century Yamato state in Japan organized lacquer production under the Monobe clan and in the 701 Taihō Reforms the Japanese government placed the supervision of lacquer within the Ministry of the Treasury. Lacquer pieces were produced by temple workshops and by hereditary crafts organizations. Urbanization in China and Japan in the seventeenth century created new markets and new popular demand for lacquer pieces for everyday use, such as trays for meals and table settings. No trousseau, no matter what the bride's class, would have been complete without some lacquerware.

The Irving table is a particularly elegant example of Ryukyuan lacquer. The pleasing parallels of frame and tabletop give this piece a solidity that is lightened by the openwork and curvature of the legs. The fantastic landscape in gold with highlights of mother-of-pearl strikes an appealing note of exoticism. The smaller repeated designs that articulate the furniture lines, such as the squirrels along the base, are drawn from traditional Asian motifs.

—DAW

BIBLIOGRAPHY

James C. Y. Watt and Barbara Brennan Ford. *East Asian Lacquer: The Florence and Herbert Irving Collection.* Exh. cat. New York: The Metropolitan Museum of Art, 1991, 367, cat. no. 177.

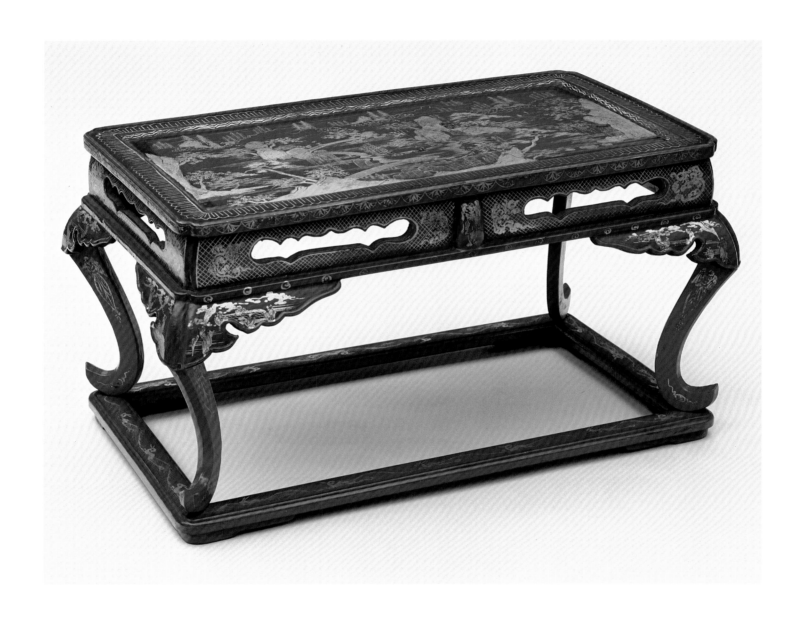

Clothing Box with Dragon Decoration

Korea, Chosŏn dynasty, 19th century
Lacquer, with mother-of-pearl, tortoiseshell, sharkskin, and copper wire inlay, and gold paint
86 x 40 x 19 cm

Florence and Herbert Irving Collection

Dragons, symbols of royalty and virtue, abound in Korean art of all forms, shapes, and media. The dragon was a composite beast, with special attributes: the head of a camel; the horn of a deer; the eyes of a ghost; the body of a snake; the scales of a carp; the claws of a hawk; the tail of a tiger; and a flaming pearl held in its mouth. Traditionally in Korea, five-clawed dragons were used to decorate objects for kings, while four-clawed dragons, as shown here, were relegated to objects for commoners.

According to historical records,[1] the Chosŏn court was greatly concerned with the iconography of the dragon. King Sejong (r. 1418–50) would examine a finished decoration, and point out the dragon's missing parts. This was partially due to the criticism of China during the early years of the Chosŏn dynasty. However, there was more flexibility in the portrayal of dragons for the commoner, which tended to be naïve, humorous, and spontaneous, representing the essence of Korean aesthetic values.

This clothing box is one of the finest examples of lacquerware from the late Chosŏn dynasty. Two dynamic dragons chasing a wish-fulfilling flaming pearl animate the cover and sides of this remarkable object. Inlaid mother-of-pearl, reverse-painted tortoiseshell, sharkskin, and twisted copper wire bring this mythical animal to life. Touches of gold pigment highlighting the design maximize the lively dramatic effect.

Lacquer, a most popular medium in Asia, was used to preserve and decorate vessels and other objects made of organic materials (the support underlying this box is wood). The earliest documented evidence of lacquer in Korea traces it to at least the third century BCE, according to the archaeological excavation of lacquerware fragments at a Bronze Age site in Namsŭng-li, Asan city, South Ch'ungch'ŏng provice. A slightly later find at Taho-ri in Uich'ang county, South Kyŏngsang province provided lacquer relics dating to the first century BCE. In Korea, the decorative use of inlay in lacquer, especially mother-of-pearl combined with tortoiseshell, was applied to a great variety of objects. Abalone shell was preferred over all materials for inlay because of its luminous colors.

The lacquer technique, identified as Chinese in origin, gained special favor in Korea and reached a high level of accomplishment in the hands of Korean artists. In the Koryŏ dynasty, most lacquer objects were Buddhist religious articles such as sutra boxes, rosary boxes, and incense boxes; in the Chosŏn dynasty, lacquer came to be applied to secular items including clothing boxes, stationery boxes, and furniture in a more mass-produced manner.

—HW

BIBLIOGRAPHY

James C. Y. Watt and Barbara Brennan Ford. *East Asian Lacquer: The Florence and Herbert Irving Collection.* Exh. cat. New York: The Metropolitan Museum of Art, 1991, 324–25, cat. no. 158.

NOTES

1. *Sejong sillok* (A true record of King Sejong), vol. 54, originally compiled in 1454.

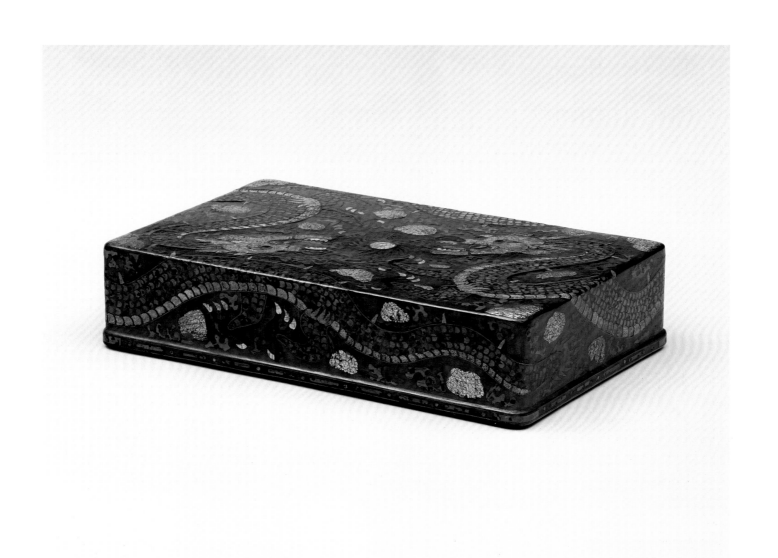

Stacked Clothing Storage Chest

Korea, Chosŏn dynasty, mid 18th–early 19th century
Wood with panels of reverse-painted ox horn and brass fittings
117.5 × 73.7 × 33.7 cm

David Rockefeller Collection

The *nong* (clothing chest), usually consisting of two or three stacked wooden boxes, was one of the essential items of furniture used in the woman's quarter of Chosŏn households. In contrast to the customary minimal and simple Korean furniture types, chests ornately decorated with delicate reverse-painted ox-horn sheets (*hwa-gak*) reflect the refined taste and highly developed craftsmanship of the Chosŏn dynasty.

Although most households used bedroom storage chests, this kind of delicately ornamented chest was produced for the upper class or even for the royal family. It was common for ox-horn paintings to be applied to small objects such as boxes, brush jars, or sewing accessories; the most frequently used background color for such paintings was red. This example is not only massive in scale, but remarkable in itspredominantly yellow palette and array of auspicious motifs. The combination of scale and design make this one of the most striking examples known. Because of the expense of the material and time consumed to produce the finished work, such large pieces of furniture with ox-horn painting decoration are extremely rare, and this chest is an outstanding example of the type.

The technique of ox-horn painting is unique to Korea. Although scholars believe that the

Chinese reverse-painted tortoiseshell technique is related, it was a Korean invention to adopt ox horn as a decorative material. The earliest historical evidence for Korean ox-horn painting decoration dates to the fifth century, in two examples now preserved in Shōsō-in, Japan: a sewing ruler and a small fragment of decoration for a lute.

The process of working a piece of ox horn for this type of decoration is extremely complicated. Selected pieces of horn would first be soaked and boiled in water, and then heated on a charcoal fire to achieve the flattened form required for the appliqué panels. The thin transparent panels would be shaved and trimmed into uniform sheets prior to the painting procedure. Generally, each sheet would have an independent and separate scene painted with very bright saturated mineral colors, which convey an especially luminous and subtle effect when viewed through the transparent horn sheet. The painted sheets are attached with a special glue to a wooden frame, and then, finally, wire-thin trimmed ox bone is inlaid between the sheets. A varnish is usually applied to extend the durability of the fragile ox horn, which is sensitive to changes in climate. Considering these characteristics, the condition of this pair of chests is excellent.

The decorative scheme of this chest consists of a multitude of repeated designs on each of the ox-horn sheets. Auspicious symbols make up most of the designs arranged on the individual panels. These symbols include the double-happiness characters used in Chinese and Korean decoration, as well as animals and insects representing longevity, prosperity, and happiness. The deer represents longevity, butterflies symbolize happiness and love

between husband and wife, phoenixes symbolize prosperity and peace, plums represent upright and faithful scholars, and peonies suggest riches and honors. These are the most prevalent motifs on the chest, among other auspicious plants and animals intertwined in the complex design. —HW

BIBLIOGRAPHY

The David and Peggy Rockefeller Collection, Vol. 3: Arts of Asia and Neighboring Cultures. New York: Privately published, 1993, 264–65, cat. no. 203.

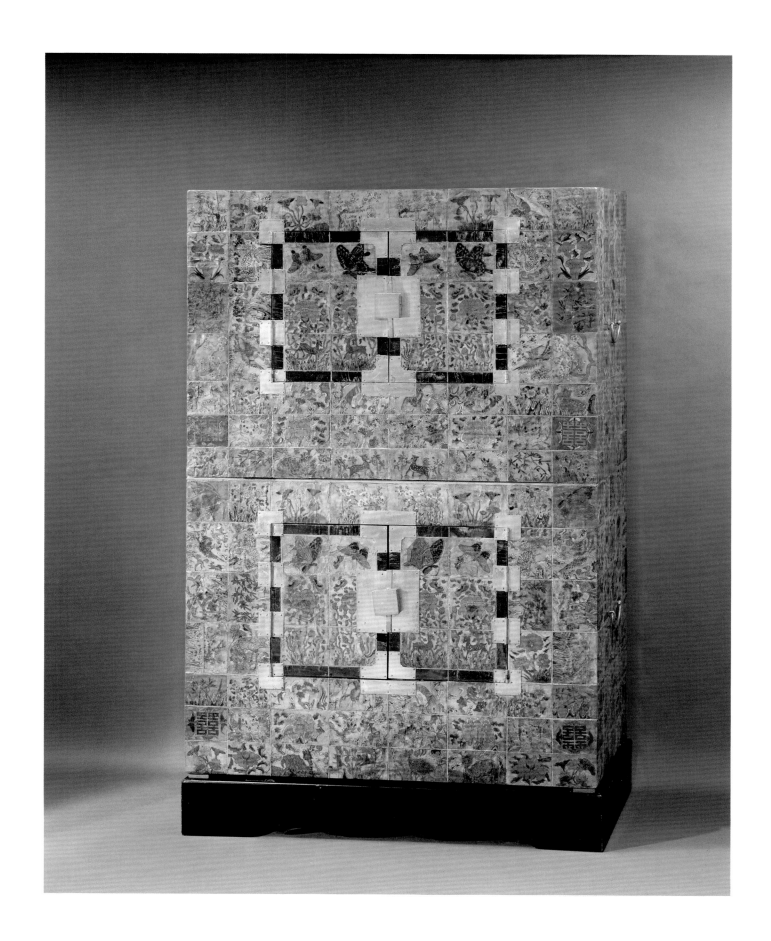

Blue and White Dish with Scrolling Flowers

China, Ming period, Yongle reign (1403–25)
Porcelain with cobalt oxide underglaze
h: 7.5 cm, diam: 40.7 cm

Mrs Myron S. Falk, Jr. Collection

This marvelous blue-and-white dish exemplifies the transition between the Yuan and Ming periods in the decorative and ceramic arts. During the Yuan period, under the great Mongolian Khan emperors, China's power and influence extended as far as Persia and Western Europe. The subsequent widespread commercial and cultural exchange caused new ideas and influences to flow into China. The influence of Persian decor, such as the floral and ivylike scrolling motifs found in their metalwork and architectural decoration, can be seen here in the central and middle registers of this dish.

During the Yuan period, Chinese blue-and-white wares were greatly admired in Persia, where potters had attempted to use their indigenous cobalt for glazes but found that they lacked the proper materials for the white porcelain bodies. Dishes like this, designed for serving large groups, were not often produced for use in China, where smaller dishes were favored for tableware. Persia and Turkey were the principle patrons of much of the blue-and-white that was produced for export in the late Yuan and early Ming periods. Indeed, some of the best-known collections of these wares can be found today in Istanbul and Tehran. The extensive trade with Persia was essentially halted in the early Ming period by the Hongwu emperor (r. 1368–99) who declared an end to all overseas trade.

This dish was made during the reign of the third emperor of the Ming period, the Yongle emperor, who usurped the throne of his nephew, the designated heir to the Hongwu emperor. The Yongle emperor is perhaps best known for his construction of the Forbidden City in Beijing, completed in 1421, which stands today as one of the world's great architectural monuments and houses the Beijing Palace Museum Collection. The Yongle emperor was also a great patron of the arts, which flourished under his reign.

The imperial kilns at Jingdezhen, in present-day Jiangxi province, had become during the Yuan period the most important site for ceramic manufacture in China. During the Ming period, this center eclipsed all others in the production of fine porcelains. The underglaze cobalt-blue decoration that first emerged during the Yuan was further developed and refined in the early Ming and perfected into what might be termed the classic Ming coloration as appreciated in the West.

The technological and aesthetic character of ceramics produced at this time can be seen in the Falk dish's very white, fine-grained, and extremely smooth body, given a rich lustrous quality by the thick glaze. Blue-and-white wares are in general made by painting designs in cobalt oxide directly onto the unbaked body that was then covered in clear glaze. The intensity of the blue pigment creates a graphic contrast between the white ground and the decoration. There is no reign mark on this dish, which is typical of the early Ming period, as very few dated Yongle-marked wares exist. It was during and after the subsequent Xuande period (1426–36) that reign marks become more prevalent on Chinese ceramic wares.

During the Yongle period, the dense decoration typical of Yuan-period export wares was simplified. Ming decoration focused more on floral patterns, including those representing the four seasons—peony for spring, pomegranate for summer, chrysanthemum for fall and camellia for winter—or of the twelve months. As the Ming period progressed, these decorative scrolling flowers were often broken apart, and were thus not as densely arranged, into single sprays of flowers and fruit-tree blooms spread over the surface. The Falk dish demonstrates this transition in its variety of scrolling chrysanthemum, peony, camellia, peach, and cherry flowers, among others, in a lively but not overly dense design. The outermost register's breaking-wave pattern is a popular decorative motif, later picked up by Japanese potters, as seen, for example, in Kakiemon-style under- and overglaze decorations. —RAP

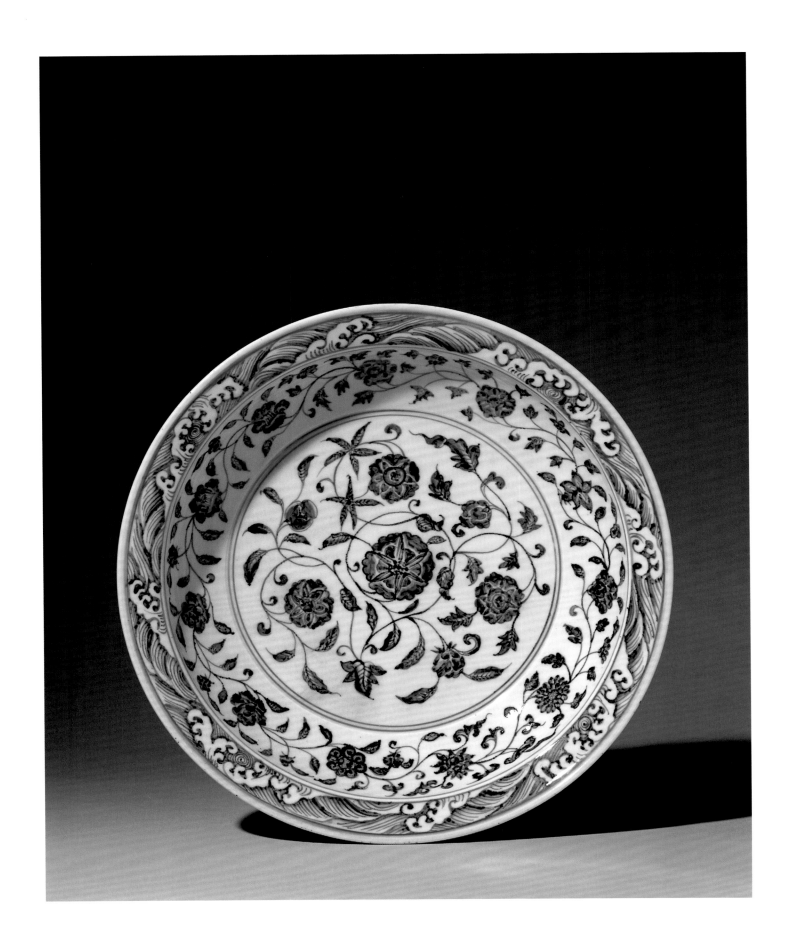

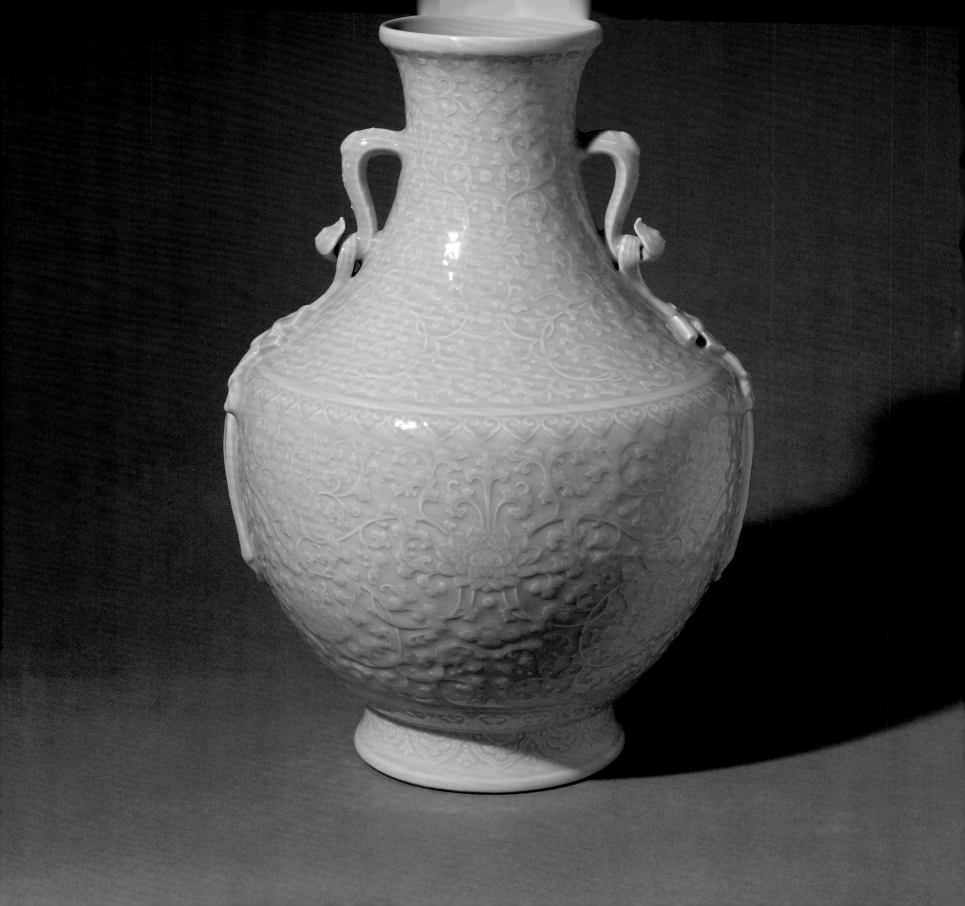

Large Celadon Vase

China, Qing period, Qianlong reign (1736–96)
Porcelain with white slip and celadon glaze
h: 50.2 cm

Dr. George Fan and Mrs. Katherine Hu Fan
Collection

Celadons from the Qianlong period often represent a balance between tradition and innovation. At this time, there was marked interest in imitating Song imperial wares and celadons, maintaining the archaistic tastes of the preceding period of the Yongzheng emperor (r. 1723–35). The Qianlong emperor was an admirer of Guan, Ge, Ru, and Jun wares. In addition to collecting fine antique ceramics and often inscribing them with poetic praise, he also ordered copies made of his favorite wares. With the technology in porcelain production at the imperial kilns of Jingdezhen reaching unprecedented heights, the finished products—in color, glaze texture, and design—were almost undistinguishable from the originals.

This incorporation of the past and present was also evidenced by the various ways in which the past was reinvented. In this magnificent large celadon vase, the vitreous light green glaze is most effectively reinterpreted. Although recalling the lustrous color and surface textures of earlier Longquan celadons, the glaze became brighter with the application of a white slip to the porcelain body, which was intended to accentuate the molded decorative reliefs. The overall shape of the vessel, with its narrow mouth, sharply curved shoulders, and elaborate handles, each in the form of a beribboned *ruyi* (a trefoil-headed sceptor symbolic of long life and good wishes), represents Qing-period taste as does the molded design of scrolling lotus and peony flowers and *ruyi* on the vessel's

exterior. However, the complexity of the decorative scheme, although distinctly legible on the surface, is subtly downplayed through the emphasis of the monochromatic glaze.

Perhaps the vase's most spectacular qualities are its impressively large size and flawless state. Usually, with pieces of this scale, sagging or other defects tend to occur during the firing process. The symmetry of the vessel's shape, the clarity of the molded design, and the consistency in the application of the glaze, contribute in making this work exemplary of its type. An equally rare and monumental celadon vase, based on an archaistic bronze, is located in the Baur Collection in Geneva.[1]

The six-character Qianlong reign mark in seal script on its base indicates that this vase undoubtedly functioned as imperial ware. Its grand scale and highly decorative motifs suggest it was most likely found within the palace environment and was not considered export ware. This particular vessel does not reflect Japanese taste in Chinese celadons; the relative austerity in the design of the Longquan octagonal dish (cat. no. 46), is more typical of wares admired in Japan. Rather, it is a significant emblem of the technical perfection Chinese ceramics attained during the Qing and the endurance of the celadon tradition in East Asia. —FY

NOTES

1. John Ayers, *The Baur Collection, Geneva: Chinese Ceramics, Vol. 3: Monochrome-Glazed Porcelains of the Ch'ing Dynasty* (Geneva: Collections Baur, 1972), A379.

Hizen Ware Footed Dish with Chrysanthemum in a Stream

Japan, Edo period, mid 17th century
Arita-style porcelain with celadon glaze with
decoration in reserve and cobalt blue underglaze
diam: 30.4 cm

Property of Mary Griggs Burke

While ceramics number among the most sophisticated artistic achievements in Japan in all periods, porcelain was a surprising late-comer, belonging more to the seventeenth century and later. Orders from the Dutch East India Company prompted the development of the nascent industry in Western Japan, and an increasingly urban population provided a domestic market for tableware. Before that time, porcelains were almost exclusively imported from China and Southeast Asia.[1]

Two failed campaigns by the warlord Toyotomi Hideyoshi (1537–1598) on the Korean peninsula in the late sixteenth century provided the opportunity for Korean potters and technologies to be brought back to Japan. With their arrival, new kiln activity began in the area around Nagoya Castle, Hideyoshi's staging ground for the invasion, in present-day Saga prefecture. The activity of what are now called Hizen kilns expanded further west and south as sources of porcelainous rock were put to use, particularly in the small town of Arita. Disruption of production at the Jingdezhen kilns in China with the downfall of the Ming government in the mid seventeenth century also provided an impetus for the Japanese kilns to become suppliers to the nation and, to some degree, the world, at least until Jingdezhen revived in the eighteenth century.

Japanese porcelain design was marvelously eclectic. In it we can see the strength of artisanal traditions that refashioned the past. All manner of surface decoration and form, from such varied sources as lacquer and textile motifs, European design specifications, and, of course, older Jingdezhen pieces, were put to use. Interestingly, Japanese innovations, especially in overglaze enamelling—familiar today as Kakiemon and Imari styles—were adapted by the Chinese and even made in quantity for export back to Japan as well as to Europe. The freshness of these early Japanese forays into porcelain production is unusually delightful.

This tripod dish, a superb example of work done around Arita in the seventeenth century, is cloaked in an iron glaze that turned to a celadon color in a reducing atmosphere in the kiln. Because the foot was glazed as well, a portion of the glaze on the interior of the ring had to be removed and replaced with iron oxide to prevent the piece from fusing to the stand used when the piece was fired, leaving the interior of the foot ring brown.

The combination of cobalt blue underglaze decoration and design in reserve on this piece, made by removing some of the iron glaze to show the white body, is remarkably new, as is the asymmetrical application of the traditional Japanese motif of chrysanthemum and water. The geese and grasses, while not wholly Japanese in execution, reflect the integration of seasonal sensibility that was very strong in all traditional Japanese arts, literary and visual.

This lovely celadon dish, from the early years of the Edo period, with its naïve grace of design, proportion, and limpid coloring, exquisitely

reflects the aesthetic values of its times, as well as contemporary technology and economics. Its remarkable beauty and innovative approach to design evolved through the complicated interplay among the tastes and pocketbooks of Europe, Asia, and the domestic markets of Japan and through the technical and material demands of production itself. The wide-ranging exchange of ideas among kilns, craftsmen, and purveyors around the world is one of the most fascinating aspects of the arts of the seventeenth century.

—DAW

BIBLIOGRAPHY

Miyeko Murase. *Jewel Rivers: Japanese Art from The Burke Collection.* Exh. cat. Richmond: Virginia Museum of Fine Arts, 1993, cat. no. 61.

NOTES

1. For example, Oliver Impey cites inventories of objects in the possession of Shogun Tokugawa Ieyasu (1543–1616) that seem to indicate that all the high-quality ceramics were imported. See Oliver Impey, *The Early Porcelain Kilns of Japan* (Oxford: Clarendon Press, 1996), 26–29.

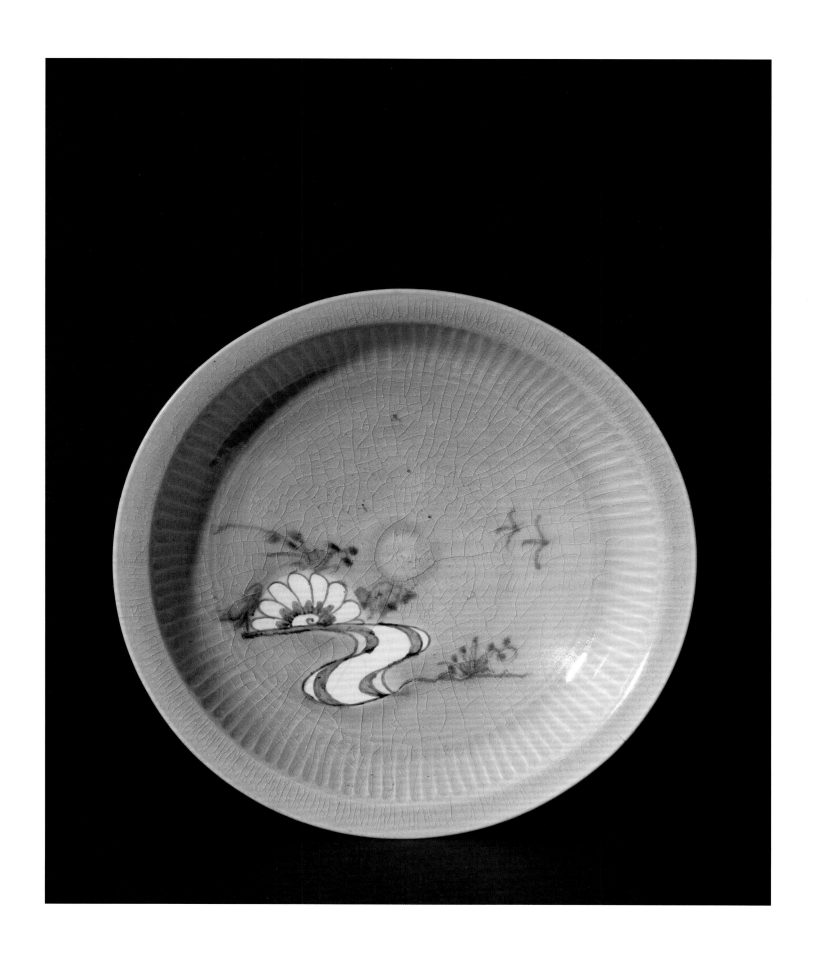

Scene from the Pleasure Quarters

Japan, Edo period, 17th century
Six-panel screen; ink, color, and silver leaf
on paper
87.6 x 219.7 cm

Private Collection

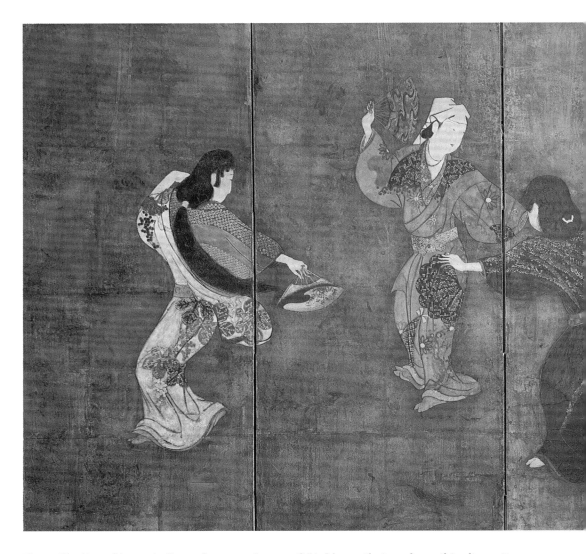

The unification of Japan in the early years of the seventeenth century brought with it tremendous social change. Displacing the aristocratic houses and even to some degree temples and shrines, prosperous merchant houses of Kyoto and Sakai, together with powerful warlords, became important patrons of the arts and participants in a new urban culture both serious and insouciant. Physical pleasures —not only of sex but also of the five senses— were a major part of their aesthetic ethos. Nowhere could the senses be more heightened than in the rooms and streets of the demimonde. Stage performers, dancers, courtesans, and their customers were all part of the color-ful tableaux that made up this alternative world. Fashionable and beautiful, the people of the pleasure quarters were a favorite subject of fiction, paintings, screens, printed picture books, and single-page prints throughout the Edo period.

This screen, originally the right half of a pair, shows such a group of au courant figures enjoying dancing and music. At the far right is a studiously nonchalant male who watches the performance, leaning on his sword, carelessly holding a fan, leading our gaze into the picture. The postures of the performers and their audience grouped in sloping diagonals lend a

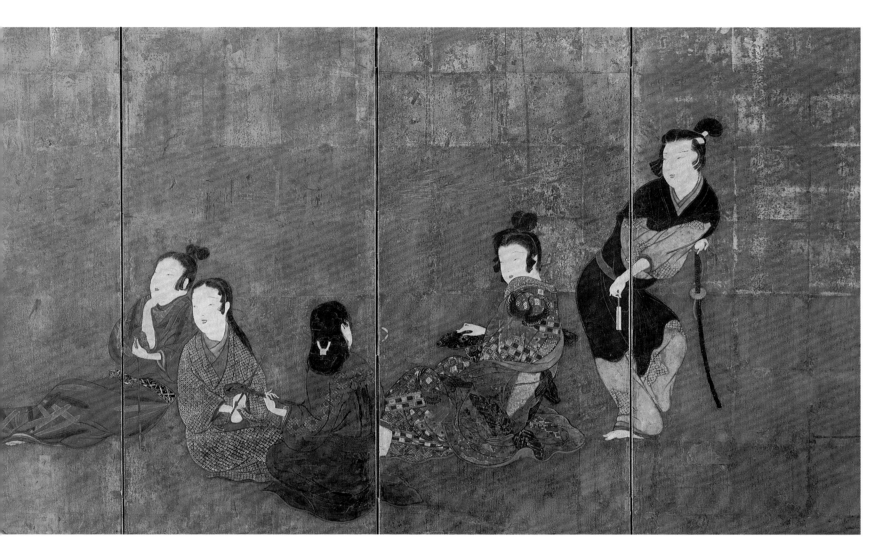

strong sense of *kabuki* to the painting. *Kabuki*, meaning "to lean" or "to tilt," was a term that came into vogue in the late sixteenth century to describe behavior outlandish and playful, and was usually associated with debauchery and perversity. (The name of Kabuki theater reflects such origins.) Set simply on the silver-leaf ground, the figures are remarkable for the way that they energize the space around them even in languor. The artist has captured the habits of body and pose of each person that carries both a realism—one senses the physical substance beneath their clothes—and a decorativeness—a patterning of form on the surface of the screen.

Vignettes of palace and home life in Ming-period woodblock-printed books, as well as a long tradition of domestic observation in Japanese handscrolls, may have informed these genre paintings (*fūzoku-ga*) that so delightfully focus on the indulgences of leisure.

The artist who painted this screen, most likely a Kyoto craftsman, was familiar with the work of the most talented of his contemporaries. The male figure at the far right is almost an exact mirror image of a ne'er-do-well in the famous Ii family screen, now in the collection of the Hikone Castle Museum in Shiga prefecture. The dancer at the far left recalls the female figures

of Hishikawa Moronobu (died 1694), whose street and theater scenes defined the colorful age of the seventeenth century.

—DAW

HOSODA (CHŌBUNSAI) EISHI (1756–1829)

Brothel and Gardens

Japan, Edo period, late 1780s
Triptych, color woodblock prints
38.8 x 25.6 cm each print

H. A. Russell Family Collection

The luxury of leisure is a unique quality of Eishi's woodblock print designs, well evident in this stately triptych of women awaiting their evening assignations in one of Edo's premier entertainment establishments. The technical superiority of this work demonstrates the high level of sophistication in the printing industry in the last years of the eighteenth century and the capabilities of the publisher, Takatsuya Isuke.

Eishi was a high-level samurai who trained in the Edo academic art studios of Kano Eisen'in Michinobu. In the 1780s he abandoned his social and moral security, officially turning over his family position to an adopted son in 1789, to work with Torii Bunryūsai (active late 18th century) and other *ukiyo-e* artists. A fine painter and master of composition in all media, Eishi was a keen observer of class and the material aspects of hierarchies within and without the demimonde.

The muted palette of yellow, green, and red-purple hues and carefully constructed rectangular units of this print reinforce the slim elegance of the women and their costumes. The calm of the late afternoon, just before the evening's amusements and carousing begin, allows us to appreciate the special composure and reserve each woman brings to her work. Bearing tea and smoking sets, their small attendants add a hint of playfulness to the scene. (Indenture could begin as early as ten years old; most courtesans debuted around the

age of fifteen or sixteen.) In the middle print, one of the women holds a bow and another the arrows from a *yōkyū* archery set, one of the parlor game amusements for the hours ahead. The expansive gardens and tasteful appointments of the rooms, rendered in a fashionable Western-style perspective, further underscore the restrained opulence of the setting. This villa was most likely temporary housing for the brothel outside of the Yoshiwara after one of the district's many fires.

The art and artifice of the pleasure quarters was to make sex an aesthetic, cultured pursuit. In its heyday (when this print was created), buying the favors of a courtesan or even participating in an evening's revelry of music, drink, games, and cultured banter was a highly ritualized process and very expensive although by no means an elite pastime. All social classes mingled in the "domain of everywhere and nowhere" (*arinsu koku*)[1] that was the Yoshiwara. There were between 2,800 and 2,900 women working in the quarter during the Tenmei era (1781–1789) and over 4,000 recorded during the succeeding Kansei era (1789–1801). (These statistics do not include the vast numbers of women and entertainers who worked the streets and in establishments outside of the licensed district.)[2] Distinct rankings and carefully manipulated degrees of access to the women who "sold laughter," along with woodblock prints, illustrated books and elaborate guides such as Tsutaya's *Yoshiwara saiken* (Close look at Yoshiwara; first published in 1775), maintained

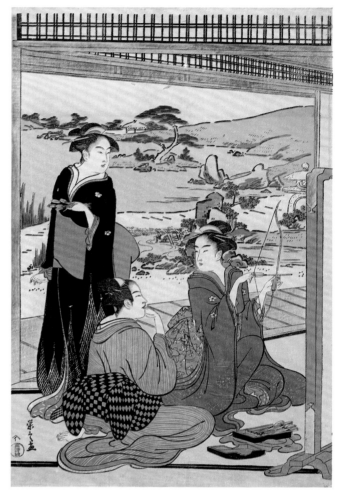

the mystique of the world of sensual pleasure while at the same time making it available for consumption by an ever-expanding, even mass, audience.

—DAW

NOTES

1. "Arinsu" was dialect for the polite form of "to have." The great majority of women indentured in the Yoshiwara were from impoverished areas to the north of Edo and Yoshiwara slang made much use of northern dialects. See Nihon Fūzokushi Gakkai, ed., *Shiryō ga kataru Edo no kurashi 122-wa* (122 stories of Edo life told by documents), (Tokyo: Tsukubanesha, 1994), 260–62.

2. Ibid. 213.

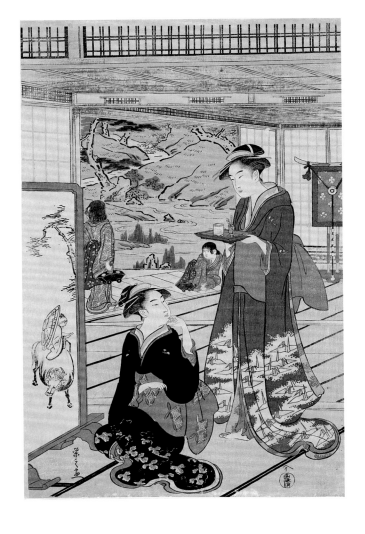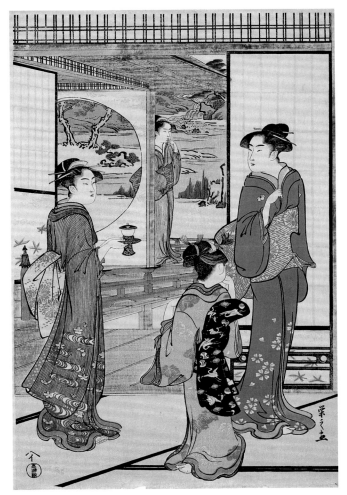

KITAGAWA UTAMARO (1753?–1806)

Hitomoto of Daimonjiya

Japan, Edo period, ca. 1796
Color woodblock print
38.8 x 25.6 cm

H. A. Russell Family Collection

KATSUKAWA SHUN'EI (1762–1819)

Matsumoto Kōshirō IV in a Youth Role

Japan, Edo period, ca. 1790s
Color woodblock print
38.1 x 25.25 cm

H. A. Russell Family Collection

The bust portrait or *ōkubi-e* (literally, "large-head picture") was first used in the late eighteenth century to depict the popular faces and fashionable demeanor of Kabuki actors.

Mementoes and records of performances and stage rosters were a commercially viable segment of the print industry, inspiring fascinating innovation and luxury in single-sheet woodblock prints throughout the Edo period. Shun'ei was a member of the Katsukawa family of print designers and artists who specialized in actor prints, as well as wrestlers. Their strong yet restrained angular style of drawing was particularly good at capturing the subtleties of bombast on stage.

This close-up of an actor portraying a young man in a domestic drama, is something of a character study, allowing us to view the actor himself practicing his craft as he composes his role. The inclusion of the hand holding the iris leaves (a somewhat immodest allusion to youthful male beauty) is a brilliant detail;

its thickness, even as it is deployed in a proper delicate turn, reveals the person behind the stage persona far more than the face. The quality of the printing, with mica background and subtle facial shading, as well as the crisp line and textile patterns, adds a further tactile dimension to this work.

The actor Matsumoto Kōshirō IV (1737–1802), identified by his crest, was at various times a student of Segawa Kikunojō I (1693?–1749) and Ichikawa Danjūrō IV (1711–1778). He was especially celebrated for his voice and diction and for his roles in *wagoto*, or romantic plays, portraying the tender side of masculinity.

Shun'ei's mentor was Katsukawa Shunshō (1726–1792), a prolific and popular artist thought to be of samurai background who was also a gifted poet. Shun'ei's fellow pupil Shunkō (1743–1812) is credited with the dramatic compositional innovation of the bust portrait. In the hands of Tōshūsai Sharaku (active ca. 1794–1795), this format became the means for displaying the grand intensity of stage presence; adapted by Kitagawa Utamaro for portraying beautiful women, it offered a more subtle means to plumb femininity and habits of body.

The coy portrait of the courtesan Hitomoto is one of a group of eight published by Iseya Kinbei. Each depicts a courtesan from a particular establishment in the Yoshiwara licensed quarters in Edo and lists her young attendants called *kamuro*. (Hitomoto's *kamuro* are Senkaku and Banki, as recorded after her name in the print's upper left corner.) Utamaro skillfully evokes the relaxed, physical presence of the woman, with her fashionable hairstyle and understated attire. His sensuous line exposes

the nape of Hitomoto's neck and curvature of her breasts, smoothly juxtaposed with her easy laughing gesture with her sleeve, her body in delicate balance with the elaborate shape of her coiffure.

Sexuality and the graphic arts have a long association in both Japanese and Chinese art traditions. Utamaro, in concert with the leading publishers of the Edo *ukiyo-e* world, most prominently Tsutaya Jūzaburō (1750–1797), created a passionate image of female beauty that was fundamentally different from all previous depictions of women in woodblock prints.[1] While we know that the real working world for women in the pleasure quarters was often one of great hardship and cruelty, there was also a deserved celebration of the accomplished craft of entertainment, along with its concomitant leveling of culture with carnal attractions, that Utamaro explores in his single-sheet prints and illustrated books.

Utamaro purports to know these women while at the same time commodifying their image. Though not realistic in a mimetic way, the elegance and beauty inherent to courtesans and their place are not idealized: instead, these qualities are given flesh and blood in Utamaro's graphic genius. When we consider that during the years of Utamaro's most splendid production, social and economic change and reform were irrevocably constricting the glamor and escapism available within the Yoshiwara gates, it seems that Utamaro's recording is almost unconsciously elegaic, depicting lives lived passionately with no promise of tomorrow. —DAW

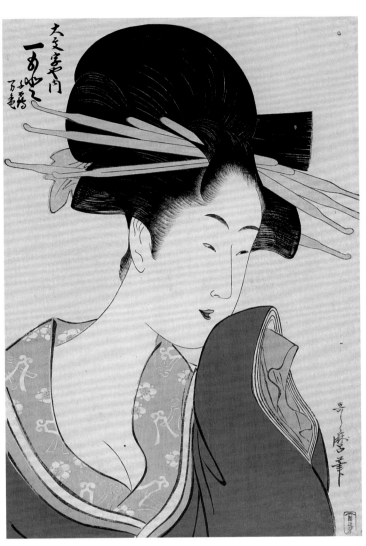

CAT. NO. 68

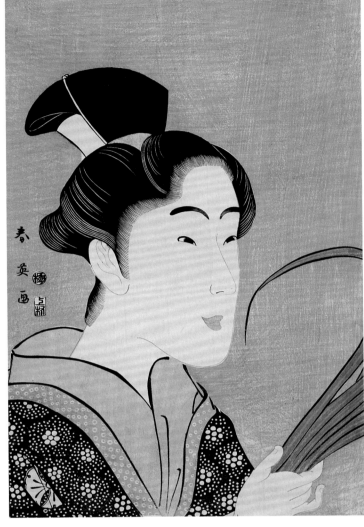

CAT. NO. 69

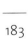

NOTES

1. For a fuller treatment of this idea and a concise reassessment of Utamaro see Timothy Clark, "Utamaro and Yoshiwara: The 'Painter of the Green Houses' Reconsidered" in Asano Shūgo and Timothy Clark, *The Passionate Art of Kitagawa Utamaro*, 2 vols., exh. cat. (London: British Museum, 1995), 35–46.

KATSUSHIKA HOKUSAI (1760–1849)

Sekiya Village on the Sumida River

and

South Wind, Clear Weather (Red Fuji)

from *Thirty-Six Views of Fuji*

Japan, Edo period, ca. 1830–31
Color woodblock prints
25.4 x 37.6 cm; and 25 x 38 cm

H. A. Russell Family Collection

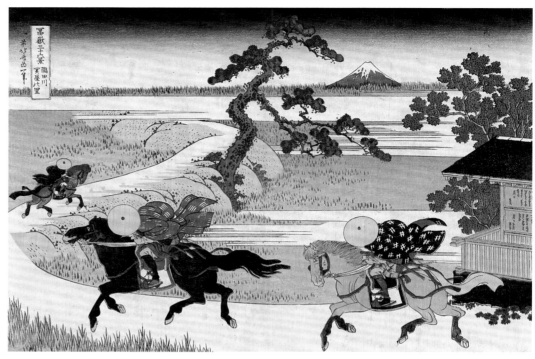

CAT. NO. 70

"Of no fixed residence" states the entry on Hokusai in an 1836 guide to Edo men and women in the arts. By his own count Hokusai moved ninety-three times during his long and rich life, but he turned this restlessness of mind and spirit to extraordinary artistic inspiration.[1] These prints are from his signature series, *Thirty-Six Views of Fuji*, a work that popularized the landscape genre within *ukiyo-e*. In a virtuoso performance, Hokusai presented his subject from a variety of distances and vantage points, from various locations, alone and in combination with scenes of ordinary people going about their daily work. Hokusai had the gift of placing the ordinary, especially the world of the lower classes, in a context of beauty and natural order. His print series are not simply genre variations on landscape, but something altogether new and documentary.

While scenery and famous places were subject matter for printed books in Japan at least since the second half of the seventeenth century (and much earlier in Ming China), single-sheet woodblock prints did not take up such themes in earnest until the nineteenth century. The "floating world" (*ukiyo*) of Japanese prints, long focused on actors, courtesans, and parodies of the classic past, shifted to include views of the city and country as travel became a leisure activity for more and more of Japan's non-elite. Place became as important as fame or personality as something to vicariously possess, for sightseeing was a means to remove oneself from the everyday, no less than a visit to the theater or the entertainment quarters.

Hokusai's personal empathy and strong pictorial sensibility transform what might have been simply a clever conceit of viewing Mount Fuji from every possible angle to a serious, but unflaggingly enjoyable, excursion into the true appearance of the Japanese countryside. The Sekiya scene brims with Hokusai's muscular energy of line, showing three anonymous post riders setting off from the checkpoint gate

at a mad pace to the south for their leg of the Edo to Kyoto journey. The rust-red glow of Fuji in the distance sets up a dynamic diagonal with the pine tree, the first rider's roan horse, and the bar-patterned coat of the second rider. Hokusai makes good use of the raised curve of the road to accentuate the recession and hasten the movement through the picture.

Another from the series, commonly known as *Red Fuji*, is without doubt one of Hokusai's greatest. Its extraordinary color printing makes an unforgettably forthright statement of the beauty that can be realized from the simplest means of paper, color, and wood. The blue shading of the sky surrounding the high cirrus clouds subtly reveals the quality of daylight as it filters and refracts through distant ice and vapor. The russet darkens at the peak of the mountain, heightening the few streaks of snow left at the summit, while the wood grain of the printing block gives texture and tactility to the surface. The long sweep of unevenly brushed green is a bold, almost painterly device that reads as wind and clearing mist at the foot of Fuji, between trees and the rocky upper section. Hokusai's design is equally magisterial in its execution; we feel the wonder of Fuji's perfect form and the play of nature upon it.

The *Thirty-Six Views* series was a wildly successful edition for Hokusai's publisher, Nishimura Eijudō. Not only did the subject matter strike a responsive chord with his mass audience, but the first thirty-six images of the forty-six finally published were also printed in fashionable imported Prussian-blue outlines.

—DAW

NOTES
1. See Kobayashi Tadashi, "Hokusai to Fugakuzu" (Hokusai and pictures of Mount Fuji) in *Edo kaigashi-ron* (On the history of Edo painting), (Tokyo: Rūri Shobō, 1983), 355–70.

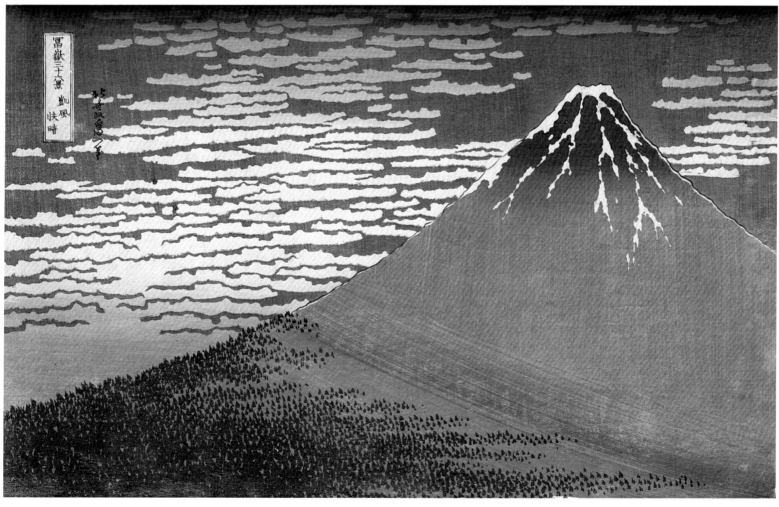

CAT. NO. 71

Further Reading, Index,
Officers and Trustees

General

Cahill, James. *The Lyric Journey: Poetic Painting in China and Japan*. Cambridge: Harvard University Press, 1996.

Lee, Sherman E. *A History of Far Eastern Art*. 5th ed. New York: Abrams, 1994.

Pal, Pratapaditya, ed. *Light of Asia: Buddha Sakyamuni in Asian Art*. Exh. cat. Los Angeles: Los Angeles County Museum of Art, 1984.

Japanese Art

Addiss, Stephen. *The Art of Zen*. New York: Abrams, 1989.

———. *How to Look at Japanese Art*. New York: Abrams, 1996.

Clark, Timothy. *Ukiyo-e Paintings in the British Museum*. Washington, D.C.: Smithsonian Institution Press, 1992.

Collcutt, Martin, et al. *Cultural Atlas of Japan*. New York: Facts on File, 1988.

Conant, Ellen P., ed. *Nihonga, Transcending the Past: Japanese-Style Painting, 1868–1968*. Exh. cat. Saint Louis: The Saint Louis Art Museum, 1995.

Cunningham, Michael R., et al. *The Triumph of Japanese Style: Sixteenth-Century Art in Japan*. Exh. cat. Cleveland: The Cleveland Museum of Art, 1991.

Guth, Christine M.E. *Art of Edo Japan: The Artist and the City, 1615–1868*. New York: Abrams, 1996.

The Heibonsha Survey of Japanese Art. 31 vols. Tokyo and New York: Heibonsha, 1972–79.

Hickman, Money L. *Japan's Golden Age: Momoyama*. Exh. cat. Dallas: The Dallas Museum of Art, 1996.

Impey, Oliver. *The Early Porcelain Kilns of Japan*. Oxford: Clarendon Press, 1996.

Mason, Penelope. *History of Japanese Art*. New York: Abrams, 1983.

Morse, Ann Nishimura, and Samuel Crowell Morse. *Object as Insight: Japanese Buddhist Art and Ritual*. Exh. cat. Katonah, N.Y.: Katonah Museum of Art, 1995.

Murase, Miyeko. *Masterpieces of Japanese Screen Painting: The American Collections*. New York: George Braziller, 1990.

Poster, Amy, and Henry Smith. *Hiroshige: One Hundred Views of Edo*. New York: George Braziller, 1986.

Roberts, Laurence P. *A Dictionary of Japanese Artists: Painting, Sculpture, Ceramics, Prints, Lacquer*. New York: Weatherhill, 1990.

Rosenfield, John M., and Elizabeth ten Grotenhuis. Exh. cat. *Journey of the Three Jewels: Japanese Buddhist Paintings from Western Collections*. New York: The Asia Society, 1979.

Rosenfield, John M., and Mimi Hall Yiengpruksawan. *Buddhist Treasures from Nara*. Exh. cat. Cleveland: The Cleveland Museum of Art, 1998.

Shimizu, Yoshiaki, ed. *Japan: The Shaping of Daimyo Culture, 1185–1868*. Exh. cat. Washington, D.C.: National Gallery of Art, 1988.

Shimizu, Yoshiaki, and Carolyn Wheelwright. *Japanese Ink Paintings*. Exh. cat. Princeton: The Art Museum, Princeton University, 1976.

Shimizu, Yoshiaki, and John M. Rosenfield. *Masters of Japanese Calligraphy: 8th–19th Century*. Exh. cat. New York: The Asia Society Galleries and Japan House Gallery, 1984.

Singer, Robert T., et al. *Edo: Art in Japan, 1615–1868*. Exh. cat. Washington, D.C.: National Gallery of Art, 1998.

Smith, Henry. *Hokusai: One Hundred Views of Mt. Fuji*. New York: George Braziller, 1988.

Washizuka Hiromitsu, Roger Goepper, et al. *Enlightenment Embodied: The Art of the Japanese Buddhist Sculptor*. Exh. cat. New York: Japan Society Gallery, 1997.

Watanabe Akiyoshi, Kanazawa Hiroshi, and Paul Varley. *Of Water and Ink: Muromachi-Period Paintings from Japan, 1392–1568*. Exh. cat. Detroit: The Detroit Institute of Arts, 1986.

Yamane Yūzō, Naitō Masato, and Timothy Clark. Exh. cat. *Rimpa Art: From the Idemitsu Collection, Tokyo*. London: British Museum Press, 1998.

Chinese Art

Barnhart, Richard M. *Along the Border of Heaven: Sung and Yuan Paintings from the C.C. Wang Family Collection*. Exh. cat. New York: The Metropolitan Museum of Art, 1983.

———. *Painters of the Great Ming: The Imperial Court and the Zhe School*. Exh. cat. Dallas: The Dallas Museum of Art, 1993.

———. *Peach Blossom Spring: Gardens and Flowers in Chinese Paintings*. Exh. cat. New York: The Metropolitan Museum of Art, 1983.

Billeter, Jean François. *The Chinese Art of Writing*. New York: Rizzoli, 1990.

Bush, Susan. *The Chinese Literati on Painting: Su shih (1037–1101) to Tung Ch'i-ch'ang (1555–1636)*. Cambridge: Harvard University Press, 1971.

Cahill, James. *Chinese Painting*. New York: Rizzoli, 1977.

Further Reading

———. *Compelling Image: Nature and Style in Seventeenth-Century Chinese Painting.* Cambridge: Harvard University Press, 1982.

———. *The Painter's Practice: How Artists Lived and Worked in Traditional China.* New York: Columbia University Press, 1994.

Chang, Kwang-chih. *The Archaeology of Ancient China.* 4th ed. New Haven: Yale University Press, 1986.

China 5,000 Years: Innovation and Transformation in the Arts, Selected by Sherman E. Lee. Exh. cat. New York: Solomon R. Guggenheim Museum, 1998.

Clunas, Craig. *Art in China.* New York: Oxford University Press, 1997.

Fong, Wen C., and James C.Y. Watt. *Possessing the Past: Treasures from the National Palace Museum, Taipei.* Exh. cat. New York: The Metropolitan Museum of Art, 1996.

Fong, Wen C., ed. *The Great Bronze Age of China.* Exh. cat. New York: The Metropolitan Museum of Art, 1980.

He Li. *Chinese Ceramics: A New Comprehensive Survey from the Asian Art Museum of San Francisco.* New York: Rizzoli, 1996.

Li Chu-tsing and James C.Y. Watt. *The Chinese Scholar's Studio: Artistic Life in the Late Ming.* Exh. cat. New York: The Asia Society Galleries, 1987.

Munakata, Kiyohiko. *Sacred Mountains in Chinese Art.* Exh. cat. Urbana-Champaign: Krannert Art Museum, University of Illinois, 1991.

Murck, Alfreda, and Wen C. Fong, eds. *Words and Images: Chinese Poetry, Calligraphy, and Painting.* New York: The Metropolitan Museum of Art, 1991.

Nakata Yujiro, ed. *Chinese Calligraphy: A History of the Art of China.* New York, Tokyo, Kyoto: Weatherhill/Tankosha, 1983.

Rawson, Jessica, ed. *The British Museum Book of Chinese Art.* London: The Trustees of the British Museum, 1992.

———. *Chinese Ornament: The Lotus and the Dragon.* London: The Trustees of the British Museum, 1984.

———, ed. *Mysteries of Ancient China: New Discoveries from the Early Dynasties.* Exh. cat. London: British Museum, 1996.

Schafer, Edward H. *The Golden Peaches of Samarkand: A Study of T'ang Exotics.* Berkeley: University of California Press, 1985.

Sullivan, Michael. *The Arts of China.* Rev. ed. Berkeley: University of California Press, 1977.

Valenstein, Suzanne G. *A Handbook of Chinese Ceramics.* New York: The Metropolitan Museum of Art, 1989.

Watson, William. *The Arts of China to AD 900.* New Haven: Yale University Press, 1995.

Weidner, Marsha S., ed. *Latter Days of the Law: Images of Chinese Buddhism, 850–1850.* Exh. cat. Lawrence: Helen Foresman Spencer Museum of Art, University of Kansas, 1994.

Wu Hung. *Monumentality in Early Chinese Art and Architecture.* Stanford: Stanford University Press, 1996.

Yang Xin et al. *Three Thousand Years of Chinese Painting.* New Haven: Yale University Press, 1997.

Korean Art

The Arts of Korea. 6 vols. Seoul: Dong Hwa Publishing Co., 1979.

Chong Yang-mo et al., eds. *Arts of Korea.* New York: The Metropolitan Museum of Art, 1998.

Five Thousand Years of Korean Art. Exh. cat. San Francisco: Asian Art Museum of San Francisco, et al., 1979–81.

Itoh Ikutarō et al. *The Radiance of Jade and the Clarity of Water: Korean Ceramics from the Ataka Collection.* Exh. cat. Chicago: The Art Institute of Chicago, 1994.

Kim Hongnam, ed. *Korean Arts of the Eighteenth Century: Splendor and Simplicity.* Exh. cat. New York: The Asia Society Galleries, 1993.

Kim, Kumja Paik, ed. *Hopes and Aspirations: Decorative Painting of Korea.* Exh. cat. San Francisco: Asian Art Museum of San Francisco, 1998.

Kim Wŏn-yong et al. *Korean Art Treasures.* Seoul: Yekyong Publications Co., Ltd., 1986.

Lee, Peter H., ed. *Sourcebook of Korean Civilization, Volume One: From Early times to the Sixteenth Century.* New York: Columbia University Press, 1993.

———. *Sourcebook of Korean Civilization, Volume Two: From the Seventeenth Century to the Modern Period.* New York: Columbia University Press, 1996.

Moes, Robert J. *Auspicious Spirits.* Exh. cat. Washington, D.C.: International Exhibition Foundation, 1983.

———. *Korean Art from the Brooklyn Museum Collection.* New York: Universe Books, 1987.

Whitfield, Roderick, and Roger Goepper, eds. *Treasures from Korea: Art Through 5000 Years.* Exh. cat. London: British Museum, 1984.

Index

Japan Society